A CULINARY HISTORY OF
ATLANTA

A CULINARY HISTORY OF
ATLANTA

AKILA SANKAR McCONNELL

AMERICAN PALATE

Published by American Palate
A Division of The History Press
Charleston, SC
www.historypress.com

Front cover, top, left to right: Early Coca-Cola advertisement, approximately 1890s. *Library of Congress Prints and Photographs Division*; Paschal's fried chicken, yams and cornbread dressing. *Author photo*; Peach slider donuts from Revolution Doughnuts. *Author photo*.
Front cover, bottom: Atlanta Market Co., circa 1900. *Atlanta History Photograph Collection, Kenan Research Center, Atlanta History Center*.
Back cover, top: Municipal Market. *Municipal Market Company*; *bottom*: Municipal Market Ceremonial Opening, 1974. *MSS 602, Boyd Lewis Papers, Kenan Research Center, Atlanta History Center*.

First published 2019

Manufactured in the United States

ISBN 9781467141239

Library of Congress Control Number: 2019932532

Notice: The information in this book is true and complete to the best of our knowledge. It is offered without guarantee on the part of the author or The History Press. The author and The History Press disclaim all liability in connection with the use of this book.

CONTENTS

Contents

1

THE VILLAGE BY THE PEACH TREE

PRE-COLONIZATION

L ong ago, before time was measured by calendars and clocks, the Muskogee (Creek) Indians marked a peach tree next to the Chattahoochee River as a convenient meeting place.[1] Peach trees were not common in that particular patch of forested land, and this peach tree was easy to find, described in later years by the first postmaster as "a great huge mound of earth heaped up there—big as this house, maybe bigger—and right on top of it grew a big peach tree. It bore fruit and was a useful and beautiful tree."[2] A network of trails soon made its way to that tree, and uncounted Muskogee women picked fuzzy pink-orange fruit as sticky juice dripped down their children's chins and hands.

Eventually, the Muskogee built a village there named Pakanahuili, literally "Standing Peachtree," referring to that large peach tree that stood at the top of the hill. The Muskogee comprised the largest Native American nation in the state of Georgia, controlling much of present-day Georgia and Alabama, but it was not a single tribe. Rather, the Muskogee were a confederacy or commonwealth of chiefdoms, with each chiefdom consisting of eight to ten villages and around five thousand people who adopted sophisticated agricultural methods, rituals, art and architecture, managed by a single chief. Standing Peachtree was the main village in its chiefdom.

For ten thousand years, the success and strength of the Muskogee Nation lay in its domination of food. Food was critical to the Muskogee way of life, and the Creek women were inventive and talented cooks, to the point that every European visitor who wrote about them mentioned the variety, flavor and freshness of Creek cuisine in their writings.

Benjamin Hawkins, George Washington's principal Indian agent in the Southeast, was continually delighted by the delicious food he ate among the Georgia Muskogee. At one Creek village in 1796, Hawkins noted that the women grew beans, ground peas, squash, watermelons, collards and onions and raised hogs, cattle and poultry. The Muskogee "wanted principally salt, that they used but little from necessity, and where they were able to supply themselves plentifully with meat, they were unable to preserve it for the want of salt."[3] For dinner, a Muskogee chief greeted Hawkins with good bread, pork and potatoes, ground peas and dried peaches, and in the morning, he breakfasted on corn cakes and pork. The Indians he visited had fowl, hogs and cattle and a four-acre field fenced for corn and potatoes.

Among the Native American tribes, the Muskogee Nation was particularly adept at agriculture, with women planting and gathering, while the men focused on hunting and fishing. The women dried and preserved fruits, vegetables and meat and boiled, roasted and smoked meat and fish. Barbecue—smoking meats on thin slats of wood—was the most popular Muskogee method of cooking. Any type of meat could be intended for the barbecue, ranging from alligator and fish along the coast to venison in the verdant woods near Standing Peachtree. Hawkins reported that a deer hunted and killed would be butchered and on the barbecue in less than three hours.

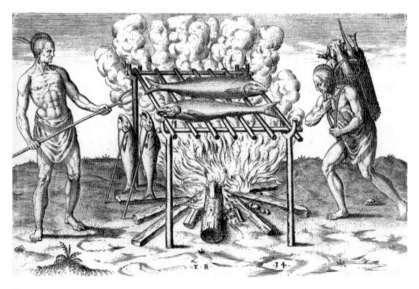

Early barbecue with Secota Indians. *Thomas Hariot, 1585, University of North Carolina, Chapel Hill (2003).*

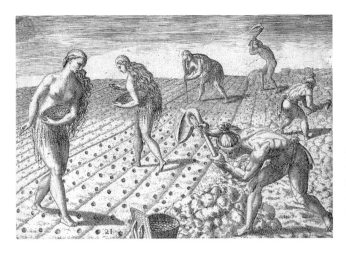

Timucua men and women cultivating a field. *Theodor de Bry, engraver, Jacques Le Moyne de Morgues, 1591, Library of Congress.*

But corn was the Muskogee Nation's most important food. Domesticated, bred and adapted from a grass called *teosinte* near the Tehuacan Valley of Mexico more than five thousand years ago, corn quickly became the predominant food across the Americas. In the southeastern United States, corn accounted for 50 percent of the Muskogee diet, and hominy was the preferred way to prepare corn. The Muskogee particularly favored *sofkee*, an invigorating morning drink of thin hominy flavored with venison. When Benjamin Hawkins came to Georgia, one village chief presented him with a basket of corn for his horses, a fowl, sofkee and hominy.

Given the importance of food, every month, the Muskogee held a festival dedicated to the first fruits of horticulture and hunting, such as the gathering of chestnuts, mulberries and blackberries. Of these festivals, none was more important than the *poskita*, or Busk, to recognize the importance of the ripening of the green corn. Held each year in July or August, depending on when the corn began to ripen, the Busk celebrated collective renewal, including rites of purification such as fasting, the destruction of old things and mass cleaning and refurbishing. Then, a priest would ignite a new fire in which young men would burn an ear of the season's first corn, recognizing that corn was a sacred plant that gave life to the chiefdom.

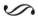

BY THE TIME THE white man reached the state of Georgia in the late 1700s, Standing Peachtree, that small village by the Chattahoochee, had become a notable trading post and rendezvous point due to its strategic

position on the frontier between the competing Muskogee and Cherokee Nations. In the first written mention of the village in 1782, a Georgia colonel begged a South Carolina general to send troops to help him battle a group of braves who were meeting at "the standing Peach Tree." In August of that year, a commissioner planned to meet with Indians at "the standing peach tree."[4]

During the War of 1812, the Creek Nation split into two. Half of the Creek Nation supported the British because they feared that the Americans would continue expanding into Indian lands. The other half of the Creek Nation supported the Americans, believing that the Americans would maintain good relations with them, become good trading partners and help them prosper. The Creek Indians who lived at Standing Peachtree were among those who supported the Americans.

As a friendly village to the fledgling American government, Standing Peachtree was chosen as the site of a U.S. infantry fort, unoriginally named Fort Peachtree. Built directly across the river from the Standing Peachtree village, Fort Peachtree was led by Lieutenant George Rockingham Gilmer, and the militia named the road running from Fort Peachtree to Fort Daniel as Peachtree Road.

Though the Muskogee and Americans were allies, tensions ran high between the closely situated Standing Peachtree Indians and the Fort Peachtree militia. When Gilmer went out for the day to scout, he often baited lines for catfish and hung the lines from limbs into the Chattahoochee River. One afternoon, a Creek Indian came to Gilmer and offered to sell him some fine catfish. An argument ensued when Gilmer claimed that the catfish was from his lines, while the Creek insisted they were from his lines. The Creek Indian threatened to slit Gilmer's throat and then ran away from the camp.

Despite these ill feelings, the village of Standing Peachtree continued to support the Americans and General Andrew Jackson. On a pleasant spring evening, Gilmer heard the Standing Peachtree braves firing bullets into the Chattahoochee River, and when he went to investigate, the warriors were going from cabin to cabin in joy and described to him "exultingly as well as they could the battle of the Horseshoe, where they had fought under General Jackson. They brought home eighteen scalps."[5] That Battle of Horseshoe Bend under General Andrew Jackson was the definitive battle of the War of 1812, in which Muskogee killed Muskogee. Some 80 percent of the Native Americans who supported the British were killed, resulting in America winning the war.

Andrew Jackson and Creek Indian William Weatherford at the Battle of Horseshoe Bend.
John Reuben Chapin, W. Ridgeway, 1859, Library of Congress.

The win was ultimately a loss for the Standing Peachtree braves. Within a year, Jackson forced the entire Creek Nation to cede twenty-three million acres of their land to the American government in payment for the "unprovoked, inhuman, and sanguinary" war fought by the Creeks who supported the British, despite the fact that the Standing Peachtree braves and many like them had supported and fought with the Americans. Within the next decade, the American government forced the Creek Indians to march westward, eventually into Oklahoma, scores freezing to death in harsh climates they had never before experienced. By 1821, the village of Standing Peachtree was empty and there were no Muskogee Indians left in the great wild woods of north Georgia.

But the present cannot shake the past. The vestiges of ten thousand years of Native American life continue in modern-day Atlanta. Cornbread and hominy are essential southern staples. Sofkee lives on as grits. Indian corn bread, known as hoecake, is frequently served with collards. Boiled cornbread or Indian fritters are called hush puppies and served with fried catfish in both that age and this. Southerners cook their beans and field peas

by boiling them, as did the Native Americans. Barbecue, Georgia's most prized meal, has not changed much in five thousand years.

Most telling, Peachtree Street, the iconic road that runs through the heart of the capital of the South, was named after the original Standing Peachtree village, in turn named after that massive peach tree that bore ripe sweet fruit by the banks of the Chattahoochee River.

From then to now, Atlanta is the city built on food.

HOMINY AND GRITS

The Muskogee Indians made a significant contribution to Atlanta's food by introducing hominy and grits. At their heart, both hominy and grits are simple foods, requiring only boiling three ingredients—coarse cornmeal, salt and water—while a dab hand at the stove prevents lumps, graininess and unevenness. The difference is in the preparation.

The Muskogee Indians favored hominy. They prepared hominy by soaking corn kernels in an alkaline mixture of wood ash and water that made a natural lye. The caustic lye ate away the exterior skin of the corn, in a process known as *nixtamalization*, leaving the soft, plump interior behind. This nixtamalization process adds niacin to the corn and helps balance essential amino acids in the body, resulting in a healthy and versatile meal. Women then dried the hominy, ground it into coarse meal and boiled it with water, milk or butter to turn into grits or thinned it with venison flavoring to make sofkee.

While early American pioneers ate hominy, grits were much simpler to prepare, since grits required only drying corn and grinding the kernels with the exterior skin between stones to create fine cornmeal, something even a farmer could do without much trouble if he lived far away from a mill.

As Atlanta grew, hominy became the staple food for both the pioneers as well as the slaves. In Georgia, the standard ration given to slaves was a single peck of corn a week with perhaps a small quantity of salt, meaning that cornmeal made up the vast majority of the slaves' diets. During the Civil War, cornmeal was the primary grain furnished to the Confederate troops.

After the Civil War, Atlantans still ate a great deal of hominy and grits. In 1867, Mrs. A.P. Hill included several recipes that were clearly Native American in origin in her cookbook, including hominy, a bread made from hominy and grits.

Ley (lye) hominy. To a gallon of shelled corn, add a quart of strong ley (lye). Boil together until the husks begin to come off the corn; rub the grains of corn between the hands and entirely remove the husk; wash it well, and boil in plenty of water until the grains are soft. It requires long boiling. As water may be needed, replenish with **hot** water. Boil in it sufficient salt to season. When nearly done, stir it from the bottom to prevent its burning. Before using it, mash it slightly with a wooden mallet, and fry in a small quantity of lard or butter.[6]

Emma Patterson, an Atlanta resident, born in 1901, remembered that when she was a child, she would make hominy by skinning corn with Red Seal lye. "We'd boil the corn in that and when it got done then we'd take it and wash it and rub every one of them husks out of it and we'd put it in big containers."[7]

In 1928, Henrietta Dull, known professionally as Mrs. S.R. Dull, provided the following recipe for hominy grits:

Hominy

1 cup of hominy (grits)
4 cups of boiling water
2 teaspoons of salt

Pour the hominy into the boiling water and stir until it comes to a good boil. Lower the fire or pull to a slow boiling point on range. Cover and boil slowly for one hour, stir frequently. When ready to serve, put a small lump of butter into the hominy and beat well for several minutes.

The beating whitens and makes the hominy much lighter.

Half a cup of hot milk or thin cream in place of butter can be used.…

Hominy to be the best must be stirred often while cooking.

Hominy and grits consumption has steadily decreased over the last century, with hominy now barely registering as a consumed grain. In 1909, 4.5 pounds of hominy and grits were consumed per capita in the United States; in 1997, 2.6 pounds of hominy and grits were consumed per capita, and the numbers continue to dwindle. The consumption is also largely racially and socioeconomically divided. A 1986 study found that low-income families were five times more likely to eat grits than their

wealthier neighbors. A *New York Times* study found that grits appeared in only 11 percent of kitchens in white families, whereas 51 percent of black families had grits in their kitchens.

Today, in Atlanta, though it is rare to find hominy in restaurants, grits continue to be a popular breakfast side, and shrimp and grits has been adopted from the Lowcountry region in Atlanta's top seafood restaurants.

2

WHISKEY DENS AND GINGERBREAD

Terminus and Marthasville: 1821 to 1847

When the American government pushed the Creek Indians out of northern Georgia, the area surrounding Standing Peachtree did not even have a name, but it became a rough frontier town. Prior to 1837, there was only one settler in the hundreds of acres surrounding Standing Peachtree, a reluctant pioneer named Hardy Ivy who had wanted property near Decatur, Georgia, but instead agreed to take on the land closer to Standing Peachtree.

About eight miles west of Standing Peachtree, in present-day West End, Charner Humphries and his family migrated from South Carolina and opened up the first restaurant in the area, a small tavern and inn at the crossroads of the Newnan and Sandtown Roads. Humphries named his tavern and inn White Hall because it was whitewashed at a time when most buildings would be in natural or weathered wood. The White Hall Tavern served as a tavern, stagecoach stop, general store and post office. Travelers could rent one of eight rooms from the White Hall House, get a basic meal at the tavern and walk across the street to the store.

At the very back of the store, Humphries kept a whiskey barrel on tap where cash customers were allowed to drink "on the house," but for strangers or occasional visitors, it was considered good etiquette to leave a dime on the barrel head after having their fair share of whiskey. Every year, White Hall hosted a muster day where the members of the local militia gathered to perform a drill of arms with feats of marksmanship. The militia provided a yearling cow as the prize, which was then killed, butchered, barbecued

and served to all the hungry men, with generous helpings from Humphries's whiskey barrels.

White Hall Tavern was the exception, however. Most travelers and pioneering settlers had little, subsisting largely on what they foraged or hunted. Any tiny amount of cotton or corn raised by settlers was traded to the few merchants for dry goods or staple groceries, and "plenty of those rugged settlers had never seen wheat flour."[8] George Washington Collier, one of Atlanta's founding settlers, described that period:

> *Why there were no towns here when I came. There was nothing except land lots and trails and corn patches. There was no money. There were no railroads, no papers. We didn't get the mail but once a week. There wasn't any business to do—much. The farmers just made their corn and ate it for bread; that was all.*[9]

In 1837, THE WESTERN and Atlantic Railroad appointed engineer Colonel Stephen Long with the task of finding a terminal point for its railroad line. He originally scouted near the location of Standing Peachtree but discovered that the topography near the river would make locating a terminal and junction point infeasible. So, he approved a spot closer to Hardy Ivy's land, marking it as the terminal point of the railroad line. Soon after, Colonel Lemuel P. Grant of the Georgia Railroad designated the same spot as the terminus of that line, declaring, "It looked like a good place to stop and we stopped."

Portrait of Colonel L.P. Grant. *Martin,* Atlanta and Its Builders.

Colonel Long didn't think much of the land; when he was given the chance to purchase one hundred acres of cheap land surrounding what he and other railroad men named the Terminus, he scoffed and refused, stating, "[T]he Terminus will be a good location for one tavern, a blacksmith shop, a grocery store, and nothing else."[10] James Calhoun, future mayor of Atlanta, agreed with Long, arguing that the "terminus of

that railroad will never be any more than an eating house," and another Dekalb County representative retorted, "True, and you will see the time when it will eat up Decatur."[11]

At first, Terminus was slow to grow. John Thrasher and his family set up a combination house and store room with a few staple goods on the shelves in 1839, but they gave up on the grocery trade within three years, since there were no more than thirty residents in Terminus. The next eating establishment belonged to an old woman and her daughter, who, a year or two later, sold cakes and root beer to passersby for nickels and dimes.

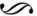

In 1843, THE CITIZENS of Terminus decided to rename the town Marthasville, after Governor George Lumpkin's youngest daughter. But Marthasville was too small to even be considered a village. There were four straggling country roads, about twelve to fourteen families living in the town and fewer than one hundred residents.

There were three notable retail establishments in the village, all associated with food: Wash Collier owned a grocery store-cum-post office, with an attached building operated by Moses Formwalt as the city's first saloon; Jonathan Norcross had a dry goods store and sawmill; and Thomas Kile owned a small grocery that also acted as a "drinking shop." The village contained a small wooden building used for church services, and

Marthasville's first two-story building. *Martin*, Atlanta and Its Builders.

the townspeople lived in log cabins. The grandest building in town was the two-story frame building used by the management of the railroad. Those were the prominent features of Marthasville.

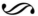

On September 15, 1845, a new day dawned for the town of Marthasville as farmers from forty miles around came on ox carts and horses to watch the giant iron horse—the eagerly awaited first train—enter the village. The villagers had never been more excited, and the engine and cars were closely examined, the conductor and engineers interviewed and the lecturer at the event spoke prophetically, marking this as a banner day, as the completion of the railroad "tied the sea to the hills."

Within a year, the railroad enthusiasm was contagious. New villagers came in droves, so by 1846, Marthasville had a population four hundred strong. But these were railroad men, rough and tumble, with few women living in the town. A year later, the village had grown large enough that there were two hotels in Marthasville, the Atlanta Hotel and the Washington House, a "long, rambling house of wood. The bar was in the front room and in the dining room the long table was spread as in the olden time. The viands were put before you and you helped yourself."[12] The two-story Washington House had eight bedrooms and no baths, but advertisements described "meals served in time for cars and stages."[13] These two hotel owners owned almost 10 percent of the slaves in Marthasville; the slaves cooked, cleaned, carried bags and performed other menial duties.

George G. Smith, one of the city's first residents, explained,

> *There was no exclusively dry good store, nor were any of the departments of trade, except heavy groceries, confined to a single article. Things to eat were very cheap. Eggs were 8 cents a dozen; chickens, 2 cents apiece; butter from 10 to 12 ½ cents per pound. I have seen good sweet potatoes sold as low as 15 cents a bushel.*

The town had no market, and "fresh meat was hawked about in a cart."[14] Food supplies were so basic that it was a point of wonder when newspaperman Cornelius Hanleiter, Atlanta's first foodie, ordered shipments of shrimp, oysters in the shell, saltwater fish, mullet and trout to be delivered to Marthasville so that he could host the city's first dinner parties in 1847 and 1848.

Options for dining, too, were limited. At the train station, Ransom Montgomery, one of Marthasville's two free black persons, sold coffee and cakes. Daniel Dougherty, a genial Irishman, set up the village's first bakery near the railroad. Bill Durham peddled ginger cakes his mother baked in her tiny log house at the edge of Broad and Mitchell Streets. Antonio Maquino, a "diminutive specimen of the French nationality," known informally as "Little Toney," kept the first restaurant, described as "a poor affair under Wheat's store, where he served oysters, and ham and eggs, and where, when the gamblers wished, they could have a quiet little game of seven-up."[15]

At some point, Maquino established a small confectionery and knickknack establishment, selling soda water, ice cream, cakes and fruits at a wagon yard on the slope between Peachtree Street and Walton Springs, a park with clear, deep and cold spring water located in present-day Downtown Atlanta. This humble refreshment stand became one of the young town's main attractions. To entice patronage, Maquino built a crude attraction known as "Maquino's Wheel." The wheel—which preceded the Ferris wheel by about forty years—was made from wood, patterned after a mill wheel and about forty feet in diameter. Dry-goods boxes, large enough for two people, were suspended from the mill wheel, and several muscular slave men pushed the handle. The young boys of Marthasville shouted with glee as it rotated while they feasted on candy and fruit.

As Marthasville grew, the residents came to believe that its town name was too provincial to meet the aspirations of the rising village. The village decided to rename itself to honor the railroad path to the Atlantic Ocean.

And so, on December 29, 1847, Marthasville officially became Atlanta.

SWEET POTATOES AND YAMS

For the pioneering settlers in Terminus and Marthasville, after cornmeal, sweet potatoes were the next most important food. During the winter months, sweet potatoes replaced corn as the primary ration for slaves, and sweet potatoes were so cheap and easy to grow that even the poorest settler could afford them. Even after the Civil War, sweet potatoes remained an important part of Atlantans' diet. An 1874 writer effused that the people who live in a "country that grows sweet potatoes and cow peas have much to thank God for."[16] In 1888, an Atlanta cultivator

wrote that the sweet potato was not "properly appreciated" by national audiences because northern farm books and recipe books focused on Irish potatoes and turnips for both men and stock; the writer argued that the southern sweet potato was a "boon that is denied them" and southerners should use it to feed both men and animals.[17]

By 1921, the Atlanta Women's Club crowned the vegetable "Queen Sweet Potato":

> *The Sweet Potato, a native of the South, is capable of being served in more tempting ways than any other product of the soil....Truly a "poor man's pie," given by a generous Maker! It contains all the necessary elements, and is easily digested. Georgians should sing the praises of Queen Sweet Potato, as California does the raisin and Ireland the "spud."*

Most Atlantans today agree that candied yams and sweet potato soufflés are an essential part of southern meals, and the recipes have not changed much in one hundred years, including the mini marshmallow–topped soufflé, such as this one from the Atlanta Women's Club 1921 cookbook (original spelling and directions maintained):

Sweet Potato Delight

2 potatoes (medium sized)
1 cup sugar
1 cup nuts
1 box seedless raisins
1 box shredded cocoanut
20 marshmallows

Add potatoes peeled and sliced thin to sauce pan, cover with sugar and water; cook until tender, place alternately layers of potatoes, cocoanut and raisins sprinkled with nuts. Add syrup in which potatoes were candied and cover with marshmallows. Cook in moderate oven until a golden brown. Serve in dish in which it is cooked.[18]

THE MARKET TOWN

Early Atlanta: 1848 to 1860

Barely large enough to be considered a village, the Atlanta of 1848 was a footnote to the larger towns of Decatur and Marietta. There were no pavements or sewers, and whiskey dens, billiard rooms, faro banks and brothels punctuated every corner of the village of two miles.

In January 1848, about a month after the renaming of Atlanta, the new town held its first election. The free white men of Atlanta met in front of Thomas Kile Grocers and made the choice between Jonathan Norcross of the Morals Party and Moses W. Formwalt of the Free and Rowdy Party. Norcross was a temperate man, a devout churchgoer who believed in the prohibition of alcohol and reduction of vices. Formwalt was a twenty-eight-year-old Tennessean who owned both a tin and copper shop that manufactured beer stills and the first saloon in the young town. It came as no surprise that in a city where vice and gluttony ruled, Formwalt won the first election and was named Atlanta's first mayor.

Under Formwalt's watch, the town of Atlanta grew even more lawless. Drinking resorts, gambling dives and brothels were run wide open, without regard to law enforcement, and locals complained that "nearly every other building was a groggery."[19] Despite the town's rough reputation, the railroad acted like a siren call and the town grew faster than anyone expected. Early resident George Smith described market day in the town of Atlanta:

> Atlanta being the only railroad center for miles around, had a very fair trade
> in country produce. The countrymen brought their chickens, eggs, and butter

into Atlanta from the country, and there was a very much larger range than there is now. The average farmer did not make much profit, for eggs sold at four or five cents a dozen; butter at seven, eight and ten cents a pound, and other country produce in proportion.[20]

Country produce was cheap because Atlanta itself was a country town and everyone had his or her own garden with potatoes, onions, peas and beans. Farmers could not sell much milk since most townspeople had their own cows. Those cows roamed the town wherever they pleased, as did the hogs, meandering through the main streets of young Atlanta. In fact, six months after Formwalt was elected, the city council fined a man one dollar for not removing a dead cow from the public streets.

The town did not have a community center or area large enough to hold many people. Most political rallies and gatherings were held at the church or at Walton Springs, the park in which Antonio Maquino had his Maquino's Wheel and concession stand. Invariably, barbecues followed the political rallies. A judge summed up young Atlanta as "a typical crossroads village of the old Southern civilization—a place for stump speeches, barbecues, and fisticuffs....A rougher village I never saw."[21] This practice of coupling barbecues with politics was in no way exclusive to Atlanta: across the South, many ambitious men, including President George Washington, had found that barbecues offered a compelling platform for political advancement.

For example, in September 1848, the Whig Party gave a huge barbecue in Atlanta to address the controversial topic of the newly established Democratic Party. Nine thousand people from the surrounding countryside packed the woods of Walton Springs to listen to the speeches, but the one thousand Democrats were more interested in the barbecue set up in the ravine. In the middle of the last speech, the marshal saw the rising number of Democrats crowding around the ropes of the barbecue tables, and Marshall Adair, a prominent Whig and early Atlantan, rode his horse back as fast as it would go to the Whig supporters and yelled out, "Dinner is ready and the Democrats will eat it all up if you don't come down right away." That broke up the speaking immediately, and as the audience turned toward the barbecue, they saw a mob rushing over the ropes and falling upon the meats and breads. The Democrats carried all the food away, and the hungry Whigs were furious.[22]

By 1850, there were around 2,500 white residents of Atlanta, 500 black slaves, and fifty stores, nearly all of which supplied whiskey. And, in that year, Jonathan Norcross of the Morals Party again ran for mayor against L.C. Simpson, a lawyer for the Free and Rowdy Party. Perhaps

Portrait of Jonathan Norcross.
Martin, Atlanta and Its Builders.

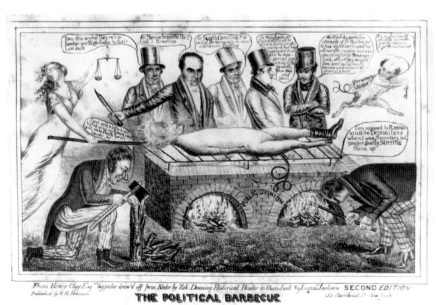

Cartoon mocking the political barbecue. *H.R. Robinson, 1834, Library of Congress.*

remembering his defeat to Formwalt, in this election, Norcross thought to entice voters. Norcross gathered votes by distributing apples and candy, while Simpson distributed whiskey and other liquors. The citizens of the town must have liked apples, for the Morals Party won and elected Norcross the mayor of the town.

Though Atlanta had two previous mayors—Moses Formwalt and Benjamin Bomar—Norcross became known as the "first mayor of Atlanta" because of his unceasing efforts to build up the city. Norcross established the Air Line Road and built several large mill businesses that employed many of the townspeople. Most importantly, as mayor, he acted as the chief of police and the superintendent of the streets, and he spent his mayoral term rooting out the lawless element in the city. This was evidenced when the city council rejected Antonio Maquino's petition to sell liquor at Walton Spring for just one day.

In 1850, "VISITORS WOULD describe the city as so new that peanut shells, apple cores and mud lined its streets and sidewalks." Besides Maquino's snack shop, a shop at Pryor Street by the railroad depot sold ice cream, sweetmeats, drinks and other knickknacks, and Ormonds' Grove and Williams' Mill were popular for picnics. At Norcross's store, one early citizen recalled that when he was a clerk, "we boys and young men in the store used to keep a keg of ginger beer in the cellar with which to quench our thirst when we got dry, but sometimes it would get too strong or hard for a pleasant drink, and we would empty it out and, as it were, make a new brew." One afternoon, a large sow that used to wander the middle of Atlanta drank the hard brew the boys had dumped out in the street and made a spectacle as it squealed and oinked through the streets of early Atlanta, drunk as any Free and Rowdy Party member.[23]

Norcross's determination to clean up the rough elements of the city led to increased political stability, which in turn led to increased food innovation. In 1851, the city council gathered enough funds to give Atlanta's first citywide barbecue, and Emmel and Cunningham opened up the first candy factory. Within a few years, the town's population swelled past seven thousand residents, making Atlanta about half the size of Savannah, and the Magnolia restaurant in Atlanta began serving turtle soup, oysters and "other fixings of a kind to rejoice the heart of the daintiest epicure." Aaron Alexander, a

Jewish druggist, took a gamble on the town's interest in food and brought the first carload of ice and opened the first soda fountain at his drugstore, which sold high-end goods at "New York prices." D. Valentino opened a new candy manufactory and bakery specializing in "every description of plain and ornamental Cakes, for weddings or parties, at short notice."[24] The Georgia Drug Store on Whitehall Street tempted gourmands with spices imported from the Caribbean, including ground ginger, cinnamon, mustard, Jamaican ginger root and white mustard seed. The Atlanta Hotel shipped in oysters daily from Savannah, serving them at its bar. The Trout House Exchange opened a restaurant, offering on the menu Bonescure, Norfolk and Savannah oysters; wild game in season; and choice liquors and cigars. By 1858, several flour mills had been established, a distillery for making whiskey was built and Anton Kontz and Egidius Fechter began manufacturing the town's first lager beer.

Food was indisputably the principal business in antebellum Atlanta. The South was the land of plenty, producing all of the nation's rice and sugar, almost all of the country's corn and nearly as much wheat as the North. Atlanta acted as the hub for the importation and exportation of all this food between the South, North and Midwest. By 1853, a mere six years after the founding of Atlanta, slaughterhouses had been ordered outside the city limits and Atlanta's first central market began to take tangible form. Stalls were built and rented for $285, and the city council set the opening time for the market at one hour before sunrise until seven o'clock in the evening. Farmers paid a small tax so they could supply fresh meat and vegetables. It was meant to be a market for local producers, and the town prohibited anyone from bringing bacon or produce for sale unless the seller brought a witness who would "testify that he grew it or raised it himself."[25]

While the local market grew, the wholesaler and retail market boomed. Rushing freight trains entered the city at all hours of the day, packed with produce and meats. Freight cars shipped in Black Belt corn and cotton, midwestern grain, bacon and mustard greens from South Carolina, Virginia and North Carolina tobacco, Louisiana salt and sugar and rice, oysters and fish from the coast. By 1859, there were seventy-seven firms in the town engaged in the sale of produce, dry goods and other commodities. The firms' exclusively cash operations and low rent meant that, in 1860, prices for groceries in Atlanta were 25 to 40 percent lower than in neighboring cities like Savannah, Charleston and Augusta. Commercial businesses purchased wholesale foodstuffs in the cents rather than the dollars: chickens cost fifteen to twenty cents, butter sold for thirty-five cents per pound and a

gallon of whiskey could be had for as little as forty-five to fifty cents. Beyond the railroad, twice per week, farmers from the surrounding countryside rolled in with mule and ox carts, bells jangling and their wagonloads piled high with eggs, chickens, North Georgia apples and creamy butter. On one particularly busy Saturday in 1850, 150 such wagons strung out along Peachtree Street in the center of the market town of Atlanta.

AS THE TOWN GREW rapidly, increasing by one thousand residents every year, the number of slaves and free blacks in the city increased as well. By 1860, there were nine slave traders in the center of town, including Clarke & Grubb, who styled themselves as "Wholesale Grocers, Commission Merchants, and Negro Brokers," revealing the casual commoditization of human life in antebellum Atlanta.

Yet slavery in Atlanta was not the same as it was in other places in the South. First, Atlanta was a new city, made up of mostly young men from the North, without the inbuilt preference for the "South's peculiar institution." Second, the rapid growth of the city hindered the practice of slavery itself. Unlike the rural South, where slavery was the primary source of labor, in the urban South, slavery was only one source of labor. Frederick Law Olmsted explained in 1857, "Servile labor must be unskilled labor and unskilled labor must be dispersed over land, and cannot support the concentrated life nor amass the capital of cities."[26] One pioneer Atlantan described this attitude in flippant terms, "There are not 100 Negroes in this place, and white men black their own shoes, as independently as in the North."[27] It was not, of course, that simple. In 1860, approximately 20 percent of Atlanta's population was black, with 7,751 whites, 1,917 slaves, and only 23 freed colored people. Women predominated in the Atlanta slave population, with white slave owners sending the men to the plantations and sending the women to the city to tend house.

Of these female slaves, the most important persona was the cook. Slave cooks spent the majority of their time in the kitchens, self-contained buildings in the backyard. A comfortable residence sold on Peachtree Street boasted "commodious out-buildings, consisting of a large Kitchen, Rock Dairy, Smoke-house, wash-house, large negro house, two horse stable, corn and fodder house, carriage house and two cow stables."[28] The stand-alone southern kitchen was meant to prevent house fires and keep the heat of the

open hearth from the main house in the blistering southern sun, but it also divided white women from the labor they relegated to their slaves and meant that slave cooks ruled over the kitchen dominion.

The cook's labor was a grueling one but also required great intelligence and creativity. One former slave cook described her work, "Everything I does, I does by my head; it's all brain work."[29] A giant fireplace stood in the back of the kitchen with a four-foot log fire, and Jefferson Franklin Henry, a former slave, recalled that when he was young he had "set on one end of that log whilst it was a-burnin on t'other," revealing how massive the fireplace and fire would be. Pots hung from hooks on an iron bar that went all the way across the fireplace, and baking was done in skillets and cast-iron ovens that sat on trivets over the coals. Since the southern states made literacy among slaves illegal, a good cook memorized all of her recipes and was considered indispensable to the family. Lewis Favor, a slave born in Greenville, Georgia, recalled that his masters hired a hotel owner for $400 to teach his mother to prepare many kinds of fancy dishes. While the field hands on the plantation ate a monotonous diet of cornbread, fat meat and molasses, he and his mother ate the same foods as the white family.

Cooks, too, had some freedom of movement since they were responsible for purchasing food. Atlanta provided a better, though still restricted, communal life for slaves, as compared to the country plantations. Slaves moved around the city and gathered and socialized in markets, grocery stores, grog shops and churches. As the need for labor grew in the booming city of Atlanta, owners began to allow slaves to keep a few cents of their payment when they were hired out to other people.

Many of these free or quasi-free blacks made their wealth in food. Bob Webster, a "practically freed" slave, was noted as a "very intelligent and accomplished house servant" with skills with meats and pastries and a fine way with preserves and pickles. Webster opened up a busy barbershop on Marietta Street, but he made his fortune from his side businesses, buying and selling goods, including tobacco, fish, fruit and chickens through his shops. He stated that he never made less than one hundred dollars a day, an astonishing sum of money in those days. Others reported that he was always seen wearing gold due to his wealth, and Webster moved into a sizeable home near his store. He once said, "No man in the place stood higher than I did, although I was a colored man."[30]

Realizing that slaves were afforded more latitude in Atlanta than elsewhere in the state, the city council attempted to stem the rising freedoms practiced by slaves in the Atlanta city limits. In 1856, the "petition of a

negro to open an ice cream saloon was refused, as being 'unwise.'"[31] The concern here was likely less related to the ice cream saloon but rather to the gathering of slaves in an informal setting, which the city council believed could lead to insubordination, riots and drinking.

Four years later, as the country argued over the election between Abraham Lincoln and Stephen Douglas, the Atlanta City Council futilely added more restrictions on the business activities of black residents by forbidding any slave or free person of color from "buying or selling or offering to buy or sell any liquor, eggs, chicken, or fish, or any other article" in the city limits.[32] Atlantans simply ignored this ludicrous rule; the demand in Atlanta for skilled domestic labor, especially for cooks and those well versed in food, was too great and the market for businesses like Bob Webster's was too strong. Slaves given permission to seek work openly walked downtown to what was long known as "Hungry Corner," where slaves available for hire gathered to meet those looking for labor to be paid daily wages.

Indeed, as the year 1860 ended, the institution of slavery had begun to unravel in the city of Atlanta.

BRUNSWICK STEW

Since the days Atlanta was referred to as a "place for stump speeches, barbecues, and fisticuffs," barbecue has always been one of Atlanta's core foods, and Brunswick stew is the necessary accompaniment at any Atlanta barbecue. The origins of Brunswick stew are murky: Brunswick, Virginia, claims that the stew was invented in 1828 when an African American cook concocted the dish from squirrels, onions, butter and bread after the venison the hunting party planned to eat spoiled. Brunswick, Georgia, claims to be the originator of the stew when a mess sergeant in 1898 threw together whatever meats and vegetables he had handy, and the twenty-five-gallon iron pot in which he created it still stands at the Brunswick, Georgia Welcome Center. The two versions are dissimilar—the Virginian version is thicker, with the meat slow simmered and the late addition of stale bread, while the Georgia version is soupier and relies more on the flavoring of tomatoes, okra and corn.

While Atlanta newspapers reported Brunswick stew being served at barbecues as early as 1882, no one did more for Brunswick stew in Atlanta than H.C. Stockdell. As a young man, Stockdell gained his fame as the

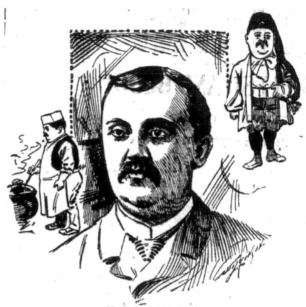

H. C. STOCKDELL,
President of the Cold Spring Packing Co. He is Incidentally, One of
the Best Known Insurance Men in the South, as Well as
a Mighty Power With the Mystic Shriners,
and a Star Among Barbecuists.

Harry Stockdell, famous maker of Brunswick stew. *From the* Atlanta Constitution, *November 13, 1898.*

maker of the finest Kentucky burgoo, a thick beef stew that is the state's signature side dish. When he arrived in Atlanta to become one of the city's first insurance agents, he began tinkering with recipes for Georgia Brunswick stew for fun, eventually perfecting the dish, cooking it at large banquets and dinners though he was already a rich man. After Stockdell received hundreds of requests for his recipe, a friend joked that he would have to go into the business of making Brunswick stew, and Stockdell took him at his word, opening up the Cold Springs Packing House in Atlanta in 1898 while also conducting his insurance business in downtown. Stockdell told an interviewer, "You see Brunswick stew is not like any ordinary canned stuff. You eat some canned goods and you tire of them. But the Brunswick stew habit grows on you."[33]

Within a year, Stockdell's genuine Georgia Brunswick stew was being canned at the rate of one thousand cans per day and shipped to housewives across the country, approximately $20,000 worth of Georgia Brunswick stew each month. The *Atlanta Constitution* delighted in the new industry: "With a can or two, when visitors come unexpectedly, it is an easy matter to prepare in a few moments a delightful dish.…The very best chicken,

beef, corn, and tomatoes are used in its preparation, and it only has to be heated to be ready for the table. It is a great thing for bachelors in their rooms and hunting or fishing parties."[34]

But the newspaper was too optimistic. Stockdell soon put his business up for sale, liquidating his cans of Brunswick stew, because he did not have the time to devote to the business, and in another two years, Stockdell announced his progressive candidacy for mayor, eventually losing to James Woodward. Upon Stockdell's death in 1912, the *Atlanta Constitution* recognized that Stockdell "made the Georgia barbecue a permanent institution. Many Georgians and distinguished visitors to the city remember the delightful occasions when he presided over the barbecue pits."[35]

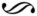

Over time, Brunswick stew recipes in Atlanta have changed and adapted. Mrs. A.P. Hill (1867) provided this simple recipe, using a Virginia model of adding bread at the end:

Brunswick Stew

Three gallons of water, two grown chickens cut up, one pound of fat bacon cut up fine. Cook the chickens until the meat leaves the bones; return the meat to the pot; add one half-gallon of Irish potatoes boiled and mashed, three tumblers of green corn, cut off the cob, one pint of green butter beans, one quart of tomatoes skinned, a good sized loaf of bread; season with pepper, salt, and butter. The bread must not be put in until the stew is nearly done. Stir until done, begin when nearly done. Squirrels may be used instead of chickens.[36]

In 1895, Maude Andrews of *Harper's Weekly* sampled a Brunswick stew at the Cotton States and International Exposition in the city. Andrews got the recipe from a black cook who reeled off the following (in original language): "yer jest takes the meat, de hog's haid, an' de libbers, and an' all sorts er little nice parts, an' yer chops it up wid corn and permattuses, an' injuns an' green peppers, an' yer stews and stews tell hit all gits erlike, an' yer kain't tell what hit's made uv."[37]

By the early twentieth century, Brunswick stews were fancier, with a 1919 recipe adding bread crumbs and parsley. A 1922 recipe for chicken Brunswick stew is frankly exhausting to read, consisting of orchestrating layers of vegetables and meats before cooking, adding pre-cooked butterbeans and sliced tomatoes and wiping the chicken pieces and dipping them in flour—then cooking it for several hours.

But a 1931 Cartersville cook named Speer Nelson, recognized as the premier 'cue artist of northwest Georgia at the time, stated that to make Brunswick stew, one was best off using the classic recipe of throwing vegetables and meats together and cooking them together until they were nearly unrecognizable as separate parts:

> For twenty gallons of stew I use—15 pounds of pork, 20 pounds of stew beef, 6 large hens, one dozen cans of tomatoes, one dozen cans of corn, one quart of vinegar; butter and pepper to season. Cook for eight hours over a slow fire—stirring constantly—and then you'll have Brunswick stew like Brunswick stew ought to taste.[38]

4

SALT SHORTAGES AND BREAD RIOTS

CIVIL WAR: 1861 TO 1863

On November 6, 1860, the nation elected Abraham Lincoln as president of the United States, plunging the country into the Civil War, and within two months, Georgia seceded from the Union. Atlanta, now a city of almost ten thousand people with one of the largest manufacturing bases in the South, bid to be the capital of the Confederacy. Atlanta's *Gate City Guardian* proclaimed the reasons in Atlanta's favor: "The city has good railroad connections, is free from yellow fever, can supply the most wholesome foods, and as for 'goobers,' an indispensable article for a Southern Legislator, we have them all the time."[39] Not as glib, the *Southern Confederacy* argued,

> As a provision market, Atlanta has advantages superior to any city in the Cotton States…except New Orleans.…[H]er people are enabled to live more plentifully and cheaply than any of her sister cities; and having direct and daily communications with Charleston and Savannah, sea fish, oysters, and the tropical fruits, are only adjuncts to its comforts.[40]

Despite the abundance of food in Atlanta, Richmond was named the capital of the Confederacy.

The start of the war was a blessing to Atlanta's economy, as the city became the center for military provisions, warehouses and factories. Trains rushed in and out of Union Station, piled high with ammunition, steel and supplies for the Confederate army. New wealth meant new luxuries: furniture stores,

dance instructors and clothing outlets that specialized in organdies and silks sprang up across the city. The *Southern Confederacy* reported "brisk business" in produce, including corn, tobacco and coffee, stating, "As usual, demand exceeds supply, freights are coming down rapidly, but the vast amount shipped West causes delay in getting whole shipments through."[41]

Yet while food flowed into the city of Atlanta, wiser heads understood that food could be the ruin of the South. The state comptroller complained that Georgia was, with respect to food, "every day becoming more dependent upon those not of us."[42] A mere two months after the war began, the editors of the *Southern Confederacy* pleaded with the farmers of the state to substitute corn and grain for their more valuable cotton and tobacco crops:

> *Let it not be forgotten that while the South is fully able to cope with external force, she is not strong enough to contend with famine.... [W]hat are we to do for bread, unless we give more attention to the grain crop than we have done for several years back?*[43]

But, at the start of the war, most thought the state comptroller and the editors of the *Southern Confederacy* were being unnecessarily pessimistic. Initially, the Southern states, as a whole, significantly increased production of corn, jumping from thirty million bushels to fifty-five million bushels in a single year. Clayton County reported abundant fruit, wheat and corn. Carroll County reported that its farmers had their best crop of wheat ever and a good crop of corn, and "if nothing happens to the peaches and wheat, we can feed an army on *peach pie*."[44] A Confederate officer reported that the provision blockade instituted on Southern ports by President Lincoln in April was "nothing: we shall have wheat, corn, and beef beyond measure, besides tobacco, sugar, and rice."[45]

The Confederate government, too, was optimistic about food supplies. Confederate soldiers received plenty of food, enough to match the rations provided to the Union armies, with a daily ration of three-fourths of a pound of fresh or salt beef and eighteen ounces of bread or a quarter pound of cornmeal, plus significant rations of coffee, rice and sugar every one hundred days. The commissary provided vegetables and fruits infrequently to prevent illness, but otherwise soldiers expected to have minimal produce in their diets, subsisting largely on hardtack and beef. Hardtack, described as "a large but miserable imitation of a cracker," was the particular staple for both the Union and Confederate armies.

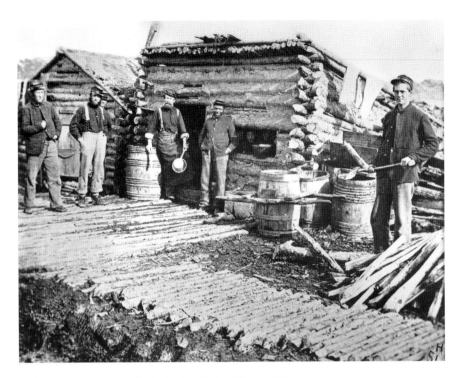

Civil War camp kitchen. *Brady Handy collection, Library of Congress.*

But foodstuffs became scarce earlier than anyone expected. Lincoln's blockade first affected luxuries like coffee, leading to imitation recipes made from beets and sweet potatoes, which Atlanta writers swore showed that the blockade was a blessing in disguise, writing, "When you smell it, you will say, 'I believe it's Java;' when you taste it, you will say, 'I think it is Java.'"[46] Likewise, a "Lover of Good Bread" in the city provided a cheap recipe for a yeast substitute by boiling peach leaves with potatoes.[47]

The early optimism did not last long. Transportation issues plagued the Confederacy. In 1862, the Union captured the Memphis and Charleston Railroad, meaning that midwestern wheat could no longer reach Georgia. Due to the Confederate army's need for the remaining railroads, an Atlanta merchant in Memphis reported that the Memphis warehouses contained more freight marked for Atlanta "than a half a dozen other cities," but that food was not being shipped. Nearly 100,000 bushels of corn rotted in Albany's warehouses, two hundred miles from Atlanta. By 1862, shipments into the city of flour, hogs, sheep and corn had declined between 30 and 80 percent from what they had been in 1860.

Farmers, too, refused to come into the city. The Confederate army passed an impressment statue that required farmers to turn over to the government 10 percent of everything they raised, from grain to vegetables, tobacco and cotton, and began seizing farmers' goods on their way to market. The military and impressment agents hoarded most of the food in massive warehouses in and outside of the city. In 1862, the Confederate Commissary Department designated the largest Confederate storehouse to be located in Atlanta, which became the central point of Subsistence Department distribution, providing a large proportion of meat for Confederate soldiers between 1862 to 1864. The abundance of food in the Atlanta commissary warehouses led one produce merchant in the city to cheekily advertise in the daily newspaper,

> *Have you seen the spacious rooms of Messrs. Willis & Young, Davis' Block, Whitehall Street, well filled with FLOUR, CORN, OATS, AND COUNTRY PRODUCE in abundance? It looks like a Commissary store to supply the army at Manassas. Be sure to give them a call.*[48]

Salt scarcity compounded the problems. The Southern states did not produce salt, long an issue in the South: even Benjamin Hawkins noted in the late 1700s that the Native Americans frequently requested salt while trading. In the age before refrigeration, salt was the primary method for curing and preserving meats, butter and fish, as well as tanning leather, and an antebellum southerner consumed about fifty pounds of salt per year. Realizing the lack of salt in the South, Georgia Governor Brown seized the bulk of the salt remaining in the state of Georgia for military usage. This resulted in instant furor due to the skyrocketing prices: a bag of salt that cost two dollars before the war jumped to sixty dollars in Atlanta's Civil War markets, a price few could afford, especially as inflated Confederate dollars flooded the market. Farmers outside Atlanta refused to slaughter their livestock because they had no salt to cure the meats. The *Confederate States Almanac*, published in Macon, offered this depressing advice: "TO KEEP MEAT FROM SPOILING IN SUMMER: Eat it early in the Spring!"[49]

Recognizing the tightening economy and lack of food, the Confederate government passed the Monopoly and Extortion Bill, which placed significant criminal penalties with a minimum sentence of one year's hard labor for speculators. Liquor was banned, and the Confederacy shut down all drinking houses and bars; one rail passenger from Memphis to Atlanta

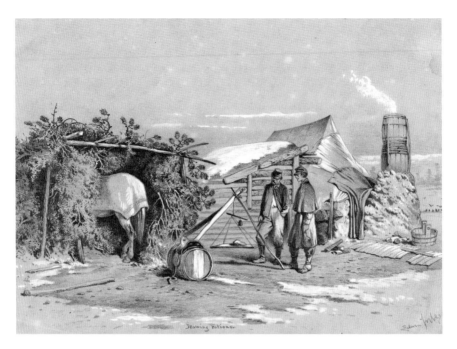

Commissary sergeant weighs meat for camp cook during Civil War. *Edwin Forbes, 1876, Library of Congress*.

bemoaned the old days: "Juleps, smashes, cobblers, and all the delightful and exhilarating beverages are as scarce as old Java Coffee."[50]

Atlanta soon became a "nest of speculators."[51] The *Atlanta Intelligencer* complained that "Atlanta is now made headquarters for itinerant speculators in gold, bank notes, Confederate currency, *meat* and *bread*."[52] Prince Ponder, a slave given liberal written permission by his mistress to travel and trade anywhere in Georgia, began purchasing "anything there was any money in," eventually opening a grocery store where he sold corn, rye, hops, flour, bacon and "anything else on which I could make any money." He soon was taking in $5,000 to $6,000 per day, accumulating a total of $100,000 in inflated Confederate currency. And some white men profited by creating an underground economy from their slaves' culinary labor; Thomas Clince and Harris Fuller were both fined $10 for permitting their female slaves to maintain and establish eating houses in Atlanta without their masters' supervision during the war.

But generally, foodstuffs dwindled while the population doubled. As Atlanta was designated one of the Confederacy's largest hospitals, wounded and ill reached the city's borders daily. Samuel Stout, the head surgeon for

the Army of Tennessee, headquartered in Atlanta, wrote to patrons begging for help: "In nothing can you aid us more than by sending us fruits and vegetables. Labor is also very much in demand. Every negro hired to the hospital enables us to send an able-bodied soldier to the field." Domestic servants were especially necessary—men as nurses, women as laundresses and both as good cooks.[53]

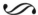

By 1863, two years into the war, Atlanta was near its breaking point. The *Southern Confederacy* reported, "Shoes, cotton rope, iron, nails, soap, candles, coffee and dry goods are changing hands at big figures that are unquotable."[54] Food thefts were rampant in Atlanta. Cows, chickens, vegetables and fruits disappeared from family plots, and citizens stopped reporting robberies of private gardens and livestock because there were so many. "In view of the *almost* impossibility of procuring the necessaries of life," the Atlanta City Council set up a committee to devise a plan by which these items would be provided at cost.

It was not enough. On March 17, 1863, a "tall lady on whose countenance rested care and determination" walked into an Atlanta grocer with a group of twenty other women. She asked the clerk the price for bacon, and when he answered $1.10 per pound, she told him they were working needlewomen and could not afford that price. They wanted the government price for bacon, and the grocer refused. At that, she drew "from her bosom a long navy repeater, and at the same time ordered the others in the crowd to help themselves to what they liked." The women took nearly $200 worth of bacon.[55] It was just one of many such "bread riots" that took place in twenty-three cities across Georgia, usually by middle-class women employed as needlewomen but being paid wages so low that they could not afford the exorbitant prices for grain, meat and salt.

While women struggled at home, men struggled in the field. In January 1863, the Confederate government significantly reduced the rations provided to soldiers to a pound of beef and a pound and a half of flour or meal per day. General Robert E. Lee informed Confederate president Jefferson Davis that the army was down to an eight-day supply of fresh and salted beef, and "unless regular supplies can be obtained, I fear the efficiency of the army will be reduced by many thousand men."[56] Even though Atlanta was shipping out 500,000 pounds of salted meat weekly, much of that meat

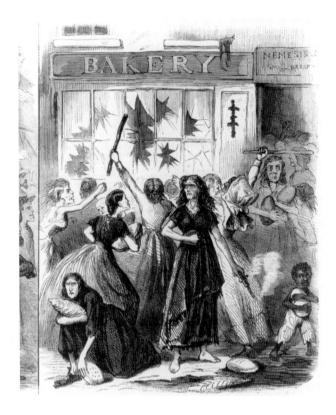

Southern women and bread riots. Frank Leslie's Illustrated Newspapers, *1863*, *Library of Congress.*

was not received by the troops due to the failing railroads. In the assault on Chattanooga, one Confederate soldier remembered living on parched corn, "which had been picked out of the mud and dirt under the feet of officers' horses. We thought of nothing but starvation."[57]

Even nature disfavored the Confederacy. Atlanta citizen Cyrena Bailey Stone wrote that the frost cut off "sweet prophecies of delicious fruit," and the peach blossoms blackened and blighted, leaving the dreary prospect of a "long Southern summer without a single rosy-cheeked peach."[58] Atlanta emptied of food in those interminable early years of the Civil War as the Union army crept ever closer and closer to the city walls.

HOECAKES

There may be no more racially divisive food in Atlanta's history than the hoecake, and those racial divisions became particularly apparent during the

Civil War. Cornbread is the South's essential bread, and hoecakes are the simplest form of cornbread, made by mixing cornmeal with water, salt and some type of fat—such as bacon grease, lard or butter—and griddling the mixture over a hot skillet, resulting in a crispy, lacy pancake that melts in the mouth when warm. Native Americans introduced hoecakes to the American settlers, and Benjamin Hawkins reported Georgia Creek Indians serving him "corn cakes" in the late 1700s. Supposedly one of George Washington's favorite foods, hoecakes were cooked on a flat metal griddle known as a "hoe," likely leading to the naming of the food.

Given that cornmeal constituted the majority of the slaves' diets, hoecakes became a common food in the antebellum period. Charlie Richardson, born a Missouri slave, recalled, "This here hoe cake was plain old white corn meal battered with salt and water. No grease. Not much grease, jest 'nough to keep it from stickin.'"[59] The hoecake was so embedded in early African American lore that many old nursery rhymes incorporated it, sung by mammies to generations of children:

> Snake bake a hoecake,
> And lef' a frog to mind it;
> Frog fall asleep, an'
> De lizzard come an' fine it.

> Lizzard take de hoecake,
> An' sell it to a rabbit;
> He take it where a honey bear
> See de cake an' grab it.

> Snake make a big mistake.
> To leave de cake ur bakin'.
> But dat don't 'scuse no triflin' folk
> For what dey come and taken.[60]

But, by the Civil War, the upper class deplored the hoecake as a cheap, base food preferred by slaves. Cyrena Bailey Stone scoffed at poor women during the Civil War who only knew how to do "the coarsest kind" of work such as baking a hoecake.[61] An editorial during the Civil War made the distinction that wheat bread was "*white* people's bread," complaining that Georgians might be compelled to live on hoecakes as the railroads began to fail.[62]

The irony was that the humble hoecake, despised as a slave food, became the primary food eaten by soldiers fighting to continue slavery. Cornmeal accounted for the majority of Confederate rations, and hoecakes were a quick way to use the product that even a man who had never cooked before could easily learn. Andrew M. Sherman, a Civil War soldier, recalled that after a prolonged march one night, he and some companions came upon an aged black couple in a hut who produced hoecakes and baked sweet potatoes that "so far as our relish of it was concerned, could not be surpassed by the best course dinner ever served at Delmonico's."[63]

After the war, the hoecake again lost prestige. Joel Chandler Harris's controversial Uncle Remus stories often feature Br'er Rabbit baking hoecakes. And in 1884, Bill Arp, the "cracker" nom de plume for columnist Charles Henry Smith in the *Atlanta Constitution*, wrote of the African Americans in Georgia, "They nibble cornbread—a mixture of meal, water and salt; nothing more. On that hoecake they will eat away the white race. The white man wants wheat, and I did not see a single wheat field in the great state of Georgia."[64]

Yet while satirists painted the hoecake as a poor black food, a food display proclaiming the virtues of corn was sent to the 1888 Paris exhibition, and the *Atlanta Constitution* reported that the exhibition should include the "varieties of food that can be made from corn meal," including hoecakes, because "the sight of these things, as well as the taste, ought to be enough to tempt the palates of European epicures, to say nothing of the peasants who pay high prices for wheat bread, or subsist precariously on rye bread."[65]

ABBY FISHER'S *WHAT MRS. Fisher Knows About Old Southern Cooking: Soups, Pickles, Preserves, Etc.*, told orally from an Alabamian slave cook to a group of Sacramento women and published in 1881, is one of the few cookbooks that contains the vast knowledge of a slave cook, and in it, she includes a recipe for hoecakes, among many other cornbreads:

Plantation Corn Bread or Hoe Cake

Half tablespoonful of lard to a pint of meal, one teacup of boiling water; stir well and bake on a hot griddle. Sift in meal one teaspoonful of soda.[66]

Mrs. S.R. Dull (1928) used a very similar recipe, using simply meal, water and salt to make her hoecake.

Confusing the situation is that, at some point, recipe authors began referring to the hoecake interchangeably as Johnny cakes. Southern Johnny cakes and hoecakes were indeed the exact same food, and Atlantans mocked Northern Johnny cakes with added pumpkin, raisins or other foreign items. An *Atlanta Constitution* writer proclaimed that the "real" Johnny cake utilized the same recipe as that of Abby Fisher's hoecake and that its origin was "in the negro cabin…[a]nd it has been asserted confidently that none but a negro can make a faultless Johnny cake."[67]

The *Dixie Cook Book* published in 1889 in Atlanta includes three different versions of Johnny Cake, including one called Alabama Johnny Cake, made from rice rather than cornmeal. The major difference in this recipe versus the previous one is the huge amount of sugar, something that would *never* have been used in antebellum recipes for cornbread:

Johnny-Cake

Two-thirds teaspoon soda, three tablespoons sugar, one teaspoon cream tartar, one egg, one cup sweet milk, six tablespoons Indian meal, three tablespoons flour, and a little salt. This makes a thin batter.[68]

As with so many things, the hoecake has lost popularity in the twenty-first century to baked cornbread and corn muffins, but there are still some soul food restaurants in the city that make a delicate golden hoecake, perfect for dipping into pot likker while meditating on the past.

CONSUMING THE HEART OF THE CONFEDERACY

BATTLE AND SIEGE OF ATLANTA: 1864 TO 1865

t the start of the Civil War, Atlanta was an overgrown market town of middling size, but by 1863, both North and South recognized that it was, as the *New York Times* put it,

> *the heart of the Southern States, and therefore the most vital point in the so-called Confederate States.... [A] flourishing city, an important railway centre, and extensive depot for Confederate commissary stores, Atlanta to the South, is Chicago to the Northwest, and its occupation by the soldiers of the Union would be virtually snapping the backbone of the rebellion.*

After the Union victory at Gettysburg, General Ulysses S. Grant and General William Tecumseh Sherman came up with a bold plan to finish the war as quickly as possible: Grant would capture Richmond while Sherman would focus on Atlanta.

By 1863, Atlanta was bursting at the seams with nearly twenty thousand residents, and Atlanta's Subsistence Department and Commissary now catalogued, stored and provided most of the foodstuffs to the entire Confederate army. Lack of food was the most pressing problem. In August 1863, Major J.F. Cummings, in charge of Atlanta's Subsistence Department, wrote, "There is no use of shutting our eyes to the fact that there is no bacon worth speaking of in the country, and that if it can't be had from beyond the limits of this state, the armies can't be supplied."[69] Confederate commissary general Northrop in Richmond agreed, "The infamous enemy who invades our country threatens to starve us into submission."[70]

While the Commissary Department was forced to impress more and more local food to feed the military, the railroads failed, leaving only the Macon and Western Railroad entering Atlanta, and inflation reached unfathomable heights. Cyrena Stone wrote in her diary, "Rare sport i[t] is now to go shopping. No purse is large enough to hold all the 'needful' that is *needed* to make more than one purchase." She recorded the prices for food "to keep for the amusement of future generations," stating that four pounds of butter cost $40, one sack of flour was listed at $120 and one ham cost $54.[71] Lucy Hull Baldwin, a child in wartime Atlanta, remembered her father bitterly handing her a Confederate $100 bill and saying, "There! Take it down the street and see if you can buy a stick of candy!"[72] In the same month, the city council bewailed the constant complaints coming in, stating that the leadership was at a loss to conceive how it could be that soldiers' families were not receiving sufficient assistance and food since "there was ample provision made by our last Legislature for their support."[73]

As Sherman and his troops slowly marched toward Georgia, the Confederacy asked gifted engineer L.P. Grant—who had twenty-seven years before designated Terminus as the end point of the Georgia Railroad—to design fortifications that would protect the city from the Union troops. In the winter of 1864, Grant requisitioned every slave in and around the city for one dollar per day paid to the slaves' owners plus rations for the slaves. The labor was grueling: hauling thousands of tons of earth, cutting lumber by hand and then carefully stacking the lumber against the earth, creating a ring of fortifications and forts that spanned ten miles around the city. Yet the Confederacy provided the slaves with rarely anything more than a survival ration: half a pound of bacon or a full pound of beef and two pounds of cornmeal on a good day. When supplies of food were exhausted, the commissaries stopped issuing rations to the slaves altogether.

Four slaves begged Union supporter Cyrena Stone to hide them after they were pressed into building the fortifications, pleading, "We don't want to make no fortifications to keep away the Yankees ourselves. Let our folks build their own fortifications. The black'uns they have got, are dying up like any thing, for they works 'em so hard, and half starves 'em besides." Stone hid the men between her cotton bales until the Union armies reached closer to the city.[74] Even Confederate officials acknowledged that the little food the slaves working on the fortifications had was "of the most inferior character."[75] Despite the lack of food, after months of toil, in April 1864, the slaves completed Atlanta's fortifications.

THREE WEEKS LATER, THE Union reached Atlanta's outskirts and the Atlanta Campaign began. Months of skirmishes, pitched battles and constant deprivation took its toll on the men as the Union pushed closer and closer into the city limits. Sherman boasted that "he should take dinner in Atlanta the fourth of July," and on that day, Marietta surrendered to the Union, placing the Union army within fifteen miles of the city of Atlanta.[76] To celebrate, a group of Union officers gathered for an unexpected treat—a can of prepared duck had been carefully kept from the beginning of the campaign in the hope that they might celebrate the Fourth in Atlanta. But when the cook began warming up the can, he neglected to vent it, and the can exploded "with a report like that of a twelve-pound gun." The Union officers "pocketed [their] disappointment and dined on hardtack, bacon and coffee."[77]

The Confederate soldiers would have been pleased to have even those basic provisions; the Rebels were deserting in droves due to the gnawing hunger that consumed their every thought. T. Holliday, a militiaman from South Carolina, wrote wryly to his wife, Lizzie, from the Atlanta front, "There seems to be some property in the water that has a tendency to give a man a good appetite. One that is sufficient to eat maggots and meal without sifting and no complaint laid only in one respect and that is that there is not enough of it."[78] To counteract vitamin deficiencies and the loss of teeth from scurvy, the men undertook what Confederate artillery captain A.J. Neal described as the "long Forage" in the Georgia woods and fields and boiled up "polk, potato tops, May pop vines, kurlip weed, lambs quarter, thistle, and a hundred kinds of weeds I always thought poison."[79]

The distance between the blue and gray lines from behind their works was so short that they could talk together, and such conversations usually revolved around the troops' all-consuming hunger. Union captain Wilbur Fisk Hinman replayed a typical such conversation about coffee and tobacco near the Battle of Peachtree Creek:

> *"Hello, Yank!"*
> *"Hello, Johnny, what yer coughin' bout?"*
> *"Got any corfee ye want ter trade fer terbacker?"*
> *"Coffee's a leetle skurce jest now, but I'd like to have some o' yer terbacker. Put some in yer gun 'n' shoot it over here. I'll give ye the corfee some other day!"*

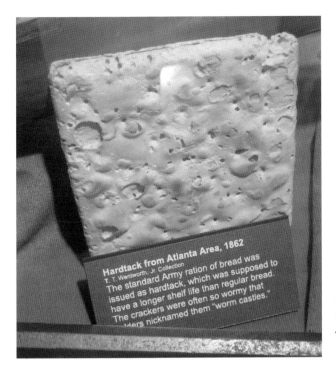

Hardtack. *Infrogmation, taken at T.T. Wentworth Jr. Collection, Wentworth Museum, Pensacola, Florida.*

"Tick don't go, Yank! No corfee, no terbacker. Old [General] Johnston won't let us trade now, anyhow. But say, whar you-all goin'?"

"Goin' to Atlanta: what d'ye s'pose?"

"Bet ye ten dollars ye don't!"

"Whose money?"

"Why, our money of co'se!"

"Your money aint good fer sour apples! Make it a hundred to one 'n' I'll go ye!"

"Look out, Yank, we're goin' ter shoot now!"

"All right; let 'er flicker!"[80]

Summer brought some reprieve to the Union and Confederate soldiers' hunger. Blackberries grew wild in the forests surrounding Atlanta, which saved the Union in one of the deadliest battles of the campaign. On July 20, 1864, after three long months fighting and marching through the wild woods surrounding Atlanta, the Union army relaxed in the open fields next to Peachtree Creek, close to where the Native American village of Standing Peachtree had once stood. Though the officers had ordered the Union soldiers to stay in the camp, a young private tired of awaiting battle

was lured by those blackberries that grew wild by the edge of the creek. He stole out to them and rambled near the forest, picking and eating.

Suddenly, a flash of light dazzled him, and he looked up to see the Rebels' bayonets glinting against the sun and the movement of six lines of gray-clad troops in the distance. He dropped the fruit, with traces of purple berry stains on his lips, and raced back to the camp, shouting *Murder! Rebels! Help!*, and the alarm went through the startled Yankee army as Confederate soldiers came charging through the woods. The private's warning was given in enough time. Though the Battle of Peachtree Creek was one of the most fiercely fought in the Civil War, the Union succeeded in pushing back the Rebels, with 4,800 Confederate dead and 2,000 Federals dead.

The battle left Atlanta in pandemonium. Exploding shells pummeled the city, and terror-stricken women and children gathered anything they could find, scrambling to find any conceivable way to get out of the town. Confederate soldiers swarmed, overwhelming the few remaining citizens with requests for food and drink, and that evening, the soldiers broke into every store and scattered provisions in the street, leaving the poor and the slaves to gather up any remaining spoils.

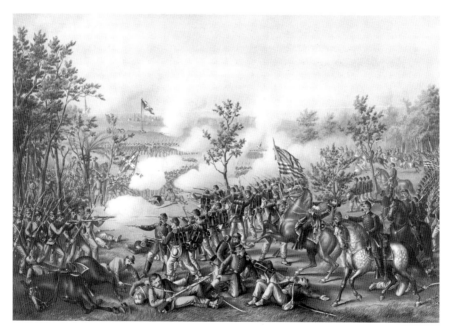

Battle of Atlanta. *Kurz & Allison, 1888, Library of Congress.*

Sarah Huff, a child at the time of the Battle of Atlanta, remembered in later years that these Confederate soldiers "respected the property rights of no one." The soldiers "claimed to have a right to whatever would aid maintenance or supply individual craving." They killed and skinned the family's last two hogs and said that if they "didn't take them, the Yankees would."[81] To protect their beehives and honey from thieves, the family moved the bee gums into the attic, and a recovering soldier stole the honeycombs before he went away that night. Thieves took nearly every single hen, turkey and duck in the coops in the City Hall neighborhood where Mary Mallard lived with her children. Confederate soldiers confiscated all of Cyrena Bailey Stone's gallons of blackberry wine, jars of pickles and ten fat pigs.

Two days later, the Confederate and Union soldiers met again at the Battle of Atlanta, two miles east of the city. It was a brutal loss for the Confederacy, with almost ten thousand dead, and the Confederate soldiers pushed back inside the Atlanta fortifications.

THE CONFEDERATE TROOPS HAD been defeated, but General Sherman faced a seemingly insurmountable problem: though the Confederacy was trapped inside Atlanta's fortifications, the Union army could not enter because "no weak spot could be found which offered promise of success."[82] L.P. Grant and the city's slaves had done their job well: the *New York Times* war correspondent reported that despite the Union's additional thirty thousand troops, the "elaborate" fortifications would slaughter Sherman's army, and as the "rebels themselves say, Atlanta is safe."[83]

Within a few days, the remaining citizens left became "accustomed to the continued roaring of cannons and rattle of musketry" as the Union launched shells into the city to convince the Confederate army to leave the fortified walls.[84] There were no chickens, no vegetables, no butter and, "in fact, nothing that would tempt an epicure. At a restaurant a guest would get a plate of ham and eggs and a cup of coffee for $25."[85] The government stores and hospitals were ordered away, and Major Cummings of the Subsistence Department moved the vast majority of the food in Atlanta's warehouses to Augusta.

At first, the shells were more of a nuisance than a threat. One morning in July 1864, a shell burst in Mollie Smith's home while the family was eating

breakfast, destroying the house. The Confederate soldiers who rescued them ate that breakfast, and Mollie's family ran to a neighbor. As they had not eaten that day, Mollie and her family were sitting down to a dinner of coffee, ham and bread when another shell interrupted that meal and landed next to the gate. The family packed up their dinner, jumped into a government wagon and stopped on a high hill overlooking the city and, there—refusing to allow shells to spoil their meal for a third time despite the warnings from a rebel soldier—spread out their dinner in a picnic while they watched "the shells flying over the city."

As the summer went on, shells incessantly hit the city. Highlighting the importance of the one remaining railroad line from Macon, Sam Richards wrote in his diary in August,

> Our garden is helping us out a great deal these hard times. We have not suffered much from thieves and have given away such "truck" as we did not need. Corn, tomatoes, and butter-beans are now in full feather.…It is to be hoped the contest will not be prolonged indefinitely for there is nothing much to be had to eat in Atlanta though if we keep the R.R. we will not quite starve, I trust.[86]

One morning, a shell hit the Market House, shocking the thirty women pawing over the meager groceries and vegetables that barely covered the white-clad tables, meats and dairy missing entirely. Pets had mysteriously disappeared, leading some to speculate that the poor were eating the dogs and cats of Atlanta. General Hood ordered one thousand bushels of corn to be ground and given to the poor, but the shelling was so heavy and constant that the grinding could not be done. Ten-year-old Carrie Berry wrote from her Atlanta cellar on August 3, 1864, "[T]his was my birthday. I was ten years old. But I did not have a cake times were too hard so I celebrated with ironing. I hope by my next birthday we will have peace in our land so that I can have a nice dinner."[87]

Meanwhile, the soldiers struggled. Injured soldiers packed the Fair Ground Hospital, and the remaining women in the city took baskets containing biscuits, rusks, broiled and fried chicken and blackberry wine to the men. The majority of the Confederate troops waited in the trenches immediately outside Atlanta, the sun scorching overhead and pounding rain in the summer afternoons, with the brief interruption at sunset when carts hastily loaded with "musty meat and poor corn-bread" were driven out to the trenches and dumped among the men.[88]

Atlanta fortifications during the Civil War. *George Barnard, 1864, Library of Congress.*

After months of shelling, realizing that Atlanta was too well fortified, Sherman decided that it would be faster to starve the city and cut off its supply lines. The Yankees fell back, leading the Atlantans to believe that the Union was deserting due to lack of supplies and claims that the Union had "been living on one cracker a day for four days." But the rumors of the Union's starvation were belied by the Rebel scouts who returned from the abandoned Federal camp carrying armfuls of hardtack and bacon and incredible prewar treats such as sardines, lobsters, canned fruit, cakes and candies.

While the Confederate troops waited, unsure of the Union's next move, the Union troops methodically dismantled the railroad from Macon to Atlanta. Generals rewarded the best railroad-busting crews with special breakfasts, including a whole chicken per man, so the crews would have the strength to wreck five or six miles of track before sundown. On August 30, Sherman was satisfied; the railroad was beyond repair, and the Union troops moved back toward Atlanta. Hood, shocked that Atlanta was now well and truly trapped, sent out 20,000 Confederate troops to head off the remaining

60,000 Federal troops. It was a deadly loss; 2,000 Rebels died while only 172 Union soldiers died.

That morning, the remaining citizens of Atlanta learned the end had come. Sam Richards wrote, "If there had been any doubt of the fact that Atlanta was about to be given up, it would have been removed when we saw the depots of Government grain and food thrown open, and the contents distributed among the citizens free gratis, by the sackful and the cartload."[89] The citizens of Atlanta finally had all of the bacon and bread they could want, but they no longer had a city.

Atlanta surrendered to the Union that very day with $1.64 left in its treasury.

Upon their entry into the city, Union soldiers peeked through the fence of a large house at the corner of the city's walls, and their mouths immediately watered as their eyes caught the arbor filled to bursting with luscious muscadine grapes, plump and purple. After months of hardtack and bacon, with hastily snatched wild blackberries, the soldiers flung themselves over the fence and, within five minutes, stripped away every grape and set to plunder the gardens, groves and storehouses of the remainder of Atlanta. The Union soldiers broke into every store in the city, hunting for liquor, and confiscated nearly everything the slave-turned-speculator Prince Ponder had stored in his warehouse.

Sherman gathered all of the remaining residents of the city, approximately 700 women and elderly men and 850 children, and ordered them out of the city to the town of Rough and Ready by either train or wagon, with barely any food and little or no money. It was a hard journey for those remaining citizens. Three days after the fall of Atlanta, the Union army surgeon James Comfort Patten passed through the fortifications and was struck by "the most pitiful sight I have ever yet witnessed." Ignoring the troops marching along the road, a young mother skinned a dead cow at the roadside. Her daughter, "some six or seven years old," stood next to the carcass with "a piece of the raw bloody meat in both hands devouring it with the eagerness of a starving dog."[90]

The former slaves faced even more hardships, despite their newly freed status. Many former slaves filled the Atlanta train station to head north, gnawing shreds of meat from old bones, making meager hoecakes and crying for food.

NOW, WITH THE CITY completely evacuated, the Union army enjoyed life within their secure urban fortress. Lieutenant Colonel Morse, the Union's provost marshal, wrote home, "Isn't a soldier's life a queer one? One month ago, we were lying on the ground in a shelter tent, with nothing but pork and hard bread to eat; now we are in an elegant house, take our dinner at half-past five, and feel disposed to growl if we don't have a good soup and roast meat with dessert."[91] Sherman sent soldiers out into the countryside for the next two months to "forage"; soldiers would leave the fortified city with five hundred empty wagons and return with every wagon full of corn, sweet potatoes, sheep, calves, pigs and fowls so the men lived like epicures.

Meanwhile, the farmers living outside Atlanta devoted their time to hiding food. One wrote in his diary, "Yankees took Phillips' wagon and two horses, all our meal and flour, one keg of syrup, one bushel of grain....What will become of us. God only knows."[92] Women came into the Union camps on an almost daily basis, bringing in vegetables and fruit to trade for bread or flour or meat, refusing to take money because there was no store at which they could buy anything. Others bartered their bodies for food in the Union camps, leading Dr. Patten to sympathize, "[W]ho shall blame them, when their children are starving?"[93]

In October, Sherman's plan was unveiled, brilliant in its brutality. Sherman sent all sick and disabled Union men away and then ordered the obliteration of the railroad from Atlanta to Chattanooga, meaning that the sixty-two thousand Union troops were trapped in the South and would march through Georgia, down to Savannah, destroying anything that could support the Rebels and feeding themselves on the ripening corn from the fields across the state. Before the Union abandoned its urban camp, Sherman ordered Atlanta burned to the ground, leaving it, in Sherman's words, "smoldering and in ruins, the black smoke rising high in the air and hanging like a pall over the ruined city."[94]

Atlanta was the beginning of the end. Sherman successfully starved Atlanta and, in doing so, starved the Confederate States of America, leading to the Confederacy's surrender in April 1865.

BACON

Frederick Law Olmsted, traveling through the South pre–Civil War, reported that bacon "invariably appeared at every meal." Emily Burke likewise concluded that "the people of the South would not think they could subsist without their [swine] flesh; bacon, instead of bread, seems to be THEIR staff of life. Consequently, you see bacon upon a Southern table three times a day either boiled or fried."[95]

Hogs were cheap and grew well in the South, where they could roam at will and feast on the nuts and berries present in the Georgia forests. A single hog butchered produced plenty of meat for both slaves and masters, and it was for this reason that pork was the primary meat ration provided to slaves. Bacon and pork, in general, was used for everything in the antebellum period: lard was the primary fat, as butter and oil were harder to come by; cracklings were mixed with cornbread batter; bacon was served at breakfast on its own; ham hocks or cured bacon were tossed with the collards or butter beans for afternoon dinner; and pork chops or fried ham might be cooked for the evening supper.

When the Confederacy made Atlanta the Subsistence Department headquarters, the city held 90 percent of the bacon in the entire Confederate states, which is why Atlanta's women rioted for both bacon and bread. And when the Subsistence Department grew short on supplies, Major Cummings specifically mentioned that there was "no bacon worth speaking of in the country." The loss of bacon and pork meat was a huge deprivation to the Southern diet.

Postwar, Atlanta picked up where it had left off, and bacon again became the most important meat. Dr. John Wilson of Columbus, Georgia, in the 1860s, criticized this overuse of pork, complaining, "The United States of America might properly be called the great Hog-eating Confederacy, or the Republic of Porkdom…[because] it is fat bacon and pork, fat and pork only, and that continually morning, noon, and night, for all classes, sexes, ages, and conditions." He blamed southerners' ill health on the fact that "hogs' lard is the very oil that moves the machinery of life."[96] Over time, southerners and other Americans came to agree with Dr. Wilson's approach, as the American Heart Association revealed the dangers of high cholesterol and saturated fat.

Industrial farming, too, changed the South's meat-eating habits. In the 1800s and early 1900s, chickens were a feast food, saved for special occasions, because a single chicken took time and effort to raise. A century

later, in 2013, Georgia produced and slaughtered the most chickens of any state in the country, while midwestern states like Iowa and Minnesota produced more hogs.

Regardless, bacon has always had a prominent place in Atlanta's cookbooks. Mrs. A.P. Hill (1876) utilized bacon and strips of bacon in dozens of recipes, ranging from roasting beef to fish soup with bacon. For a patient who had scarlet fever, she insisted on a peculiar cure: as soon as the disease was ascertained, "rub the patient night and morning with fat bacon, rubbing every part of the body but the head slowly and carefully." For curing bacon, she made it clear that the "first requisite in making good bacon is, that the hogs be in good condition; then, that they should be killed when the wind sets *decidedly* in the north; take advantage of the beginning of the cold weather; never kill upon the wane or decrease of the cold."

The *Atlanta Woman's Club Cook Book* (1921) used bacon in numerous recipes from green beans to eggs to potatoes. The most interesting is this version of pigs in a blanket:

Pigs in Blankets

Dry large fat oysters on a cloth, roll around each one a very thin slice of bacon and skewer with new tooth-picks. Fry in greased chafing-dish. Serve on rounds of toast.[97]

WANTED: A GOOD COOK

RECONSTRUCTION: 1865 TO 1877

Within weeks of the destruction of Atlanta, residents began returning to their beloved city, building it faster than even before. After the years of deprivation and starvation, food was the first priority. While the ash from Sherman's bonfire settled in the streets, Whit Anderson opened a barroom where he served guests with "dignity and grace," and a grocer opened on Peachtree Street. There was a minimal amount of foodstuffs—or, for that matter, any stuff—in the city prior to the resolution of the Civil War, as seen in H.H. Anderson's pleading notice in the March 1865 newspaper:

> *Wanted, nails, lead, horse shoes, scrap chains, or whole ones, old axes, irons, brass buttons, butter, eggs, chickens, flour, wheat, corn meal, potatoes, vegetables of any kind, for all of which I will pay cash.*[98]

The city fathers enticed farmers to reenter the city to sell their goods, first allowing them to sell on street corners and then building two "neat and tastily arranged market houses," in which butchers and green grocers rented stalls. Before long, mule carts piled high with collards, peaches and corn from the outlying country towns lined the dusty roads of Atlanta. Wholesale and retail produce merchants set up shop in the city before any other merchants since the demand for food exceeded that for dry goods.

Prices rapidly began to approach the early war period. Prewar, a pound of butter cost thirty-five cents; in 1864, in the midst of the Civil War, butter cost ten dollars per pound; and by February 1865, even before the war was

officially over, a pound of butter cost six dollars. Wealthy debutante Octavia Hammond explained the influx of food into the city in the early months of 1865: "We manage to do very well here. Country wagons keep us supplied even cheaper than Augusta. Bacon is five dollars a pound, butter six, flour a dollar and a half, syrup twenty a gallon, eggs six a dozen, potatoes twenty a bushel and meal the same. There seems to be plenty of everything. New stores are opening every week."[99]

Effie McNaught, a middle-class woman, was not as optimistic as the wealthy Hammond; she wrote that "people live very hard here, corn bread mostly, and seem thankful to get that."[100] Refugees and migrants overwhelmed the city. In May 1865, a Union officer wrote that as many as fifty thousand freedmen and white people in north Georgia were "utterly destitute of bread or any kind of food" and women and children walked from ten to forty miles for provisions.[101] The military authorized rations to about fifteen thousand people in Atlanta, including ninety-five thousand pounds of bread and ninety-five thousand pounds of meat. Kate B. Massey

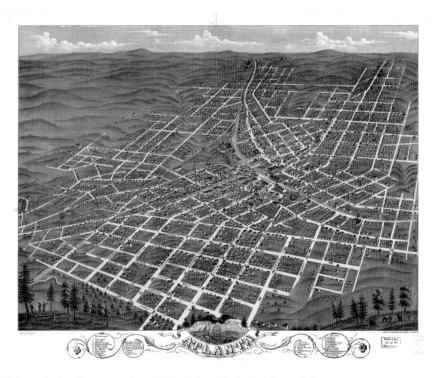

Atlanta during Reconstruction, 1871. *A. Ruger, St. Louis, Library of Congress.*

recalled years later that as a girl in the late 1860s, she had been surrounded by "swarms of white beggars. I remember one family whose plea was that they had nothing to eat for two days except [weeds like] poke salad and pepper grass boiled without salt."[102]

But the city grew and grew and grew. Just a year after the Civil War, the population eclipsed its prewar size, the city rising like the phoenix from its ashes. A northern reporter traveling through Atlanta in late 1865 wrote, "From all this ruin and devastation a new city is springing up with marvelous rapidity.…Chicago in her busiest days could scarcely show such a sight as clamors for observation here."[103] A correspondent from Mississippi complained that Atlanta was a "devil of a place": "At dinner to-day I could not eat for the noise. The boarders came rushing in, ate in five minutes, and rushed out, putting on their hats in the dining-room to save time."[104] Two years after the war, twenty thousand residents—almost eleven thousand white citizens and a little over nine thousand black citizens—filled the city, building home after home, and erecting 250 brick and wood stores.

The destruction of the plantation economy fundamentally changed the South. Rather than plantations providing food to its residents, hundreds of small towns sprang up across Georgia, each providing its goods through the country store, and those stores purchased their goods largely from Atlanta. The wholesale produce business boomed, with twenty-nine exclusive wholesale grocers lining Alabama Street, and Atlanta's food supply equaled almost 50 percent of the shipments the Western and Atlantic Railroad handled. By 1872, inbound shipments of bacon, corn, oats and flour were roughly 400 to 500 percent greater than they had been before the war.

A line of 125 canvas-covered wagons loaded with country produce stood on Peachtree Street every Saturday, waiting to be unloaded and sold to the hungry crowds. Mountaineers in rough homemade jeans, high boots and wide straw hats, their wives in full calico skirts, big aprons and sun bonnets, sold dried apples, hickory nuts and strings of pod peppers from the backs of their wagons, small hound dogs pacing in the shade beneath. The city also kept tight control over the quality of produce sold; in 1873, the *Daily Herald* complained that farmers sold spoiled fruits and vegetables to the poor at reduced prices, threatening the city with cholera, and the municipal government responded by requiring licensing and quality checks.

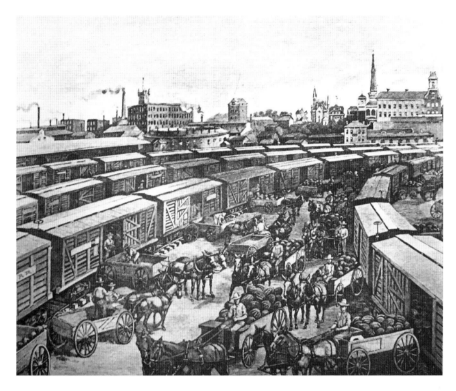

Watermelons coming into Atlanta market. *Norman Shavin, Underground Atlanta, 1973.*

The truth was that Atlanta lured "every man, young or old, who had $100 or more to invest…[like] the pilgrims to Mecca or Jerusalem," and food entrepreneurs made their fortune in the revitalized city.[105] The popular drugstore of Redwine & Fox purchased a marble and silver-mounted Arctic Soda Fount, "by far the most beautiful thing of the kind ever seen in Georgia," and Dr. Redwine mixed his own fruit soda syrups.[106] Morris and Emanuel Rich opened their iconic Rich's Dry Goods Store, which soon began selling foodstuffs, including their legendary coconut cake, and Egidius Fechter and Edward Mercer set up the City Brewery, later incorporated as the Atlantic City Brewing Company. James H. Nunnally opened a candy store on Peachtree Street that quickly became a favorite gathering place for Atlanta's young people, as it served a curious specialty, brick ice cream with center designs of diamonds, hearts, clubs, spades, slippers and other patterns.

Candy manufacturing became one of the city's staple enterprises, bringing in around $300,000 in revenue in 1875. G.W. "Wash" Jack was the largest

confectioner, known as the "king of the candy and crackery business of the south," and began his business in October 1854.[107] By 1875, he had a gleaming retail establishment at the corner of Whitehall and Alabama, worth over $240,000, radiant with glittering glass, gilding, chandeliers and a kaleidoscope of toys and dolls at the window to entice young customers and their mothers. Willis Venable, the celebrated soda jerk, owned the large soda fountain in Jack's store, made of Tennessee marble and trimmed in silver, and children eagerly purchased the brightly colored candies and boxes of tempting cakes and crackers filling the clear windows. Jack had a thriving wholesaling business in candies and crackers as well; a cake bakery stood on the third floor, a cracker packer on the fourth floor and a stick candy factory on the fifth floor of the building.

The city also became a safe haven for African American food entrepreneurs. Myra Miller was born a slave in Virginia and then either traded or sold to a master in Rome, Georgia, as a cook. In 1871, she came to Atlanta to use her prodigious cooking talents to open a bakery that soon became Atlanta's favorite wedding cake manufactory. Atlanta's aristocracy, such as it was, flocked to her pastry creations, which were "masterpieces of culinary genius" and the "most delicate flowers and designs were worked on the icing."[108] Most wedding cakes of that time were fruitcakes, a labor intensive and expensive cake that few cooks regularly made. The fruitcake necessitated chopping numerous ingredients, ranging from nuts to raisins to citron and orange peel, and required significant arm strength since the batter was thick and difficult to mix. It was then preserved with brandy so that cake slices could be sent by post to family and friends who were unable to attend the wedding. Miller made cakes for families as far away as Macon and made wedding cakes for the best and most prominent families across the state. Upon her death, the newspaper reported that "perhaps no colored woman in Atlanta received more honors in these last rites," and a tall and beautiful obelisk crowns her grave in the African American section of Oakland Cemetery.[109]

In the mid-1860s, Robert G. Thompson arrived in Atlanta with the plan to launch a nice dining room of the kind found in New York or Chicago. To some fanfare, Thompson opened Thompson's Restaurant across

from the railroad, at No. 4 Whitehall Street, and brought in two French chefs from Nashville to helm his kitchen, advertising mock turtle soup and oysters on the menu. Unlike many restaurant owners at the time, Thompson, himself, was a caterer and personally supervised the cooking, leading to the restaurant's immediate popularity.

By 1873, it was the premier dining establishment in Atlanta, crowded with gourmands, and served a variety of fruits, oysters and fish. Meals cost twenty-five to fifty cents each, and a year later, to compete with the saloons, Thompson added a lunch counter that served hot meals at all hours in the day and night at "popular prices," as well as the restaurant, which prepared every delicacy in the market.

Thompson was a prolific marketer and often put out ads to amuse and interest readers, including this one:

> *THE PLACE TO GO TO—Would you eat roast beef that is not too stimulating, ham that is not bilious, fish that is digestible, pastry that is anti-dyspeptic and that melts upon the tongue like flakes of lukewarm snow? Then go to Thompson's restaurant.*[110]

On another occasion, the *Atlanta Constitution* printed a short poem to advertise Thompson's:

> *Thompson's quail on toast*
> *Are his glory and his boast*
> *While his oysters on the shell*
> *Sound hunger's sad death-knell.*[111]

The restaurant was a success but only catered to a small portion of Atlanta's populace. Thompson's did not welcome African Americans or women at the white-clad tables. In the mid-1800s, hotels, saloons and restaurants were male dominions, with black male employees serving white male patrons and black male cooks in the kitchens. Women of quality rarely ate at restaurants and then only if invited by their husbands; an *Atlanta Constitution* article ridiculed New York women taking up the "Parisian custom" of eating at restaurants, deploring the fact that in New York "[y]ou may see women and girls sitting at the same table with men and ordering their meals with the nonchalance of old habitues."[112] Single ladies who ate at Thompson's Restaurant tended to be sex workers, invited to eat in Thompson's back private rooms by the men who paid them.

But by the 1870s, recognizing that women wanted an establishment to dine in while shopping or meeting friends, restaurants began opening ladies' dining rooms and ice cream parlors at which a woman could eat unattended in the confines of a female-friendly space. Thompson expanded his business in 1875 to two buildings on Broad Street plus the restaurant on Whitehall Street, with a house fit for boarders, and a ladies' ice cream parlor. Generally, ladies' dining rooms were inferior in every way, with the women relegated to basements and dark rooms, but Thompson produced the best ice cream in the city, manufactured from pure cream, and his wife, Alice Thompson, managed a nice and clean Ladies Parlor, so Atlanta's society women liberally patronized the establishment.

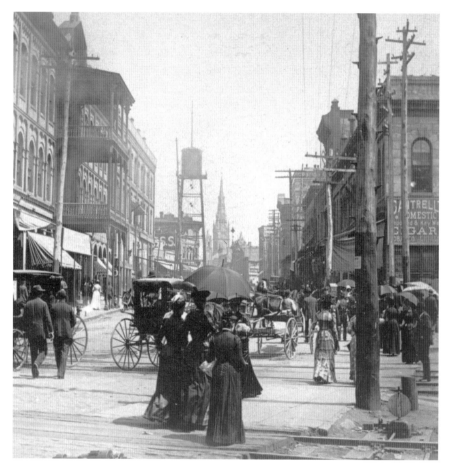

Atlanta, 1891. *Library of Congress Prints and Photographs Division.*

Yet Atlanta's restaurant business was tiny, with only ten total restaurants, generating $30,000 in revenue, in comparison to the wholesale grocery market which brought in $10 million per year in revenue. Though most people still ate all of their meals at home, Thompson's Restaurant grew steadily and his wealth increased, allowing him to send his daughter to study at Vassar and to purchase a palatial mansion on Whitehall Street. He added bathrooms to his restaurants and opened an attached hotel and then expanded to a larger space on Alabama Street in 1882. Six years later, he leased the refreshment privileges of the "brightest star in Atlanta's galaxy of suburban attractions," a miniature Alpine garden known as Little Switzerland, located near Grant Park. A banquet held at Thompson's in 1888 reflected the elevated quality of the restaurant's cuisine: six types of oysters from broiled to cooked with claret wine, quail, 'possum, venison, cold roast turkey, broiled ham, smoked tongue and chicken, lobster and shrimp salads, plus six types of cakes. That banquet was one of his last events; in December 1888, R.G. Thompson's health declined, and he offered his restaurant for sale, ending the twenty-year reign of Atlanta's first fine-dining restaurant.

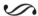

WHILE ATLANTA WAS ONCE again the land of plenty, the city had one major shortage: a lack of good cooks. Postwar, the best African American cooks found jobs in hotels or with elite families. Felix Brown, for example, grew up in slavery and learned to cook as a small boy. A year after the Civil War ended, at age twenty-two, he began working in hotels in Atlanta and soon rose to the top of his profession. He worked at the National Hotel and then became the head cook at the gorgeous Markham House for five years, serving elaborate meals that the *Atlanta Constitution* described as "magnificent" and "elegant," with such delicacies as boned turkey larded with truffles and flambéed oyster patties. By the late 1890s, he was one of the wealthiest African Americans in Atlanta, with a beautiful property on Edgewood Avenue valued at $8,000.

Those who could not find work in the top hotels or with top families often went to work as cooks and servants in the city's boardinghouses. In the early years of Reconstruction, Atlanta's entire hospitality industry struggled with inadequate employees due to emancipation and the migration of many former slaves to the North. An Atlanta teacher explained the "ingenious"

methods used by a hotel dining room to resolve its lack of employees in the 1860s: a single black child kept the flies away by manipulating improvised fly brushes suspended on a rope across the long room, and the restaurant utilized Lazy Susans so that guests could obtain their own salt, pepper, butter, cheese and preserves.

Homeowners across Atlanta felt the lack of good cooks even more keenly. Prior to the Civil War, white women of all income levels lived relatively luxurious lives since slaves did all of the manual labor, including cooking. Desperate for good cooks during Reconstruction, Atlanta housewives filled the newspapers with wanted advertisements. Gertrude Thomas, weary of eating hard biscuits, thought providence brought her Leah, who prepared light, fluffy biscuits and "one of the best plum pies" Gertrude ever tasted at five dollars per month. But, when Gertrude's husband asked Leah to provide written proof showing that her previous master had allowed her to look for work, Leah left, much to Gertrude's chagrin. She wrote, "I certainly sacrificed a good deal to principle for I lost an opportunity to get an excellent cook at 5 dollars per month.[113] Good black cooks commanded higher prices than any other former slaves, too; Virginia Shelton, an Atlanta housewife, initially offered Hannah, a highly skilled cook and washer, five dollars per month but was forced to agree to Hannah's terms of eight dollars per month plus bringing on Hannah's husband at ten dollars per month.

Meanwhile, black cooks regularly complained about the long hours and low pay. African American cooks in Atlanta were underpaid compared to the rest of the nation; in San Francisco in 1878, a cook received almost $40 per month in wages; in New York, a cook earned $20 per month, while Atlanta housewives paid their cooks between $5 and $10 per month. It was common to see black women and children scrounging for castoff produce in the garbage cans on market days due to the low wages. Some employers openly admitted that they intentionally paid low wages because they expected their cooks to "pan-tote" or take home table scraps to their children. Atlanta newspaper editors argued that the low wages were acceptable because the "younger negro women, who have grown up since the war, are very generally idle and untrained in household craft. They can neither sew nor cook, and their morals are as lax as their minds are undisciplined."[114] The low wages were endemic; in 1870, only one black person in the city had real and personal wealth of more than $5,000, and 71 percent of adult black males and 96 percent of adult black females owned no property at all.

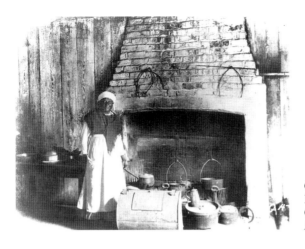

Cook in kitchen at Refuge Plantation, Camden County, Georgia. *Historic American Buildings Survey.*

Black cooks held one strong threat: they could quit. An Atlanta newspaper complained, "One great need of Atlanta is cooks who won't leave families without notice, and breakfast and housegirls who will remain a month."[115] Another complained that it was getting harder to find a cook, stating that the city's housewives were "frustrated" in trying to "keep help about the house" and appalled that they had to "go into the kitchen and prepare their own meals."[116]

The lack of cooks led to a new food problem: white women in Atlanta were, for the first time, required to work and prepare their own meals. The *Atlanta Constitution* explained this novel condition in June 1869 when it lamented,

> *Poverty before the war was an unknown thing among us. The poorest people found no difficulty in living comfortably. Our women, as a body, were free from the necessity of working for support....It is now different.... The country is filled everywhere with poor, good women who must look to themselves alone to win meat, bread, and clothing.*[117]

Another claimed, "In the next five years, if the colored helps deteriorate in the same ratio as they have since the 'late unpleasantness,' Southern women will generally have to become 'chief cook and bottle-washer.'"[118]

This struggle to learn cooking continued for most of the latter half of the nineteenth century. Nearly eighteen years after the end of the war, newspaper editors continued to complain about the white woman's ignorance in housekeeping. On the one hand, poor women were blamed for their shoddy food: "One of the greatest faults with the tables of the less

wealthy classes is the quality of the cooking. The ignorance that is displayed in the preparation of meals is enough to harrow up one's soul."[119]

While writers lambasted the poor as ignorant, others laid the blame for wealthy women's poor housekeeping counterintuitively on the fact that they no longer had expert servants:

> *In the slave days, every southern lady was an accomplished housewife. She supervised, instructed and advised until the cook had become perfect and was installed as cook for life....Having to deal with casual servants, there is no longer any temptation to train a servant as a cook. The moment she becomes proficient she is apt to leave you.*[120]

An 1883 culinary instructor likewise made the following confusing argument: "[T]he abolition of slavery also abolished good cooking except as to the negro women who were educated by their mistresses in the culinary art, and the mistresses themselves."[121]

In 1867, two years after the war ended, Annabella P. Hill, a white woman from a socially prominent family, decided to do something to resolve the problem of inexperienced housewives. Hill was born and raised on a plantation in Morgan County, Georgia, the youngest daughter and the pet of her family of five. At seventeen, Hill married Edward Young Hill, a notable young lawyer, who soon was elected to the superior court in Troup County, where the family moved in the best circles. Hill became known for her hospitality and accomplishments as a hostess.

With her fortunes considerably reduced after the war and her husband's death, the widowed Hill sold her plantation and her home in Troup County, moved to bustling Atlanta and took up a position as the principal of the Orphans' School. On the side, she wrote a cookbook, titled *Mrs. Hill's Southern Practical Cookery and Receipt Book*. This cookbook, published in Atlanta in 1867, became one of the most influential cookbooks in the South in the next thirty years and continues to provide a great deal of insight into the mind of the antebellum and Reconstruction southern cook.

Hill dedicated the book to "young and inexperienced Southern housekeepers," who, "in this peculiar crisis," needed counsel to take upon the responsibilities of housekeepers, "a position for which their

Shrimp and grits at Sweet Auburn Seafood. *Author photo*.

Pulled pork sandwich. *Author photo*.

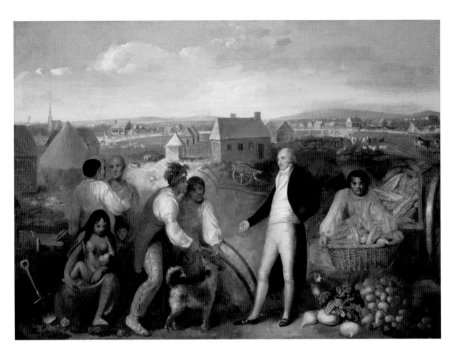

Above: Benjamin Hawkins and Creek Indians trading corn and other goods; unknown painter; 1805. *Greenville County Museum of Art: The Southern Collection.*

Left: *Le Petit Journal* cover depicting Decatur Street during the Atlanta Race Riot of 1906. *Library of Congress and Bibliotheque National de France, October 7, 1906.*

Delmonico's menu from the banquet where Henry Grady gave the "New South" speech. *Henry Woodfin Grady papers, available at Emory University Rare Materials Collection.*

Postcard touting rise of "Billy Possum" after Taft 'possum dinner. *Neatorama.*

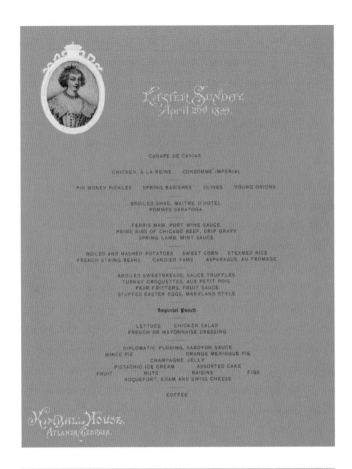

EASTER SUNDAY.
April 2nd 1899.

CANAPE DE CAVIAR

CHICKEN, À LA REINE CONSOMMÉ IMPERIAL

PIN MONEY PICKLES SPRING RADISHES OLIVES YOUNG ONIONS

BROILED SHAD, MAITRE D'HOTEL
POMMES SARATOGA

FERRIS HAM, PORT WINE SAUCE
PRIME RIBS OF CHICAGO BEEF, DRIP GRAVY
SPRING LAMB, MINT SAUCE

BOILED AND MASHED POTATOES SWEET CORN STEAMED RICE
FRENCH STRING BEANS CANDIED YAMS ASPARAGUS, AU FROMASE

BROILED SWEETBREADS, SAUCE TRUFFLES
TURKEY CROQUETTES, AUX PETIT POIS
PEAR FRITTERS, FRUIT SAUCE
STUFFED EASTER EGGS, MARYLAND STYLE

Imperial Punch

LETTUCE CHICKEN SALAD
FRENCH OR MAYONNAISE DRESSING

DIPLOMATIC PUDDING, SABOYON SAUCE
MINCE PIE ORANGE MERINGUE PIE
CHAMPAGNE JELLY
PISTACHIO ICE CREAM ASSORTED CAKE
FRUIT NUTS RAISINS FIGS
ROQUEFORT, EDAM AND SWISS CHEESE

COFFEE

KIMBALL HOUSE.
ATLANTA, GEORGIA.

Top: Easter Sunday
dinner menu at
Kimball House, 1899.
*New York Public Library
Buttolph Collection, Rare
Book Division.*

Left: Durand's
Restaurant at corner
of Union Station.
*https://www.leofrank.
info/images/atlanta.*

Depiction of the New South, with prosperous black and white attendees going to Cotton States Exposition. *Library of Congress Prints and Photographics Division, illustration from* Puck, *volume 38, no. 972, published by Keppler & Schwarzmann, October 23, 1895.*

Varsity. *Carol Highsmith, Library of Congress.*

Original Waffle House location. *Waffle House.*

Martin Luther King Jr. Birth Home. *Historic American Buildings Survey, Library of Congress.*

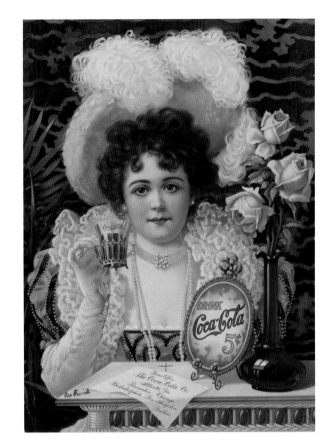

Right: Early Coca-Cola advertisement, approximately 1890s. *Library of Congress Prints and Photographs Division.*

Below: Ship-A-Hoy Restaurant, circa 1940. *Boston Public Library, the Tichnor Brothers Collection.*

Davis Fine Foods Cafeteria postcard. *Boston Public Library, The Tichnor Brothers Collection.*

Atlanta postcard, featuring tearooms and Coca-Cola sign, circa 1940. *Boston Public Library, the Tichnor Brothers Collection.*

Cockerel Grill Menu

Order By Number Please

1. HOMEMADE FRESH VEGETABLE SOUP . Cup .20
2. RICH'S OWN SHRIMP BOAT75
3. SHRIMP REMOULADE95

Salads

4. FRESH TOSSED SALAD, CHOICE of DRESSING .50
5. FRESH TUNA FISH SALAD PLATE . . .75
6. One-half CHILLED GRAPEFRUIT with Brandy Sauce .20

Hot Rotisserie Sandwiches

7. SUGAR CURED BAKED HAM . .95
8. TENDER SLICED TURKEY . .95
9. CHOICE CORNED BEEF . .95
 (Served with French Fries and
 Cockerel Grill Barbecue Sauce
 or Giblet Gravy)

Cold Sandwiches

LIVERWURST — 75

12. BAKED SUGAR CURED HAM .75
13. SLICED MEAT of TURKEY . .75
14. COLD SLICED BEEF . . .75
Served with Rich's Famous Potato Salad

10 SLICED TO ORDER
SUCCULENT U. S. CHOICE PRIME RIB
of BEEF on Rich's French Bread
Barbecue or Natural Gravy
Served With French Fried Potatoes
or Garden Sliced Tomatoes
1.10

11 SLICED TO ORDER
Tender White and Dark Cuts of Turkey Meat
Served on Rich's Toasted French Bread, with
Hot Cheddar Cheese Sauce and Mushrooms,
Served with French Fries
or Garden Sliced Tomatoes
1.10

15. CHEF'S SPECIAL DAILY—Irish Beef Stew 95c

16. TURKEY SALAD PLATE
Tomato and Egg Wedges

Saltines or French Bread — 75c

Desserts

17. Danish Pastry . . .15
18. Toasted Pound Cake . .15
19. Rich's Famous Pecan Pie .30
20. Ga. Pecan Cream Torte .30
21. Apple Pie with Cheese .25
COBBLER — 25
WITH CREAM - 30

Beverages

22. Hot Coffee .10
23. Iced Tea .10
24. Sweet Milk .15
25. Buttermilk .15
26. Tomato Juice .15
27. Orange Juice .15

MAN'S RETREAT UNTIL 2:30 P.M.
LADIES Served--2:30 P.M. to Closing

RICH'S
Cockerel Grill

Rich's Cockerel Grill menu (note the separate seating for men and women). *Atlanta History Center.*

Left: Chef Kent Rathbun sprinkling salt on steaks at Atlanta Food & Wine Festival. *AF&WF/ Raftermen Photography.*

Below: Harold Shinn at Buford Highway Farmer's Market. *Southern Foodways Alliance, Kate Medley.*

Hoecakes. *Author photo*.

Bacon-wrapped oysters. *Author photo*.

Left: Buttermilk biscuits made with AtlantaFresh buttermilk. *Author photo*.

Below: Moonshine-based bootlegger's companion at Smoke Ring. *Author photo*.

Collard greens at the Municipal Market. *Author photo.*

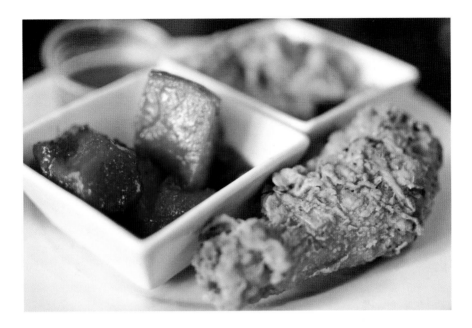

Above: Paschal's fried chicken, yams and cornbread dressing. *Author photo*.

Left: Paschal's modern restaurant, with black-and-white picture depicting historic restaurant where civil rights leaders met. *Author photo*.

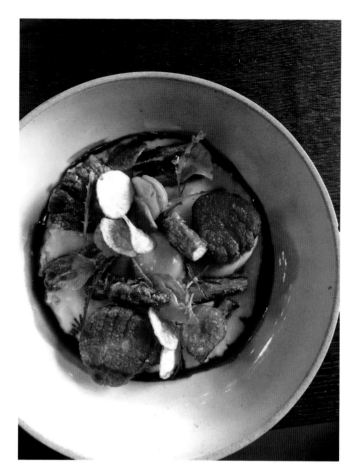

Right: New
Southern cuisine
at Bacchanalia.
Author photo.

Below: Peach
slider donuts
from Revolution
Doughnuts.
Author photo.

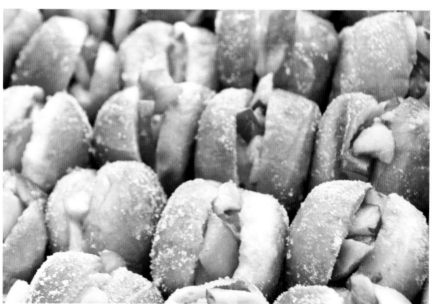

Left: Your Dekalb Farmers Market. *Dekalb Farmers Market Inc.*

Below: Municipal Market. *Municipal Market Company.*

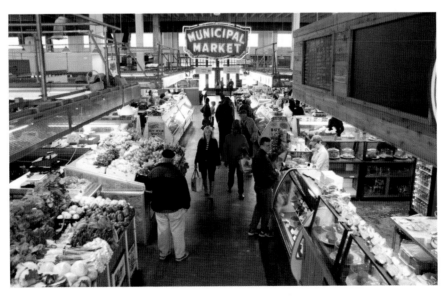

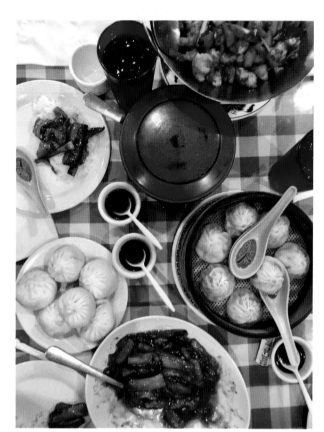

Right: Dumplings at Chef Liu's on Buford Highway. *Author photo*.

Below: MacLab's inventive and creative macarons in Duluth. *Author photo*.

inexperience and ignorance of household affairs renders them wholly unfitted." She apologized that some recipes were "tediously minute" but felt it necessary to provide such detail to those new in cooking; to that end, she included such novice recipes as how to take the peel off a banana, how to boil rice, how to fry eggs and how to make a ham sandwich. The vast book also provided useful guidance to the more experienced housewife on cooking over a hearth stove, making cakes and breads and more complex instructions, such as curing bacon, making scalloped oysters and pickling and preserving.

At the same time, as white women began cooking, they realized that cookery was excruciating and demanding work, which lead to a movement to implement labor-saving devices in southern kitchens, such as the cast-iron stove and baking powder. Prior to the Civil War, white masters cared little about the condition of the kitchen, kept in poorly ventilated outbuildings away from the main house with rudimentary implements and massive hearth fires without any significant means to regulate temperature. In the introduction to *Mrs. Hill's Cookbook*, just two years after the war, Reverend E.W. Warren implored men to remodel the southern kitchens and outfit them with the modern cast-iron stove, describing the antebellum arrangement of the distant kitchen with separate smokehouse as "horrid," "unsightly" and "fatiguing." He urged the men to "[u]nite your kitchen with your dwelling, and furnish with a stove, etc. Inclose your pump under the same roof; have your pantry large enough to hold your supply of provisions, and let all your arrangements be labor-saving."[122] Soon enough, Mrs. A.P. Hill featured regularly in newspaper advertisements for cast-iron stoves in Atlanta, encouraging women to install one in their homes.

In 1870, Georgia became the last Confederate state readmitted to the Union, and Reconstruction officially ended in 1877, with Atlanta named the new capital of the state of Georgia. But the dilemma of Atlanta's food remained. More food filled warehouses, grocers and homes than ever before. The white men of the city grew wealthy from the grocery trade—the single largest business in the city, amounting to approximately $11.5 million—as western merchants routed most of their produce through Atlanta to coastal cities like Charleston, Savannah and Jacksonville.

But the white women of the city did not know how to cook all that food. In December 1875, Reverend E.W. Warren and Mrs. A.P. Hill, along with other notable women in the city, met to establish an "industrial school," named the Georgia School of Education and Industry for Women. Hill wrote a scathingly blunt letter, read aloud at the meeting, stating that this school was one of the "pressing necessities of the south," because, "That there is lamentable ignorance of these duties is too apparent to be disputed. The best excuse for this widespread ignorance lies in the fact that before the war the south was served by slaves—now we must serve ourselves. To do this intelligently and skillfully, we need training."[123]

The editors of the *Atlanta Constitution* supported the development of the school, claiming that it would be both chivalrous and sentimental for men to allow women entry into womanly spheres of labor, such as sewing and cooking. Other women argued that both wealthy as well as poor women should attend the school and be trained for useful employment; Elizabeth Gabbett wrote, "[W]hy should a pretty woman be a drone in the hive?"[124]

Instead, society women, considering it demeaning to attend an industrial school, established the Atlanta Cooking Club, a social activity in which a wealthy young woman cooked a dish "with her own fair hand" and then brought the dish to be eaten potluck at a club meeting.[125] Trying to ease the sting of society ladies cooking, the *Atlanta Constitution* claimed that it was "becoming the fashion to learn to cook" and described the club in florid terms: "The young ladies are enthusiastic, and the dainty dishes prepared by their fair hands will never fail to attract the young man. A man never dreams what culinary artists Atlanta beauties are until he attends a meeting of the Cooking club and feasts on some of the good things."[126]

It was a futile effort. As Atlanta tumbled into the Gilded Age and the dawn of the New South, black men and women continued to man the majority of Atlanta's kitchens, feeding the populace at negligible wages and suffering indignities that would eventually break the city of Atlanta.

BISCUITS

When Gertrude Thomas sought a cook who could make a good biscuit, she was searching for a cook of the highest caliber because southern biscuits have always been the marker of a great cook. Wheat flour was considered a delicacy for a long time in Atlanta because it had to be imported from the

North or Midwest. So, though southern-style biscuits are today an essential part of southern cuisine, in the antebellum period, only the wealthiest in Atlanta would have eaten biscuits made with wheat flour.

The biscuits eaten in the Reconstruction period were different than the southern-style biscuit we know today, because they tended to use yeast and more resembled dinner rolls than the flaky biscuits we make today. One of the most popular forms of biscuit was the beaten biscuit, more akin to hardtack or a cracker. Named because the cooks literally abused the dough with a mallet or hammer for a quarter of an hour or longer, the smooth, plasticky dough blistered as it was beaten and, when cooked, lasted a long time. The Georgia beaten biscuit was such a popular specialty that, in 1897, the Woman's Exchange in Atlanta shipped ten dozen beaten biscuits to a New York hostess.

Baking powder was invented after the Civil War, and Dooley's Yeast Powder and Sea Foam Baking Powder advertised heavily in Atlanta in the Reconstruction period. But there was a great deal of controversy and confusion about the newly invented product, as newspaper exposés revealed that alum was used in manufacturing baking powders, and poor-quality baking powders turned the baked goods bitter. Many cooks did not know how to cook with baking powder or baking soda, preferring to utilize yeast. An 1883 Nashville culinary instructor traveling through Georgia complained, "[A]t half the houses I stopped the biscuits were raw at the bottom, and either as heavy as lead or yellow as a pumpkin with soda."[127] Mrs. A.P. Hill, for example, included six biscuit recipes in her cookbook, and only one includes baking soda and none use baking powder.

But the advertisers for the baking powder manufacturers did their job well. Frequent, persistent advertisements convinced Atlanta women that baking powder produced the best, soft, flaky, tall biscuits. In 1921, the *Atlanta Woman's Club Cook Book* published six recipes for biscuits, and every single one includes either baking powder or baking soda.

By the time Henrietta Dull (Mrs. S.R. Dull) published her cookbook in 1928, biscuits had become such a critical part of southern cooking that the front illustration of her cookbook shows a pile of perfectly round buttermilk biscuits alongside fried chicken and a pie, and her smiling picture shows her with a tray of biscuits ready to eat from the oven. White Lily Flour, too, had been heavily advertising its low-gluten soft winter-wheat flour that produced exceptional biscuits. Dull's classic buttermilk biscuit recipe remains the timeless standard:

20th Century Buttermilk Biscuits

2 cups flour (2½ after sifted)
1 cup buttermilk
4 tablespoons shortening
1 teaspoon salt
½ teaspoon soda
2 teaspoons baking powder

Into the flour put salt, soda, baking powder, and sift into bowl. Mix in shortening with tips of fingers, or chop in with spoon, add buttermilk, using spoon, and make into a dough. Lift onto a well floured board, knead just to get smooth and firm enough to handle.

Roll or pat out to one-half inch thick, cut, place on baking sheet, bake in hot oven about ten minutes. Acid buttermilk is better for cooking, and for every cup of milk one-half teaspoon soda is necessary. Use a tea biscuit cutter.

Today, there is no better guide on the southern biscuit than Nathalie Dupree's and Cynthia Graubart's exhaustive compendium *Southern Biscuits*, in which they give dozens of variations on the classic recipe, including unusual recipes like ones made with goat milk butter and yogurt, concluding that there is, in fact, a southern biscuit for all. While their versions are many and varied, they conclude that making true southern biscuits requires "a touch of grace—a gift that some people are blessed with."[128]

THE BACK OF DELMONICO'S MENU

THE NEW SOUTH: 1877 TO 1905

On December 22, 1886, a baby-faced thirty-six-year-old Atlanta man sat in the famed Delmonico's Restaurant surrounded by New York's elite. Henry Grady was the brilliant editor of the *Atlanta Constitution*, an avid reader whose favorite book was *Les Misérables*, a noted journalist for his crisp and forthright style and one of Atlanta's most prominent men. In Delmonico's exquisite dining room, lit by electric chandeliers and elaborately decorated, Grady waited nervously to speak at the New England Dinner sponsored by the New England Society. All 360 seats were sold long in advance, and several hundred people ate the gourmet meal in side rooms or in hallways and lined up along the walls and in the doorways when the speeches began.

The dinner was long and heavy, a ten-course meal, the menu beautifully drawn and printed entirely in French, with dishes ranging from filet de bouef a la Matignon to foie gras aux truffes and finishing with Delmonico's plum pouding au rhum. The dinner ended, the tables were cleared and Grady leaned back to listen to the speeches. DeWitt Talmage, a noted reformer and abolitionist, gave a short prayer, and General William Tecumseh Sherman spoke about the Civil War to loud applause.

Throughout the speeches, Henry Grady doodled on the back of his menu. Though he had written and spoken about his vision for the South for many years after the war and spent considerable thought in what he would say in the six weeks before the speech, he had prepared no written materials for his first opportunity to spread his message about the South's

Henry Grady. *Public domain.*

progress to a nationwide audience. Asked a few days before what he intended to say at Delmonico's, Grady replied, "The Lord only knows? I have thought of a thousand things to say, five hundred of which if I say them will murder me when I get back home, and the other five hundred of which will get me murdered at the banquet."[129] He sat at Delmonico's head table and scrawled on the back of the beautiful menu in a hasty hand five or six phrases and then stood to begin the speech.

Grady later described that moment: "Every nerve in my body was strung as tight as a fiddle-string, and all tingling. I knew then that I had a message for that assemblage, and as soon as I opened my mouth it came rushing out."[130] His lilting, sweet voice stretched over the men gathered, and he began, "There was a South of slavery and secession—that South is dead. There is a South of union and freedom—that South, thank God, is living, breathing, growing every hour." Grady stretched out the olive branch, paying homage to Abraham Lincoln as a great man, but shared his love of the Old South, asking the audience to think of the soldiers' pitiful struggle after returning from the Civil War. He then wryly referred to Sherman as "a kind of careless man about fire" and went on to describe the rebuilding of Atlanta: "[F]rom the ashes he left us in 1864 we have raised a brave and beautiful city; that somehow or other we have caught the sunshine in the bricks and mortar of our homes, and have builded therein not one ignoble prejudice or memory."

He spoke movingly of the progress made by the South, the equality created for black citizens and the industriousness of the white men and urged northerners to invest in the New South, claiming that "one Northern immigrant is worth fifty foreigners." He defined this New South in terms of food production, the principal business of the Southeast and Atlanta:

The Old South rested everything on slavery and agriculture, unconscious that these could neither give nor maintain healthy growth. The New South presents a perfect democracy…less splendid on the surface but stronger at the core—a hundred farms for every plantation, fifty homes for every palace, and a diversified industry that meets the complex needs of this complex age.

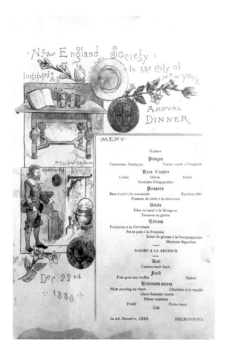

Left: Delmonico's menu at banquet where Henry Grady gave the "New South" speech. *Henry Woodfin Grady papers, available at Emory University Rare Materials Collection.*

Right: Back of Delmonico's menu where Henry Grady scrawled his notes for the "New South" speech. *Henry Woodfin Grady papers, available at Emory University Rare Materials Collection.*

Grady ended with a rousing query to the audience around midnight, "Now, what answer has New England to this message? Will she permit the prejudices of war to remain in the hearts of the conquerors, when it has died in the hearts of the conquered?" The audience roared back, every man on his feet waving his handkerchief, and shouting "No, No, No!" so loudly that the yells could be heard around the block.[131]

The speech was a phenomenal success, leading to Grady's instant fame. A Washington newspaper reported that Grady had "eaten one of Delmonico's best menus and had made one of the best after-dinner speeches ever made in New York. In fact it was a revelation to New Yorkers."[132] Northern newspapers spoke in glowing terms of Grady, his proper respect for Abraham Lincoln and his vision of the New South as helping to unify North and South with a common appeal to industrial growth. Southern newspapers lauded Grady as breaching the differences between the South

and North without humbling himself or issuing a humiliating apology for the war and remembering the best of the antebellum days. When Grady's train arrived home in Atlanta, thousands gathered with a brass band in the pounding rain to welcome him and carry him off to partake in a delicious champagne punch in parlor 104 of the Kimball House, as he was hailed the hero of the hour.

Henry Grady's speech, first scribbled on the back of a Delmonico's menu, came to define the New South and Atlanta.

Henry Grady's New South was Atlanta's response to the Gilded Age, described best by Mark Twain, who wrote about New York: "What is the chief end of man?—to get rich. In what way?—dishonestly if we can; honestly if we must." Woodrow Wilson, then a young Atlanta lawyer, quit his practice in 1885 after observing, "Here the chief end of man is certainly to make money, and money cannot be made except by the most vulgar methods."[133] Another observer was even more scathing, "The God of Atlanta is money."[134] Money was the chief virtue of the late 1800s, and as headquarters of the New South, wealth flowed into Henry Grady's Atlanta.

Chief among the carpetbaggers, Hannibal Kimball was a fast-talking, fast-moving northerner, described as a "steam engine in breeches."[135] Kimball's biggest success was in hotels. In 1871, he opened the Kimball House, considered the grandest hotel in the South. The restaurant served delicacies like mock turtle soup with Krug champagne, tenderloin of beef larded with mushrooms, rose blancmange and English plum pudding.

A reporter at the *Atlanta Constitution*, on a behind-the-scenes look at the Kimball House kitchen, described the kitchen storeroom as containing "every possible thing to eat" with a princely stock of $5,000 to $8,000 worth of goods carried at all times, enough to look like a "well-stocked grocery store." The storekeeper bought flour by hundred sacks, ham by the thousand pounds, oysters by the dozen gallons, with dressed turkeys in heaps, quarters of beef hanging, whole carcasses of lambs and hogs, haunches of venison, geese, chickens and ducks.

The Kimball House pastry chef, paid one hundred dollars per month, worked with two assistants to produce between three hundred to eight hundred pies per day, with a perfect regiment of custards and puddings. Fifty-gallon soup boilers filled with consommé or mulligatawny soup lined

Kimball House Hotel. *Public domain.*

one portion of the twenty-eight-foot-long cooking range, and a twenty-five-foot-long carving table, heated by steam, was fitted with compartments for meat, vegetables and breads that would be scooped up by a corps of waiters and taken to the affluent guests.

When a fire from a nearby fruit vendor destroyed the property, the indefatigable Hannibal Kimball broke ground on the new Kimball House within months, and the new hotel and restaurants were built even larger and grander than before.

IN 1877, ATLANTA'S FIRST telephone installation occurred on the premises of the Western and Atlantic Railroad, which connected passenger agent B.W. Wrenn's office with the train dispatcher's office in the Union Depot. About noon, the telephone workman completed the installation. As the workman was leaving, Wrenn, slightly nervous about the new machine, asked if "it would work now."

"Oh, yes," the workman responded.

"And can I talk over it?"

"Of course."

"How do I work the thing?" asked Wrenn.

The installer turned the crank to ring and then said: "Here he is."

Wrenn picked up the receiver and put it to his ear, initiating the first telephone call made in Atlanta.

"Who's there?" he asked.

"Kontz, Anton Kontz," answered the city's brewery owner. "That's Wrenn, ain't it?"

"Yes, I'm hungry. Send word to Henry Durand to get me a good dinner."[136]

It was a fitting first telephone conversation for Atlanta, the city built on food. Henry Durand was a mainstay among Atlanta's epicures and food lovers. In 1878, Captain Wilson Ballard, a leading pioneer, had charge of the baggage department at the Union Depot when it occurred to him that the train station needed a restaurant, since the only fine-dining restaurant in the city was Thompson's on Alabama Street. Henry Durand went to work for the captain and, within a year, was made a full partner, so that when Captain Ballard died in 1884, Henry Durand bought out the depot restaurant and turned it into one of Atlanta's top restaurants. It was a small place but packed with newspaper men, grocery buyers and general travelers in and out of the city due to its convenient location at the train depot.

At Durand's lunch counters, he served his celebrated cup of coffee with toothsome muffins that melted in the mouth and an "ideal paper-knife ham sandwich."[137] Durand purchased old Government Java and Arabian Mocha directly from suppliers and created an ingenious proprietary system of distillation after he conceived that "the most essential feature of a restaurant is to serve the best coffee, bread and butter."[138]

The upstairs restaurant boasted a splendid fruit stand with a tempting display of Caribbean fruits, such as oranges, pineapples and bananas and served plump quails and fresh oysters. In 1887, a passenger who had eaten at Delmonico's in New York claimed that he had never had a "choicer steak, a finer cup of coffee" than he got in Durand's restaurant. Guests could dine on a juicy sirloin steak for $1.25, Spanish omelette for $0.40, shining pompano at $0.60, and end his evening with mince pie and the famous muffins. Bachelors landed there for three meals per day, and the waiters knew all of Atlanta's big shots, "what they did, how rich they were and what they liked best to eat."[139] The restaurant stayed open twenty-four hours per

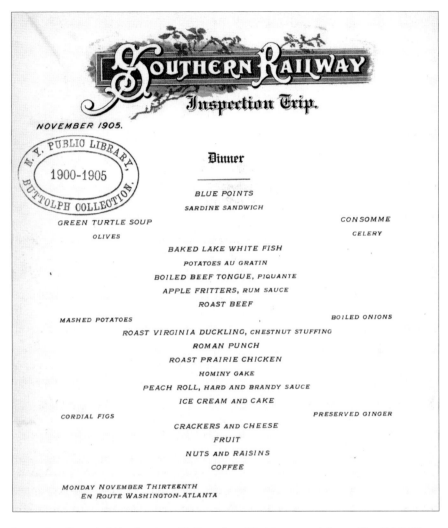

Inspection dinner held by Southern Railway from Washington to Atlanta. *New York Public Library Buttolph Collection, Rare Book Division.*

day, a welcome respite for travelers arriving at all hours of the day and night, and never closed for a single day until 1913.[140]

Durand explained his success in 1892, "My business increases every year, about in proportion to increase of travel and the growth of Atlanta." Durand brought in fresh vegetables from his own farm in DeKalb County and purchased Michigan celery, Florida strawberries, Chicago beef and ducks and Mobile quail. He had an exclusive contract with Smith's dairy in LaGrange, Georgia, for forty gallons of milk per day, with the cows milked

at 3:00 a.m., the milk immediately put on the train, where it was sent up sixty miles packed in ice, and reached the depot restaurant at 6:00 a.m., so the farm-fresh milk and cream could be served with Durand's coffee.

Durand explained, "The epicure calls for few things which we cannot furnish. If they are not to be found in the Atlanta market they are in our refrigerators. There is plenty of good eating in Atlanta, and it is getting better all the time."[141] Durand was right: Atlanta's wholesale and retail grocers thrived, largely based on their reliance on a cash market. Atlanta's wholesalers imported food from all over the country and sold at prices 20 to 35 percent lower than anywhere else in the state. In 1901, the grocery trade was the single largest trade in the city at $12 million in revenue, and no city in the South carried an assortment of food equal to that kept in Atlanta, leading to the rise in caterers and restaurants as well. In 1881, there were twenty-six restaurants in the city and, ten years later, fifty-six restaurants.[142]

To compete with the new restaurateurs, Durand opened a ladies' café that had elegant appointments, palm trees and potted ferns and installed electric ceiling fans, a welcome respite from the midday summer heat. A decade later, Durand opened a second palatial café on Alabama Street just below Whitehall, next door to G.W. Jack's Candy and Cracker Emporium. Durand, concerned with keeping a clean kitchen, included a large exhaust fan in the building of the restaurant, one of the first of its kind in Atlanta's commercial kitchens, and used Georgia marble and mahogany in the modern restaurant. Guests feasted on the finest oysters from the Atlantic coast, including Blue Points of Long Island and Norfolk oysters from the Chesapeake Bay, and he served oysters both at the railroad depot and the East Alabama restaurant. The Alabama Street restaurant was a mainstay in Atlanta until 1930, when Henry Durand passed away, to be deeply regretted by his friends and the foodies of Atlanta.

In 1881, Atlanta, eager to embrace the New South, wanted to showcase its growth, resilience and industriousness, and the city seized upon expositions as a way to demonstrate its success. Recognizing Kimball's achievements in the hotel industry, Governor Colquitt appointed Kimball as the organizer of the International Cotton Exposition, held at Oglethorpe Park. The exposition was a huge feat, with gross receipts of over $250,000 and over one thousand exhibits, including Eli Whitney's original cotton gin.

A Mr. Jones kept a restaurant on the exposition grounds. For sixty cents, the restaurant served lamb chops, bread with tomato sauce and boiled Irish potatoes, while another guest ordered steak with sweet potatoes and tea, two nice chops and potatoes and a well-cooked steak and bread. Because of the low prices and great quality of food, the best people in the city mobbed the restaurant, and the newspapers encouraged guests to eat there, stating, "There is no excuse for families carrying lunch to the grounds when such inducements are offered as can be had at Jones's restaurant. It is cheaper to go there and get an elegant lunch or dinner than to pay for the trouble of carrying about a lunch."[143] Samuel Inman, leading real estate developer in Atlanta, stated, "One of the chief reasons that secured the success of the exposition is that we secured Mr. Jones to take charge of the restaurant. When you feed the people cheaply and in good style they are willing to stand many other inconveniences."[144]

Capitalizing on the success of the 1881 exposition, six years later, Atlanta held the Piedmont Exposition to exhibit the natural resources of the Piedmont region at newly created Piedmont Park. President Grover Cleveland, with his beautiful young bride, Frances Folsom, attended the Piedmont Exposition in October, arriving late in the evening, leaning on the arm of Henry Grady. Though a large dinner had been prepared for them at the Kimball Hotel, the presidential couple had a simple late supper of milk and crackers and retired to the bridal chamber. The next day, nearly the entire city of Atlanta attended President Cleveland's speech, spoken from a balcony at the Markham Hotel, and then he and his wife adjourned to a giant supper at the Capital City Club. Every possible delicacy was available, from cold turkey to sandwiches, fried oysters, handsome table cakes, fruits of all kind and champagne opened in the greatest quantity.

The organizers of the various expositions lauded themselves, proclaiming the city of Atlanta and its successes as the harbinger of the New South, playing beautifully into Henry Grady's idyll of economic prosperity and industriousness in the Southeast.

OYSTERS

Oysters may seem to be a strange specialty for a city completely landlocked and 250 miles away from the nearest ocean. But, in the 1800s, oysters were nationally a trendy and popular dish, to the extent that the average

New Yorker ate six hundred oysters per year, in comparison to the modern man who eats an average of three oysters per year. As New York was the culinary and fashion capital of the country, Atlantans wanted to mimic New York's culinary trends, hence the obsession with serving oysters in the nineteenth century.

Cornelius Hanleiter, Atlanta's first foodie, specially ordered shipments of oysters for his first dinner parties, and Toney Maquino's interest in oysters was likely to cater to a more expensive crowd. Three years after the Civil War ended, restaurants referred to oysters as delicacies to be enjoyed in Atlanta's hotels and restaurants, and the newspapers reported oysters as the "most delicious of bivalves, cooked in the finest style of the art."[145] Because Atlanta was so far from the coast, most oysters consumed in the city were canned, so when restaurants had fresh oysters, they published an advertisement listing the amount of fresh oysters received with the location from which they arrived. New York was America's oyster capital, and Atlanta restaurants boasted shipping oysters from Long Island. In New York, oysters were cheap since they were harvested in the city's bays, so that both saloons and high-end restaurants served oysters; in Atlanta, there were no nearby oyster beds, so oysters were an expensive item, served at the city's best restaurants.

At home, oysters were considered essential fare at the dinners held by Atlanta's upper class. Mrs. A.P. Hill included almost twenty recipes for oysters, from soups, stews, sausages, scallops and dressings, revealing the popularity of the meat in the late 1800s. She stated, "Those who wish to enjoy this delicious bivalve in perfection, must eat it the moment it is opened, with its own gravy in the under shell. If not eaten *absolutely alive* its spirit and flavor are lost."[146] The *New Dixie Cook Book* in 1891 included over fifty oyster recipes, ranging from oyster catsup to oyster omelette to oyster croquettes and beef and oyster pie.

By 1927, the last of New York's oysters beds closed due to pollution and toxicity, and as a result, in Atlanta, the culinary obsession with oysters dramatically dropped. Nearly a century later, oysters have been making inroads in Atlanta's haute cuisine with new oyster bars popping up across the city, including at Decatur's Kimball House, a nod to Hannibal Kimball's once legendary restaurant.

WHAT HAPPENS WHEN THEY EAT WITH ONE ANOTHER

AFRICAN AMERICANS IN THE NEW SOUTH: 1877 TO 1905

Henry Grady's New South left one glaring omission. It was predicated on the superiority of the white man. At his last speech before his death, Grady acknowledged that the success of the New South required the disenfranchisement of black voters, arguing that it was wrong to conflate "[t]wo utterly dissimilar races on the same soil, with equal political and civil rights, almost equal in numbers, but terribly unequal in intelligence and responsibility."[147] The skeleton under the rhetoric was that Grady wanted a separate South for African Americans, in which the black man would be inferior and the races would interact only for the black person to support the white. Journalist Ray Stannard Baker described this attitude best when he wrote, "Many Southerners look back wistfully to the faithful, simple, ignorant, obedient, cheerful, old plantation negro and deplore his disappearance. They want the New South, but the old Negro."[148]

Though African Americans made up almost 40 percent of Atlanta's population in the final years of the nineteenth century, few white people in Atlanta stopped to consider how the black people in the city lived, and the largest proportion of those African Americans were unknown to them. W.E.B. DuBois of Atlanta University once said that "the best of the Negroes and the best of the whites almost never live in anything like close proximity."[149] Jim Crow laws were in early stages, largely because many African Americans could not afford the enjoyment of restaurants, hotels and resorts. But in the fifty years since their emancipation, African Americans had run with the opportunities given to them, establishing wealth and a completely parallel black middle class.

James Tate came to Atlanta with a secret. Emancipated at age forty, the son of his white plantation master, Tate was the rare emancipated slave who could read and write. With a meager $16 of stock, he opened the first black-owned business in the city shortly after the Civil War ended, a small grocery store selling produce and dry goods. Thirty years later, through thrifty living and clever business sense, he was one of the wealthiest African Americans in Atlanta, making his living by selling food to black customers. He owned two grocery stores with $6,000 of stock in each and numerous truck gardens in the countryside where he hired men to grow vegetables and fruits that were then delivered to markets in the city, including his own. As he was known as the father of Atlanta's black businesses, an 1896 *Atlanta Constitution* article pointed to Tate as an exemplar for all African Americans, stating that he had "in a great measure solved the problem of the future of his race. He has proven that success is in the reach of the negro if he will pay close attention to his business and put into practice sound business principles."[150] Recognizing that education and literacy gave him that leg up, Tate became Atlanta's first black teacher, establishing the first elementary school for black children under the Friendship Baptist Church.

James Tate. *Carter, The Black Side.*

The basement of Friendship Baptist Church also housed a tiny institute to teach young African American women that eventually became Spelman College, one of six institutions created to educate the newly emancipated slaves. These six black institutions—Morehouse College, Spelman College, Atlanta University, Clark College, Gammon Theological Seminary and Morris Brown College—later affiliated and jointly renamed as the Atlanta University Center, were the crown jewel of Atlanta's black upper class. President Edmund Asa Ware, a white abolitionist and educational reformer, modeled the elite Atlanta University after his alma mater, Yale University, and Oberlin College, the most successful integrated university in the country. As such, Atlanta University was the first university in Georgia to enroll both black and white students from the start.

Before the doors to Atlanta University opened, Ware summoned the faculty to discuss how the students and faculty would eat. He saw three possibilities: meals could be served at different times and be racially separated; or, there could be separate racially divided tables; or, everyone could sit down and eat together. Ware declared, "The last way is the best because we have come here to help these people and we cannot do it best at arm's length." The university adopted Ware's solution and, in 1869, four years after the Civil War ended, Atlanta University made a bold stand, flouting all prevailing conventions and laws and seated all diners together, whether they were black or white.

An Atlanta University student who attended the school in the 1880s explained the importance of integrated dining, describing this "intimate association three times a day" as creating "an influence over manners, speech, personal appearance and attitudes that could not be exerted so effectively in any other way and it is that, it seems to me, which has marked Atlanta University graduates outwardly more than anything else." He stated that this was "no small decision to make at that time when never before in the lives of those Negro boys and girls had they or any of their kind sat down anywhere with white people on terms of equality. And I know of no other place in Georgia and I am sure there were few places anywhere in the South where a like thing was done."[151]

This early adoption of culinary desegregation at the university infuriated Georgia's citizenry, journalists and politicians. Five years after the school opened, a white newspaper editor visited the university and, at first, praised the students and their learning. But the editor was appalled at the intermingling of the races while eating, describing the North Hall dining room in disgust:

> *Here we saw them file in, black, white and yellow, teacher and pupil, Saxon and African, cheek by jowl; all intent upon the gustatory work before them. It was a practical amalgamation, and sickening, social equality intensified....* [It is this] *which poisons this whole concern and will make it stink in the noses of native Georgians.*[152]

Ware and the Atlanta University faculty ignored the journalists and citizens who complained, even accepting loss of funds to continue permitting all students and faculty to eat together as a sign of respect and understanding. A half century later, Atlanta University Center students would bring the university's model of integrated dining to a national audience.

W.E.B. DuBois was a stranger in a strange land. Raised in a tolerant Massachusetts community, well traveled and educated mainly at Harvard, DuBois took on a professorship at Atlanta University, and he entered a Deep South he had mostly avoided. Yet he found a mission, believing that providing an exceptional education to African American youths would create the Talented Tenth, an elite group of black intellectuals who would, in his view, save and uplift the race.

DuBois's groundbreaking sociological research included an investigation of Atlanta's black businesses, arguing that the significance of business ventures among black men could not be undervalued, because such business ventures would result in economic emancipation and true equality. In Atlanta, DuBois found that, just as food was the principal business in the white side of the city, food was the principal business in the black side. Of the sixty-one black-owned businesses surveyed by DuBois in Atlanta, thirty-four were involved with food: there were twenty-two grocery stores, seven meat markets, two restaurants, two saloons and one creamery, all of which almost exclusively served the black community.

DuBois noted that many African American food entrepreneurs cleverly leveraged their expertise working at white-owned businesses and then created a parallel business in the black community, competing and taking business away from their former bosses. For example, when Elijah Richard Graves married his wife in 1876, he gave her fifteen cents, which was half of his entire possessions at the time, and said, "As I give you this, I will give you more." Soon after, he took up a job making candy, working for the Block & Company manufacturing establishment, where he mastered the candy-making art and then opened his own successful candy-making firm. As the only black-owned candy-making operation in Atlanta, Graves's business prospered, and by the 1890s, he owned a neat little cottage on Magnolia Street and an attractive and inviting candy store nearby.

Likewise, J.O. Connally walked from Chattanooga, Tennessee, to Atlanta at age seventeen with not a penny in his pocket. He began working for a white butcher named Mr. Shields, grinding sausage and selling meat seven days a week, not even getting Sundays off to attend church. Connally left Shields after ten years of work when the butcher refused to raise his salary or give him time off, and Connally established his own butcher shop and meat market in the city, creating a flourishing business worth $3,000 by the 1890s.

W.E.B. DuBois. *Library of Congress Prints and Photographs Division.*

While black food entrepreneurs created successful businesses all across the city, Auburn Avenue was the home of the most prestigious black businesses. Dr. Moses Amos, the first black druggist in the state, owned the Gate City Drug Store, the first black-owned drugstore, and operated a

lunch counter in one corner and a post office in the other. Gus Williams's Piedmont Ice Cream Store operated a few doors down from the Gate City Drug Store and was the only ice cream saloon in the city that catered solely to black clientele, serving sophisticated frozen treats, including limes and sherbets, a strong rebuttal to the pre–Civil War law that had banned a slave from establishing an ice cream saloon as "unwise."

BESIDES THE PRIVILEGED DINING halls of Atlanta University, there was only one other place in the city of Atlanta where white and black men met together and ate and drank as equals—in the dives and saloons of Decatur Street. Decatur Street held the city's worst reputation, and historians have painted it in grim colors. During the day, a riotous street market operated on the pavement, where visitors and locals bought cheap goods and feasted on fried fish from any number of six-by-nine stalls. At night, middle-class men and women of both races met at modest dance halls to waltz and converse or devoured chicken fried in closet-sized kitchens. Crowds packed the subterranean dives, and black men and "women of loose morals" drank and smoked, dining on chitlings, beer, coffee and pork, and watched buck dancers jiggling and shuffling to piano and ragtime music pounded out on dilapidated instruments. The police complained that chances were ten to one that trouble in Atlanta would start on Decatur Street, leading to the building of the new police station and prison on the street.

The crime was certainly amplified by excessive drinking. Decatur Street housed almost 50 percent of Atlanta's saloons, with roughly forty saloons along a two-mile stretch in the early 1900s, and most concentrated near Five Points and the railroad depot. While elegant saloons with rosewood billiard tables and gas fixtures existed on Peachtree Street, the saloons on Decatur Street tended to be simple, long rooms with a bar that provided cheap libations to its guests. Entirely male-dominated spheres, the saloons held spittoons for tobacco juice, nude artwork based on classic paintings in lieu of later curvy pinup girls, public hand towels hanging from the bar and a single fork in a glass of water for guests to use to serve themselves at lunch. In the nineteenth century, that free lunch was a necessity—a combination of salty items, such as pork or beans or Irish stew—to entice drinkers to its bars. By the end of the century, the city council prohibited free lunches, arguing that it allowed saloons to avoid paying food preparation licenses,

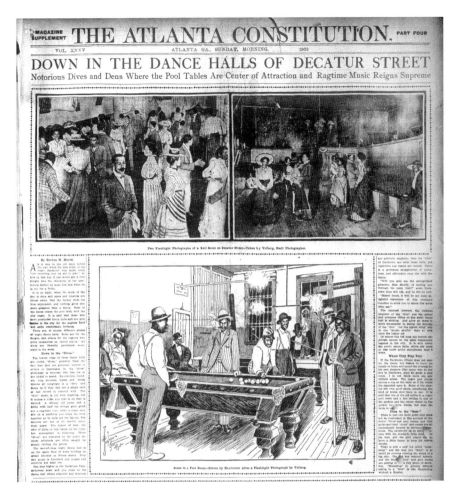

Atlanta Constitution exposé on Decatur Street. *From the* Atlanta Constitution, *July 2, 1902.*

while encouraging "free lunch fiends," poor men who would make a meal out of the free lunches, going from saloon to saloon and drinking heavily while eating the viands offered.

Behind the façade and the reputation, though, Decatur Street was crucial to Atlanta's food history. Decatur Street was one of the few places where African Americans could relax and enjoy themselves, escaping from the drudge of poverty and the ceaseless work in their jobs. By 1893, articles described Decatur Street disparagingly as a "congress of all nations," because the city's small Chinese population, the large black contingency, the poor white men, the newly arrived Jewish residents, the Greek fruit peddlers

and tavern owners and any other representative nationality gathered in Decatur Street's strange twisting passage ways, where people could eat and drink together without regard to wealth or status. The city council passed a resolution in 1900 allowing restaurants and bars to be declared "white only," but there was no designation for "black only" businesses, meaning that the businesses in Decatur Street continued to cater to whites and blacks, with blacks normally seated at the back of the restaurant or behind a curtain, but still allowing some informal mingling between the races.

In addition to the forty saloons, Decatur Street housed several restaurants, little cubbyholes filled up in lunch counter fashion with the masses mingling over Washington pie and coffee, and one ice cream parlor where men and women ate perched on small stools. Some women offered tiny boardinghouses. Rosa Edwards operated a lunchroom on Decatur Street with rooming facilities (ten cents per night for a mattress in a room that held nine or more beds). A police janitor held a licensed dive in the basement of a brick building, where he charged men five cents but admitted women for free, and the patrons danced to piano, bass violin and a "patty-hand man" until midnight, while eating cheap food and drinking cheaper alcohol. On one occasion, white spectators attended the dive to watch six black couples competing for a cake, the black men dressed like "swell society dudes" and the black women wearing short dresses of gaudy and flimsy material; the newspaper called the dancing "exceedingly good."

AT LEAST SOME OF Decatur Street's poor reputation was solely based on the fact that it *was* a poor black neighborhood, and as such, the people who congregated there were automatically assumed to be less worthy. For example, a turn-of-the-century Atlanta City Directory listed most white eating places as "Restaurants," while black establishments were classified as "Lunch Rooms," regardless of the style of service at either. Even elite African Americans condemned the dives harshly, with a *Voice of the Negro* article complaining that Decatur Street was crowded with "staggering men and swaggering, brazen women congesting the shops, the saloons, the alleys and the back ways—people divested of all shame and remorse."[153]

In June 1893, a city council committee with the mayor investigated the area and reported they "found a number of dives and dens that are a disgrace to civilization—a disgrace to anything—they would disgrace savagery. They

are filthy, full of foul odors and are frequented by a lot of generally worthless negroes."[154] The mayor remarked with respect to the restaurants, "I don't see why anybody could get an appetite in such holes." Within a few weeks, the police and city council shut down and thinned out a number of the businesses on Decatur Street, refusing to grant licenses to numerous saloon, business and restaurant owners.

Weeks later, P.J. McNamara, an owner of property and estate trusts in Decatur Street, wrote a long, impassioned letter to the *Atlanta Constitution*, arguing that the city's actions in closing businesses on Decatur Street fundamentally harmed the city's economy and did not accurately reflect the motives of the black people who met there, offering one of the few black defenses of Decatur Street. He wrote:

> *Now, as to the crowds of negroes congregating at the various business places. Is it not true that the merchants like such crowds? If they did not want to put up with the sweet scent of the negro why did they go to Decatur street to do business? There has been a great deal said about the arrest of twenty-seven negroes at the cheap eating house, known by the negroes as the "Big Turner." What was the evidence by the arresting officers? Only this and nothing more. There was a big crowd of negroes laughing and talking....Who are the merchants on Decatur street, white or colored? The negroes have but little money but they make it go a long way.*[155]

P.J. McNamara was right; many of the merchants on Decatur Street were black and aimed toward the African American population, which by 1900 amounted to around forty thousand. James Tate, for example, had a huge two-story brick grocery store on Decatur Street and resided on the street as well, belying the usual assumption that Decatur Street was simply a set of ruffians and criminals. The white Judge J.H. Landrum, whose office was located on Decatur Street, explained that he chose the locale because of its cheap rent and that there were a number of "reputable, good, reliable business houses on this street who lose considerable patronage simply because their business happens to be on Decatur Street." Judge Landrum and other prominent businessmen even floated the idea of changing the name of the street from Decatur Street to the dignified-sounding Society Avenue because the ladies of the city should "exclaim 'horrible' if their skirts should happen to swish an inch below Pryor into Decatur Street."[156]

The prohibition and temperance activists vilified Decatur Street, too. In 1885, a heated battle took place in Fulton County as the Wets and Drys tried

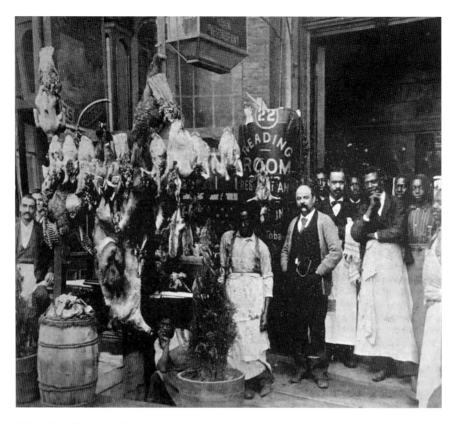

Folsom Reading Room Restaurant. *1893 Company Review.*

to convince the citizens to vote either for or against a local prohibition bill. At the West Point Depot, the Wets held a rousing feast with men packed so thick that it was almost impossible to squeeze through, the crowds devouring great chunks of baked meats—pork, mutton and beef—with hunks of bread and whiskey and beer kegs regularly tapped, ending the party at two o'clock in the morning. The Drys likewise lured their voters with food, spending around $10,000 on their campaign effort, serving beef, ham, mutton, 'possum, coffee and eggs at the black Wheat Street Baptist Church and oyster stews and coffee at Friendship Baptist Church. A noted 'possum vendor had prepared over a hundred 'possums for the feast, but a rumor spread that some of the 'possums were actually cats, which scared the voters, and a message was dispatched to him stating he need not serve the 'possums.

The next morning, after a night of feasting across Atlanta, Fulton County citizens voted to go dry by a mere 219 votes, making Atlanta the first large

city in the United States to prohibit alcohol. The initial round of prohibition did not last long in Atlanta, as the Wets repealed the prohibition law two years later, but the 1886 prohibition had profound effects. With the saloons closed, Decatur Street transformed into a neighborhood of restaurants and "blind tigers," serving alcohol illegally by promising guests a "free drink" along with a visit to see a blind tiger, two-headed dog or other natural oddity, which may or may not have existed. At the same time, soda fountains proliferated, since drinkers needed an alternative to alcohol.

And in that single year and a half of prohibition, a Civil War veteran named Dr. John Pemberton began inventing a temperance beverage that would change the world.

JOHN PEMBERTON WAS A morphine addict, a Civil War veteran, a brilliant pharmacist and a lousy businessman. Though he had established the largest drug trade in the city at the elegant Kimball House after the war, by the 1880s, he had fallen into bankruptcy due to a lack of good management, with a creditor calling Pemberton a "broken down merchant." Pemberton began manufacturing new patent medicines, developing a product known as French Wine Coca, marketing it as a "great invigorator of the brain." Pemberton's wine certainly did invigorate, since it contained four ingredients, all of which acted as aphrodisiacs and invigorants—coca leaves, African kola nuts, damiana and pure grape wine. Within a few months of the invention, Pemberton thought his financial worries were over, as the bottles of French Wine Coca started selling well. And then Fulton County adopted prohibition, limiting sales of French Wine Coca due to the alcohol content in the wine. At the same time, Pemberton sought to create a syrup that soda fountains could sell by the glass for a nickel, rather than trying to sell the more expensive bottle of French Wine Coca, which cost closer to a dollar.

Throughout the winter and early spring of 1886, Pemberton obsessively experimented with a new coca and kola temperance drink to cure headaches, sending it to be tested at Joseph Jacobs' Pharmacy where Willis Venable manned the soda fountain. Venable, the self-proclaimed "soda fountain king" of Atlanta, had previously held sway over soda fountain counters at many of Atlanta's largest businesses, including G.W. Jack's Candy and Cracker Emporium. At Jacobs' Pharmacy, Venable owned the soda water fountain,

mixing beverages with syrups to meet the clamoring fan base, particularly during prohibition when saloons were closed.

The legend goes that Venable accidentally mixed Pemberton's Coca-Cola syrup with soda water one afternoon in 1886 and a customer liked it so much that it became the Atlanta soda fountain's most popular drink. The reality was more mundane: Pemberton sent his nephews down to Jacobs' Pharmacy to watch men try the Coca-Cola syrup with soda water to see if it was a viable product. The soda men, at first, did not think much of the drink; Foster Howell, a soda jerk in 1889, said that though Coca-Cola is "very popular here and has held its own…we are not specially stuck on it… [b]ecause there is no money in it. We are compelled to keep it to supply the demand, but there is no money in a glass of coco-cola at five cents."[157] In 1887, Pemberton, weak and ill from stomach cancer, sold his formula to Asa Candler, a well capitalized and industrious Atlanta businessman. Within a year, Pemberton died at the age of fifty-seven, leaving behind a widow who would end her life as a pauper.

Candler, meanwhile, was $50,000 in debt, struggling with constant headaches and stomach troubles and attempting to market Coca-Cola. After the company plastered Coca-Cola prints on oilcloths across streetcars and buildings, employed drummers to advertise the product across the country and purchased huge, insistent newspaper advertisements, Coca-Cola sales mushroomed. When 1890 began, Candler was no longer in debt and realized that if he abandoned his drug business and concentrated on Coca-Cola, he could make his fortune.

Candler decided to economize by moving to 42½ Decatur Street (for the low rent), where he manufactured Coca-Cola above a pawnshop, secondhand clothing store and black saloon. He was not a popular tenant because the forty-gallon kettle of brewing syrup occasionally boiled over, resulting in the sticky brown goo oozing through the floorboards into the establishments below. He soon moved into a larger building on Auburn Avenue and then to Peachtree Street, as sales skyrocketed based on the genius of Coca-Cola's marketing. Within thirty years, Candler was Atlanta's richest man, ensuring that Atlanta's own Coca-Cola reached every soda fountain in the country.

IN 1895, THE AFRICAN American community in Atlanta buzzed as it planned for the opening of the Negro Building at the Cotton States and International

Exposition, the black community's first attempt to showcase its achievements since the end of the Civil War. The exposition was Atlanta's largest yet, and concerned about how Atlanta's five main restaurant owners could feed the twelve thousand guests per day, the newspaper reported facetiously that an enterprising individual could make a fortune by establishing a "patent sandwich nickel-in-the-slot machine," what the modern American would call a vending machine.

By September, Atlanta was finally ready to welcome 800,000 guests over a three-month period. President Grover Cleveland flipped an electric switch from his home in Massachusetts, turning on the lights at the exposition in Atlanta, and the citizenry rushed in, eager to ride the Phoenix Wheel and the Scenic Railway and see the Liberty Bell shipped in from Philadelphia. And, on that day, Booker T. Washington gave a speech that resonated across the country and sealed the Atlanta Exposition as one of the most important in history.

Booker T. Washington was born into slavery in Virginia and spent his early childhood living with his mother, the plantation cook, in a one-room, dirty cabin that served as the cookhouse for the plantation. Hunger was chief among Washington's childhood memories. One afternoon, during the Civil War, he was summoned to fan his two young mistresses as they shared a snack of ginger cakes, which seemed to be the "most tempting and desirable things that I had ever seen," and he "then and there resolved that, if I ever got free, the height of my ambition would be reached if I could get to the point where I could secure and eat ginger cakes in the way that I saw those ladies doing."[158]

After painstakingly making money working at salt furnaces and coal mines, Washington attended Hampton Institute and Wayland Seminary and was then offered the job as the president of the newly formed Tuskegee Institute at age twenty-five. The institute began with literally nothing, meaning that the students had to dig their own kitchen and dining room, and the students cooked all of the meals and grew their own food. Washington focused the institute on an industrial and technical education, under the idea that upward mobility and the rise of the African American race would occur when black youths mastered industrial and technical skillsets.

At the exposition, Washington presented this "Atlanta Compromise," espousing those views, refusing to challenge segregation and disenfranchisement. Instead, he urged blacks to "cast down your buckets where you are" and make progress as laborers. He stated that the "wisest among my race understand that the agitation of questions of social equality

is the extremest folly." The white audience loved the speech, with newspapers proclaiming it as the best type of sense.

It was a strange moment in Atlanta's culinary history. At Piedmont Park, the Negro Building showcased black achievements to an integrated audience while, at the opening ceremony, a black man reassured the white audience, "In all things that are purely social we can be as separate as the fingers, yet one as the hand in all things essential to mutual progress." At Atlanta University, where the black and white students ate and learned together, W.E.B. DuBois harshly condemned Washington's Atlanta Compromise, calling it accommodationism that would curtail the progress of the race. On Auburn Avenue, black men became successful food entrepreneurs by taking business away from their former white bosses. And in the Decatur Street back rooms and dives, black and white people drank, ate, danced and caroused together, ignoring the philosophical conversations, not realizing the powder keg about to explode on their very street.

LIBATIONS

While it is certainly true that Atlanta is a city built on food, it also is a city built to drink. From its early drunken days with the Free and Rowdy Party through Coca-Cola's impressive rise, there have always been libations to serve alongside the city's food. Of these, it is worth taking a quick peek at liqueurs, wines and 'shines.

Generally, prior to the 1890s, Atlantans were drinking and producing a lot of alcohol. In 1860, Georgia produced more wine than any other state in the country, totaling twenty-seven thousand gallons. The *Atlanta Intelligencer* announced that every Georgian could have his own vineyard and make his own "pure unadulterated wine." Mrs. A.P. Hill (1867) included recipes for muscadine wine, grape wine, blackberry wine, cider wine, tomato wine, strawberry cordial and blackberry cordial, as well as cherry bounce and other types of brandy.

One of Mrs. A.P. Hill's most interesting recipes is the nonalcoholic Agraz, which she describes as "the most delicious and refreshing drink ever devised by thirsty mortals," made by straining unripe grapes pounded with loaf sugar and water and freezing the mixture.[159] Once Georgia enacted prohibition laws, women stopped making liqueur and wines, and in Mrs.

Dull's 1928 cookbook, she does not have a single recipe for an alcoholic beverage and only includes nonalcoholic punches, cocoa, tea and coffee.[160]

Moonshine has been, on the other hand, made throughout Georgia's history. As it was produced in the mountains of Georgia, during Prohibition, rumrunners made frequent trips from Dawsonville to Atlanta, leading the Dixie Highway to be nicknamed as the nation's Alcohol Trail. An Atlanta resident who wanted alcohol would call the one pay phone at a service station in Dawsonville and ask in code if "peaches were in stock"; if the Dawsonville bootleggers had made enough moonshine, a runner would race down the highway in a rear-spring Ford coupe, loaded with around a thousand pounds of white lightning, encased in tin cans, onion sacks or half-gallon Ball jars, to bring to the railroads and blind tigers in Atlanta. Until Prohibition ended, Atlanta had one of the largest bootlegging enterprises in the country.

WHEN CORNBREAD KILLED

JIM CROW ATLANTA: 1906 TO 1924

By ten o'clock in the morning on July 31, 1906, the Atlanta heat was already suffocating fourteen-year-old Annie Laurie Poole as she walked to her neighbor Mrs. Cheshire's home. Annie Laurie, a white child living in the bucolic Lakewood community, had grown up across the river from the black colleges at Brownsville. Fatigued by the heat that morning, she decided to stop along a neighboring cantaloupe field and pick some melons, perhaps taking one or two to Mrs. Cheshire and a few for her own family. She scrambled down the banks and had begun filling her wide sunbonnet with ripe fruit when a large black man suddenly appeared from the shrubbery at the edge of the road. Annie screamed as he grabbed her and kept on screaming as he yanked her by her long hair forty feet into a thicket of trees. There he forced himself upon her, and she screamed and screamed and screamed, until she fainted.

At least, that's what Annie Laurie claimed happened, as reported in the *Atlanta Constitution* the next day.

A small black child who worked at a farm nearby heard the screams and told Annie Laurie's mother, who ran down Hapeville Road and shouted for help. Annie Laurie's cousin and friends scoured the vicinity near Lakewood, where they came upon a shanty and found Frank Carmichael, a tall black man with a pair of shoes covered in red mud. He was hauled to the front of Annie Laurie's house, where fifty white men and boys milled outside, guns at the ready. Annie Laurie appeared at the door, looked at Frank Carmichael and said, "Oh! It is him." Forty guns fired at once and

Carmichael fell to the ground, his blood seeping into the red clay. The men thrust the dying Carmichael into a wagon and took him to Annie Laurie's father, working at his Pryor Street grocery store, to prove that Annie Laurie's honor had been avenged.

Police did not investigate Annie Laurie's accusations further, though by the end of the day, two physicians reexamined the girl and found no evidence of any injuries or sexual molestation. They told reporters that their diagnosis was Annie Laurie had "a nervous character." No charges were filed in the killing of Frank Carmichael. The *Atlanta Journal* editorialized that giving black men like Carmichael more equality and the right to vote would result in more of these outrages.

The incident in the melon patch was the first of many assaults reported by the newspapers in the next several months. Combined with Hoke Smith's incendiary candidacy for governor calling for absolute disenfranchisement of the black man and the publishing of Thomas Dixon's controversial *The Clansman: A Historical Romance of the Ku Klux Klan*, Atlanta was simmering in a state of racial unrest by the early fall.

On September 22, 1906, boys stood on the corners, yelling "Extra! Extra!," pushing out newspaper after newspaper, with extra additions published throughout the day, each one with giant bold black letters: "Two Assaults," "Third Assault," "Negro Attempts to Assault." With tensions already high, white men gathered as the bars closed on Decatur and Peachtree Streets. Though the mayor tried to pacify them, the whiskey-fueled men on Decatur Street would not be calmed.

For three days, a mob of approximately ten thousand white men attacked black citizens and black-owned businesses along Decatur, Pryor and Peachtree Streets, eventually heading to Brownsville, where the university students and professors barred themselves in their homes. Rioters poured into the lobby of the Kimball House looking for black porters and waiters to beat, and the waiters and busboys at Durand's Restaurant dropped their dishes and bolted past the Union Depot as the mob reached them. In a violent rebuke to Henry Grady's New South, rioters shot two black barbers in their shop near Marietta Street and dragged them to the statue of Henry Grady that watched over the city's broadest avenue, where they unclothed and mutilated the men. When the riots ended, the mob had killed twenty-

five to forty black people, injured hundreds and destroyed millions of dollars in black real estate and property. Two white people were killed.

The newspapers later admitted that their reports of black assaults on women had been exaggerated three or fourfold, but it was little solace to the devastated black communities. Over one thousand black residents permanently left the city in the days after the riots.

Cooks refused to return to work, leading one newspaperman to state with rare humor in the middle of the crisis, "The spectacle of the young man of the family peeling the potatoes and the mater and sisters cooking the meals was quite the thing Sunday."[161] As far away as Jackson, Mississippi, black cooks quit in droves after the Atlanta riot, and since the supply of cooks in Jackson had never been plentiful, the newspaper tried an odd sort of reassurance, telling black workers that they were being unnecessarily timid because although "occasional lynchings occur in the state…during the past forty one years, or since the days of reconstruction, there has not been a single race riot in Jackson."[162]

The businesses on Decatur Street received the majority of the blame for the race riot. The city council permanently closed 36 saloons serving blacks in the Decatur Street area and permitted only 18 restaurants and saloons serving blacks to reopen. The *Atlanta Journal* snickered, "The only way you can get a drink in Atlanta is to have a physician write you a prescription, take it to the mayor and have him O.K. it."[163] A year later, the city enacted prohibition laws, which closed down over 120 saloons, liquor houses, and wholesalers.

The riot resulted in the immediate segregation of the city, with black businessmen retreating into the outskirts of the central business district and establishing themselves on Auburn Avenue and in the Atlanta University area. Prior to 1906, Auburn Avenue had been a racially mixed area with only five black-owned businesses. One year after the riot, there were twenty-nine black-owned businesses on Auburn Avenue, including five eating places. Stricter Jim Crow laws quickly sprang up, forcing restaurants that had previously served both black and white patrons to only serve blacks. Ruby Baker recalled a decade after the riot that for African Americans, "eating downtown was out of the question. You had to either come back to Mitchell Street or go to Decatur Street or Auburn Avenue."[164]

It was an appalling blow to the leaders of Atlanta. Just five years before, a 1901 historian celebrated that the city had never had a race riot: "The white man and the negro have lived together in this city more peacefully and in a better spirit than in any other city, in either the north or the south."[165]

Atlanta, the city heralded as the model of the New South *and* the model for African American achievement, was irrevocably tainted by the 1906 race riot. W.E.B. DuBois established the National Association for the Advancement of Colored People (NAACP) in response to the riot and other riots across the country, and the city's white leadership promised to take a more measured approach in future instances of racial unrest.

The Atlanta race riot resonated in the city's food, too, with white men and women romanticizing the times when there were "good black folks," resulting in a renewed desire for old-fashioned plantation fare. The menus at high-end restaurants pre-riot and post-riot are startling in their dissimilarity: Pre-riot, the Piedmont House offered an elaborate menu featuring items like terrapine á la modern, lobster en caisse, filet de bouef pique and roast green goose with chestnut dressing, recipes that would have fit in well in any high-end restaurant in England. Post-riot, the same hotel offered a menu with oyster cocktail, salted nut meats, filet of mackerel au vin blanc and baked macaroni. The baked macaroni dish was, in particular, a throwback, a recipe brought by Thomas Jefferson from France and served frequently at his Monticello plantation. It became one of the favorite dishes of slaveholders and eventually evolved into the modern macaroni and cheese. At the same time, nationally, menus began to *sound* less elite because New York began translating foreign language menus into English to support the new class of wealthy who did not speak multiple languages, and the rest of the country soon followed.

At home, too, housewives wanted their cooks to prepare the suddenly fashionable plantation fare. To fulfill this "crying need," in 1911, African American entrepreneur Samuel F. Harris started the "Black Mammy Memorial Institute," an Athens, Georgia school that trained "plain, everyday workers for the house and field" because he claimed the "greatest mistake" in educating black people had been training them as "teachers and leaders."[166] Harris wished to distinguish himself from the elite institutions like Atlanta University and Tuskegee Institute, believing that the future of the race depended on bringing back the "good black mammy" whose "loyalty and famous cookery" had come across through the ages.

But the most jarring example of antebellum fervor was the 'possum dinner planned for President-elect William Taft in January 1909. The menu, created by Charles Merritt, the caterer at the Piedmont Hotel, and requested

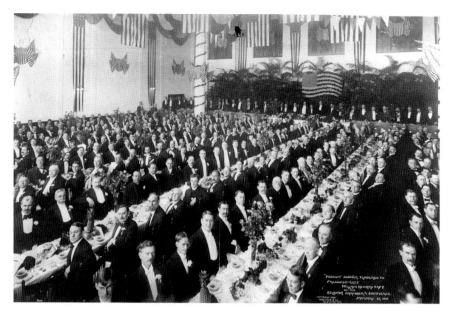

'Possum dinner for President-elect William Howard Taft at the Atlanta Chamber of Congress. *Drucker & Co., New York, Library of Congress Prints and Photographs Division.*

by Taft, became the talk of the country, especially after the chamber of commerce asked for one hundred 'possums for the dinner, leading one journalist to wryly remark that, "such questions as the tariff, the trusts and woman's suffrage have taken a back seat, while the people have risen up to talk about 'possums."[167] Recipes and dead marsupials arrived at the Atlanta Chamber of Commerce's offices, as 'possum hunters from around the state sought the honor of having their meat served to the president-elect.

At last, Taft sat in the grand banquet hall of the Piedmont Hotel, with a leather and gold-embossed menu set before him. The prominent white men of the city entertained by singing antebellum slave songs and sermons, including one song that a judge's "old 'mammy' used to sing him to sleep" because they wanted to give Taft an insight into "what the south was before the war."[168] Taft ate broiled Georgia shad Chattahoochee style, spiced Georgia watermelon and native radishes, and as the grand finale, an eighteen-pound barbecued 'possum 'n' 'taters was brought in ceremonial fashion on the shoulder of the head waiter. A New York paper wrote that the cooks, all "old plantation darkies," prepared the main dish well and Taft "went after his 'possum as if he liked it," eating it so quickly that a nearby doctor advised him to slow down.[169]

WHILE TAFT GORGED ON 'possum 'n' 'taters, a few miles away, A.J. Fincher, a twenty-five-year-old African American farmer, suffered at Grady Hospital from grotesque skin lesions, sores in the mouth, inflamed skin, diarrhea, slowly advancing toxemia and dementia. He had the dreaded pellagra and died within weeks. Fincher was the fourth case of pellagra in just three months.

Two months before, two otherwise healthy white women, thirty-seven-year-old Emma Fain and thirty-four-year-old Sallie Smith, turned up at Grady Hospital with the city's first pellagra cases. The newspapers published their deaths with this frightening headline, "ATE CORN BREAD; DEATH RESULTED. Two Cases of Most Peculiar Disease at Hospital. Physicians Are Puzzled." The disease was spreading across the South, with new reports coming in on an almost daily basis. And worst of all, in a city where hoecakes and grits were eaten at every meal, the doctors reported that eating moldy corn or cornmeal was thought to cause it. By April 1909, the surgeon general of the United States had confirmed that there was a pellagra outbreak, with almost two thousand cases of the disease appearing across the South in just four months.

Atlantans responded by abandoning their cherished cornmeal. Within a month after the surgeon general's report, flour prices had gone sky-high, jumping from $5.60 per barrel to $7.60 per barrel, leading one reporter to posit the insurmountable challenge facing Atlanta households, "[T]he consumer stands faced with the proposition of either running the risk of having pellagra or of paying an exorbitant price for flour if he eats any bread at all."[170]

Though pellagra was more common among the poor, the disease killed people from all socioeconomic strata and racial classes. It was an ugly awful disease with no cure and simply ruined lives: Mrs. J.H. Millwood, fifty years old and the mother of ten children, slit her throat with a razor because she believed she would never recover from pellagra, and her body was found lying in a pool of blood by her eight-year-old son. J.O. Williams, aged fifty-four years, a farmer and meat market manager, shot himself in the stomach with a rifle, saying his life was not worth living due to chronic pellagra. By the end of 1909, pellagra reached epidemic status, and between 1906 to 1916, more than 3 million southerners were affected, resulting in over 100,000 deaths.

In 1916, Atlanta hosted the tenth annual meeting of the Southern Medical Association, and the question on every doctor's mind was what to do about pellagra. The first to speak was Dr. Joseph Goldberger, the groundbreaking

epidemiologist appointed by the surgeon general, who decided that rather than focusing on the cornmeal, he should focus on the people suffering from the disease. In 1915, with the permission of the governor of Mississippi, Goldberger began a novel experiment at Rankin Prison Farm, ultimately finding that pellagra was not caused by germs or mold or bacteria or sand flies or the type of corn. He compared two groups of inmates: a control group that ate a traditional poor southern diet of strictly cornbread, molasses and pork fat, who soon developed pellagra, and an experimental group that ate a well-rounded diet of meat, fresh vegetables, milk and cornmeal and daily doses of brewer's yeast. Those who ate well-rounded diets never got pellagra even when infected with pellagra-tainted blood, and eating meat, dairy and fresh vegetables surprisingly reversed the symptoms of pellagra.

Goldberger never found out exactly what was lacking in the typical southern diet that resulted in pellagra, but the U.S. surgeon general began stressing the importance of eating balanced meals, urging families to increase milk, poultry and egg consumption. It would be a difficult shift: a journalist traveling through the South in 1905 reported that the poor needed cooking teachers because they lived on hog meat and potatoes, not knowing how to draw upon the "fullness of the earth." Likewise, a home economist in Mississippi commented that country families ate poorly because the mothers and fathers worked all day, leaving the young children to cook for the family without any knowledge or skill, resulting in the family being reared on "fried hoecakes and soggy biscuits, yellow with soda."[171]

In 1937, eight years after Goldberger died, scientists discovered that pellagra was due to niacin deficiency. It happened like this: the ingenious Muskogee Indians taught the colonists and slaves how to make hominy by rubbing corn with lye, a process that catalyzed the grain's niacin, resulting in a niacin-rich food. The slaves often did not have the time to make hominy, instead grinding simple dried corn kernels into grits, but the sweet corn planted by antebellum Southerners had relatively high levels of niacin due to the Georgia red clay and corn kernel shells. As the South transformed into the New South, landholders opted to plant lucrative cotton in southern fields and instead imported midwestern maize, which contained 30 to 50 percent less niacin than sweet Georgia corn. By 1907, midwestern mills had become extremely efficient at removing the shell from the kernel, grinding the meal, resulting in a de-germinated, niacin-deficient product. But while the processing of corn had changed, the diets had not; many Atlantans had continued to subsist largely on niacin-deficient cornmeal and pork, resulting in pellagra and their gruesome and untimely deaths.

The cure was a dietary change—more fresh green vegetables, dairy, eggs and meat and less corn. The cure would fundamentally change the way Atlanta ate. By the 1950s, pellagra had vanished, and the largest nutritional-based disease outbreak in U.S. history was almost forgotten.

A YEAR AFTER DR. Goldberger announced the cure for pellagra, the U.S. Senate voted to declare war against Germany and enter World War I. As in the Civil War, scarcity of food was a huge problem during World War I. A few weeks before the United States entered the war, the government organized the National War Garden Commission to encourage Americans to contribute to the war effort by planting "victory gardens" so that more food could be exported to the Allies. The government pushed the philosophy that "food will win the war!" In addition to the victory gardens, Presidents Woodrow Wilson and Herbert Hoover initiated a U.S. School Garden Army to mobilize children to enlist as "soldiers of the soil," distributed canning and drying manuals and produced pamphlets teaching amateur gardeners how, when and where to sow. In 1917, as a result of these combined efforts, 3 million new garden plots were planted, generating an estimated 1.45 million quarts of canned fruits and vegetables.

At the same time, Atlanta native and social reformer Nellie Peters Black was changing the way produce was grown in Georgia. As president of the Georgia Federation of Women's Clubs, Black realized that the "power of organized womanhood" could exert significant influence in agricultural reform. She organized a "Grow at Home" campaign, which complemented President Wilson's wartime call for victory gardens and the surgeon general's call to southerners to eat more well-balanced diets. The "Grow at Home" campaign used the organization and social function of women's clubs to encourage farmers to garden and women to can the produce they grew. Black challenged the women's clubs to compete against one another to see which club could pickle and can the most produce, and she met with numerous local farmers to encourage them to stop cotton production in favor of local produce.

Most importantly for Atlanta, in 1918, at the height of World War I, the Atlanta Woman's Club, headed by Mrs. Irving Thomas and Deryl H. Sharp, met with the city to discuss setting up a city-wide market that focused on Georgia produce and meats. The city allowed the Woman's

Club to set up an open-air farmers' market, the first of its kind since Reconstruction. The forward-thinking Woman's Club hired a market expert to come and review the produce to be sold at the market, and he discovered what Nellie Peters Black already knew: most Georgia farmers were master cotton growers and did not know how to grow vegetables. The expert recommended setting up a curb market with agricultural seminars to educate farmers to raise more produce.

The curb market was an instant success and praised by both the housewives and the farmers. In the next few years, the Atlanta Woman's Club raised $300,000 to build a permanent fireproof structure, and the city purchased the land and hired noted architect A. Ten Eyck Brown to design the building. In 1924, the Municipal Market at Edgewood Avenue and Bell Street opened in the exact center of Greater Atlanta. The market served as an outlet for products grown by local truck farmers who wanted to sell their produce with minimal overhead charges, and it quickly became the largest single retail center for farm products in the state.

The new market was immediately lauded as a "signal municipal improvement" and a "credit and benefit to all Atlanta," and within months, the newspapers praised the market for its beautiful fruits and vegetables, selling at significantly lower prices than at other locations in the city. In addition to the farm products, a meat seller butchered hogs in the basement, another vendor baked goods and a large restaurant with a soda fountain and a quick lunch stand anchored the back of the market. By 1927, the market was clearing $1 million with 147 farmers' stalls.

African Americans were not allowed to sell their goods inside the segregated market, but they set up a busy colorful curb market on Edgewood Street, often competing with the interior vendors on price and quality. The exterior curb market became as popular as the interior Municipal Market, and soon both markets came to be known unofficially as the "Sweet Auburn Curb Market," a term that has stuck through the ages.

As the 1920s began, for the first time in its history, Atlantans of all races and socioeconomic status had the equal opportunity to purchase food for reasonable prices. And that led to a whole new revolution: the rise of convenience foods and restaurants.

'POSSUM

Opossum, uniformly described as *'possum* when eaten, may seem like a joke today, but for centuries, 'possum was Georgia's most popular meat. Willis Cofer, a former slave, said his mouth watered just thinking of 'possum "baked wid plenty of butter and 'tatoes and sprinkled over wid red pepper." Rachel Adams's mother scalded them, rubbed them in hot ash and cleaned them until they were "pretty and white." Susan Castle remembered that her father used to catch so many opossums that he would put them in a box live, fatten them up and roast them when the family was hungry.

'Possum hunting was a treat for wealthy families as well. Young boys would go with old slave hands to catch 'possums, returning with the animal tied on a hickory stick, with the meat roasted and prepared for a feast in the morning. Catching a 'possum for dinner is no easy feat. Around 9:00 or 10:00 p.m. in the middle of winter, when it is full dark, a hunting party assembles and has a 'possum dog "tree" the game, barking when it catches scent of the nocturnal marsupial. The most experienced hunter shines a torch, until the group sees the 'possum's eyes reflecting from the branches. The group will then cut the tree down, or if it is a small tree, a man will climb to get the 'possum. The dogs will catch the 'possums, normally live, and the hunters will place the animal in a bag or tie it on a stick and carry it home. The 'possum would be served with roasted sweet potatoes, known as 'possum 'n' 'taters, and served with nonalcoholic persimmon beer, as opossums frequently lived on persimmon trees.

The 'possum itself has been described as a superior meat because, when roasted, it gives off a fatty, meaty taste, akin to roasted turkey, though when cleaned and cooked, it resembles nothing more than an enormous brown rat sitting on a tray. For those who could get past the sight of the meat, the taste met all epicurean standards. An 1883 article described the dish as such: "The appetite that would not bow down before a crisply barbecued 'possum, surrounded by halves of golden yellow yams that have absorbed the essence of the richly flavored meat—the appetite that would not bow down before such a dish as this is cold, and proud, and unreasoning."[172] Perhaps because it was initially a food eaten by the poorer class, Mrs. A.P. Hill did not include a recipe for 'possum in her 1876 cookbook, nor did the 1895 Tested Recipe Cook Book.

Postwar, 'possum 'n' 'taters came to be the preferred food for attorneys and politicians, and 'possum suppers were frequently given for the bench and bar, as well as eaten at Thanksgiving and Christmas. By 1874, one Atlanta

wholesaler was doing brisk business in the 'possum trade, selling nearly sixty live opossums every day for between fifty cents to a dollar to the restaurants and grocers in the city, and the daily produce market sold opossums and squirrels alongside turkeys and chickens.[173]

So, when President-elect Taft asked for 'possums in 1909, it was not an unusual request for Georgia diners, but it was not something that anybody would have expected at a high-end gourmet dinner fit for a president. After the dinner ended, a delegation presented Taft with a small plush opossum, which they said was destined to replace Teddy Roosevelt's teddy bear. The Georgia Billy Possum Company churned out thousands of stuffed toy opossums in the first year before folding, and composer J.B. Cohen and lyricist G.A. Scofield wrote a ragtime tune called "Possum: The Latest Craze," and the last verse mentions that famous dinner:

> *Ole Teddy Bar's a dead one now*
> *Sence Bill Possum's come to town.*
> *An'it taint no use to make excuse*
> *Or raise a fuus an' frown*
>
> *Jes get in touch wit'de President*
> *Eat possum when you dine.*
> *Den ask a Job of de Government*
> *An' you'll cert'ly be in line.*[174]

Since 'possum had made the national stage as a gourmet dish, Atlanta cookbooks all included recipes for it. The *Atlanta Woman's Club Cook Book* (1921) provided this one:

Roast Opossum and Sweet Potatoes

1 Opossum
Salt
1 dozen sweet potatoes
Black pepper

Dress and place opossum (whole) in large pan with one and one-half gallons cold water; boil until tender. Drain and place in covered roaster—Surround with sweet potatoes (which have previously been

peeled and boiled). Season with salt and pepper to taste. Put roaster in oven until both potatoes and possum are crisp and brown.

Soon, states around the country tested Taft's tastebuds with 'possum at nearly every meal, and Louisiana tried to get Taft to eat alligator, leading the *New York Times* to publish an admonishing editorial, "It is no part of the president's duty to eat strange foods merely to satisfy neighborhood pride. We earnestly beg Mr. Taft to stop with the 'possum."[175] Franklin Delano Roosevelt, another president with close associations to Georgia, continued Taft's fondness for the meat and ate and served 'possums, even going on numerous 'possum hunts near his home in Warm Springs, Georgia.

But Herbert Hoover put a stop to the edible 'possum on the White House table by adopting a wild opossum wandering through the White House lawns as an official pet and naming it Billy Possum. By the late 1950s, due to restrictions on supplying wild game to restaurants, 'possum had declined as a common food, though it is still occasionally eaten in rural Georgia today.

WHAT'LL YA HAVE?

THE RISE OF ATLANTA RESTAURANTS: 1925 TO 1950

In 1920, Atlanta's population climbed to 200,000 people, doubling the size from the turn of the century. Yet, though many things had changed—the advent of the Automobile Age, the national Prohibition laws taking effect, the spread of suburban neighborhoods, the building of major factories and Coca-Cola's massive international growth—some things had not changed at all in Atlanta. One of those was that, as had been the case since the antebellum period, black women still did most of the cooking. In 1930, over 21,000 black women, or 90 percent of all black women employed in the city, worked as domestic workers of some kind.

Alice Adams, a maid and cook for a Druid Hills family for forty years, remembered, "I would go in, fix breakfast, fix the midday dinner for the children, cook, at six o'clock serve dinner, wash the dishes....Next morning, back in the same routine....The family was very nice, but I'll tell you what it was—long hours and little pay."[176] Adams's employment was only a short step up from indentured labor: she received four dollars per week and worked twelve hours per day for six and a half days per week, with only half a day off on Sunday, up until the 1940s. When Adams told her employers that she wanted full days off on Thursdays and Sundays, the female employer said, "No, I can't do it because I never had to cook, I've never had to wash dishes, and I'm not going to do it."[177] Adams threatened to quit, and the family relented.

The low wages meant that in the early 1900s even white families of modest means hired a cook. Journalist Ray Stannard Baker found it particularly

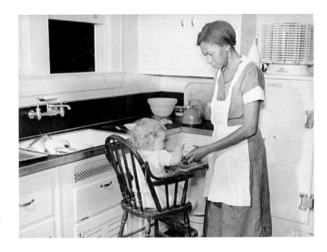

African American domestic servant in 1930s Atlanta. *Marion Post Wolcott, 1939, Library of Congress.*

strange that, when he visited a mill village in Atlanta to see how the poorer people lived, he found that they hired a black woman to cook and "while they sent their children to the mill to work, the cook sent her children to school!"[178]

But then, the Great Depression hit the nation. Locals competed fiercely for existing jobs, while migrants from the countryside arrived from their struggling farms. Men and women begged the police to arrest them so they could get a night's rest and a hot meal. It was common to see children scrabbling in garbage cans for food. The city used the municipal auditorium as a soup kitchen, and attorney Mildred Kingloff remembered that the soup was thick, very nourishing, with potatoes, large chunks of meat, onions, celery and carrots: "[T]hey would give you your dinner in a tin bucket. You'd bring your own tin bucket…and they'd fill that up and give you a half a loaf of what was a nickel loaf of bread. And I have literally seen lawyers in that line, in the soup line. And when I recognized the person, I would—this occurred maybe two or three times—I would deliberately shield my face so that he would not know that I had seen."[179]

The Great Depression affected domestic workers particularly hard, as employers cut wages or dispensed with household help altogether. In Atlanta, between 1930 and 1940, as domestic jobs declined, black women's employment in manufacturing jobs doubled. The black factory workers lived on Auburn Avenue and Decatur Street, while the white workers clustered in Cabbagetown, the mill village built by the Fulton Bag and Cotton Mill bordering Oakland Cemetery.

As Roosevelt's New Deal helped bring the South out of its economic doldrums and black women now worked more in factories than in the

home, Atlanta housewives realized a startling fact: cooking had shifted from one of the most labor-intensive and unpleasant household tasks to one of the easier jobs. Commercial food processing meant that women no longer needed to butcher and clean raw chicken or pull dirty carrots from their gardens. And the growth of convenience foods meant that factory workers did a lot of the prep work in putting meals together.

WHEN HERMAN LAY ARRIVED in Atlanta in the 1920s, he didn't think much of convenience foods. Lay was a natural salesman, opening his first business at age ten, peddling Pepsi-Cola bottles from a stand in his front yard in Greenville, South Carolina. After stints at college and as a jewelry salesman, Lay got a job selling peanut butter and peanut butter crackers for Sunshine Biscuit in Atlanta on Mitchell Street. Then he lost his job due to the Great Depression. Ever persistent, Lay placed classified ads and wrote two hundred letters to prospective employers. He got one positive response: from Barrett Potato Chip Co. in Atlanta.

Prepackaged potato chips were, in the late 1920s, considered to be a novelty food, not something that people would eat on a regular basis. Invented by a black cook named George Crum in the 1850s in Saratoga Springs to satisfy a curmudgeonly customer, Crum had not been allowed to patent his "Saratoga Chips" due to his race. Restaurants occasionally served freshly prepared Saratoga chips, and in the next half century, some northern families began manufacturing potato chips in small batches, selling them at carnivals or fairs. In 1926, a Californian entrepreneur revolutionized the industry by packaging the potato chips in wax paper bags to keep them from getting stale, so the mass-market potato chip industry had just gotten underway when Barrett offered Herman Lay a job.

Herman Lay with Lay's Potato Chips. *Furman University.*

Lay was not impressed by Barrett or the business model. He initially turned the job down, but a week later, when he still could not find work, he started selling Barrett's potato chips out of the back of his Ford Model A at

"road stands, grocery stores, filling stations, soda shops, and anywhere else customers might buy chips, including schools and hospitals." Lay became Barrett's most successful salesman, and when Barrett passed away, Lay raised $60,000 to buy the company.

Lay renamed the company H.W. Lay & Co. Inc., with the headquarters on Boulevard in Atlanta, and renamed the product Lay's Potato Chips, expanding rapidly in new markets and building new plants in Atlanta and across the Southeast. He utilized clever marketing—coining the catchphrase "Can't Stop Eating"—used a red and blue bag and touted a potato mascot named Oscar to differentiate his product from others. In a city where white housewives were cooking the majority of the meals for the first time, Lay's Potato Chips became an easy and cheap snack or complement to sandwiches, barbecues and picnics.

Within two years, Lay's business was so successful that he almost sold it. "I just felt it was too good to be true," Lay said years later. "I couldn't see how people could eat more snacks tha[n] they were already eating."[180] Lay's Potato Chips became the first national potato chip brand, elevating the convenience food to a multimillion-dollar industry within a few years. Given that Lay's was produced and invented in Atlanta, it should be no surprise that when the company began offering flavored chips in 1958, the first flavor was Georgia's favorite meal—barbecue-flavored potato chips.

In 1961, Lay's closed its Atlanta headquarters when the company merged with the Frito company to form the Frito-Lay corporation. But one hundred years after Herman Lay started his company in the Old Fourth Ward neighborhood, his product still dominates the market; in 2017, Herman Lay's original Lay's Potato Chip accounted for 30 percent market share of the $22 billion domestic potato chip industry.

Convenience foods were not the only invention that helped the early twentieth-century housewife. Marvelous technological innovations had occurred in the kitchen, resulting in clean-burning, quick-starting gas stoves, a huge improvement over the smoky, temperamental wood-burning stoves. But the Atlanta Gas Light Company needed a way to advertise these gas stoves to Atlanta housewives, to show families that these stoves were safe, efficient and worth the expense. Mrs. S.R. Dull was the answer.

Henrietta Celestia Stanley was born in the midst of the Civil War in Laurens County, Georgia, on her family's plantation. As a child, she loved watching the black cooks making food and soon learned how to imitate their work, making recipes from memory. At age six, she bribed the family cook into allowing her to make her first corn pone on an open hearth.

When she turned thirty, Henrietta Dull's husband suffered a nervous breakdown, leaving her to manage the household and her six children. Dull found salvation in cooking. She wrote, "Suddenly I found I had to be the breadwinner. I knew how to make good things to eat and have them made. I mastered a gas range. I made it work for me and talk for me."[181] She first made and sold baked goods from her home kitchen for the ladies of her church. Her exceptional cooking led her to establish a full-time catering business, planning parties and events for the wealthiest people in the city. For daytime parties, she made gallons of chicken salad, cheese straws and beaten biscuits or, at an evening event, creamed chicken, oysters and delicately browned timbales, and the family home was always popular on cake baking days, when the neighborhood children would crowd around to get licks of Dull's icing.

Mrs. S.R. Dull was the perfect answer to Atlanta Gas Light's problem of how to entice women to use their stoves. She was a successful, poised, well-connected woman with a wry sense of humor *and* she cooked exceedingly well. As cast-iron stove companies had hired Mrs. A.P. Hill to advertise for them in the 1880s, Atlanta Gas Light hired Mrs. Dull in 1910 to travel around the state to demonstrate the new gas stoves. "A cookstove is like a new husband," Dull told young ladies. "You have to live with it and learn to get the best out of it."[182] Her lectures and demonstrations were so well attended that she frequently sold out giant auditoriums, leading her to become one of the most highly sought spokespersons in the South, not only for the gas company but also for other southern-based products like White Lily Flour.

In 1920, the *Atlanta Journal* named Henrietta Dull editor of the home economics page of its new Sunday magazine. At first, she was a timid writer, unsure of how to translate her knowledge in cookery onto the page, so she took the assistance of a rising young journalist named Peggy Mitchell, later known as Margaret Mitchell, the author of *Gone with the Wind*. Dull's frank and brisk weekly columns, titled Mrs. Dull's Cooking Lessons, graced the pages of the *Atlanta Journal* until she was eighty-four years old and are still a delight to read: "Why don't women like to cook? There are many reasons and good ones, too, with which to answer this question, and the best one I know is that: First, they don't know the first thing about cooking."

In 1928, Dull published her compendium of recipes, a four-hundred-page tome simply titled *Southern Cooking* that became *the* last word on southern cooking. She began the book with a sentence that upended everything Atlantans had previously thought about the kitchen as an ill-fitted place relegated to slaves and servants: "The woman is the heart of the home, and the kitchen is the heart of the house."[183] Cooking up to the very end, Henrietta Dull passed away at the age of one hundred in 1965, but her food and recipes continue to influence modern Atlanta restaurateurs and home cooks.

DESPITE THE NEW CONVENIENCES, cooking still took up a great deal of time since most people ate all their meals at home. Women wanted a break from cooking every night, so quick-service restaurants began to cater to feminine demands for better cleanliness and food options. At the same time, recognizing that there was an increasing segment of female workers, diners and cafés began allowing unaccompanied women to enter previously male-only domains, reserving specific tables as "Tables for Ladies Only."

The Greek population of Atlanta played a significant role in the early rise of those restaurants. Though a small immigrant population numbering around five hundred, the Greek residents had made their mark in Atlanta as fruit vendors in the early 1900s. When the city council permanently shut down fruit stands, the Greek citizenry cleverly transferred the majority of their savings into food businesses. A year later, over a third of Atlanta's Greek population owned a food-related business, such as confectioneries, saloons, ladies' dining rooms, soda fountains and restaurants. The *Constitution* remarked, "No small part of the credit for the remarkable growth of Atlanta during the past two decades is due to the Greeks.…There were few restaurants in Atlanta before the advent of the Greek. It was considered a luxury by one to dine or sup in a restaurant, as the prices were high, the service bad and the waiter insolent."[184]

The numbers reveal the sudden acceptance of restaurants, diners and lunchrooms: in 1901, the city had 18 eating places; in 1920, there were 372 eating places; and in 1930, there were 737 eating places. In 1901, eating places could be classified as either fine-dining establishments like Durand's Restaurant or hasheries that served cheap fare like those on Decatur Street. By the 1920s, there were many more types of eating places: sandwich

shops and lunch counters served sandwiches to daytime workers, meat-and-three establishments served hot lunches at inexpensive prices, women entrepreneurs helmed tearooms and cafeterias with buffets that straddled the line between the lunchroom and the fine-dining restaurant.

A BRIEF PERUSAL THROUGH newspapers from the 1920s to the 1950s reveals hundreds of restaurants that have come and gone. Davis' Fine Foods was a longtime favorite with its huge cafeteria, as was Ship-A-Hoy, which was an elaborate nautical-themed restaurant. Those—like many others—did not last, but there are a few exceptional restaurants that have remained a part of Atlanta's culinary fabric and have become iconic southern eateries. Of these, the Varsity is the oldest.

Frank Gordy grew up in Thomaston, in Middle Georgia, and enrolled at Georgia Tech to please his mother. But, like Herman Lay, Gordy didn't enjoy college. He dropped out after one semester and headed down to Florida, where he first encountered drive-in restaurants. When he returned to Atlanta, he remembered how hard it was to find an inexpensive meal near the Georgia Tech campus, unsurprising considering the lack of restaurants in the city at the time. He started selling hot dogs out of a twelve-by-seven-foot shack near his uncle's garage, calling his hot dog stand the Yellow Jacket, after Tech's mascot. With $1,860 in profits, Gordy leased a house up North Avenue in 1928 and named his new restaurant the Varsity.

Gordy's Varsity hot dogs, hamburgers and onion rings were a treat for families who rarely went out to eat, and not a single thing on the menu cost more than $0.10. The restaurant was an immediate success. On his first day in business, the Varsity had almost three hundred guests and posted $47.30 in sales. By the 1940s, Gordy employed two hundred carhops and had to erect a tower to direct traffic. He was a fixture in every part of the business, from developing the recipes, to tasting them, to managing the crowds. He ate chili dogs almost every day, ensuring that the quality of his food remained consistent. Gordy, too, was clever in staying with trends; in 1949, the Varsity opened television rooms, allowing guests to come in and comfortably eat and watch television at a time when few homes had their own television set.

The Varsity created its own lingo: customers parked in the massive lot in their Fords, and a carhop came and asked, "What'll Ya Have?" and they might order a Naked Walking Dog (a plain hot dog on a bun) or a Glorified

Steak (a hamburger with mayo, lettuce and tomato). To drink, they would order a Varsity Orange (a slushy frozen orange drink), and if they were lucky, maybe John Wesley Raiford, better known as "Flossie Mae," would come out and sing the entire menu. By 1950, the Varsity had claimed the title of the "World's Largest Drive-In," and Atlanta's high schools rang with the tones of teenage boys asking girls to "meet me at the Varsity."

Frank Gordy passed away in 1983, and the Varsity on North Avenue closed for the first time in fifty-five years on the day of his funeral. The restaurant lives on with multiple locations across Atlanta.

Joe Rogers Sr. said the best meal he ever had was a plate of turnip greens, fatback and cornbread served to him by an elderly black couple in a rural Tennessee shack on a frigid winter day during World War II. In 1955, Rogers tried to model that feeling in a new restaurant concept, "to make people feel better because they ate with us."[185] He teamed up with neighbor Tom Forkner in the Avondale Estates neighborhood to build a restaurant that combined fast-food speed and round-the-clock service with the warmth of a seated diner.

The neighbors built a tiny $14,000 "shoebox"-style building at the edge of Avondale Estates and Decatur, with thirteen stools and a jukebox, in September 1955. They "didn't want it to look expensive because we wanted it to look like you could come right in and be comfortable."[186] Realizing that the Varsity and other hamburger joints were doing takeout, they wanted a menu that would be largely sit-down. "[W]e knew you couldn't take out a waffle or it'd become flimsy." Hence, Waffle House was born.

The first menu included a pecan waffle for fifty cents and a cheese omelet for sixty-five cents, and in the back of the Avondale Estates restaurant, the commissary held sacks of potatoes, Dixie Crystals sugar and White Lily flour. Rogers explained, "We made everything ourselves in the beginning, even mayonnaise."[187] The restaurant had a slow start but, within a decade, was doing well with multiple outposts across the city, leveraging its inexpensive meals with locations across southern highways as people searched for a good meal while driving. Like those at the Varsity, Waffle House customers adopted their own language, and longtime southerners have their favorite Waffle House order like hash browns "scattered, smothered, and chunked" (hash browns scattered, smothered with cheese and chunked with ham).

Unlike many other fast-food institutions, Waffle House has stuck by its southern roots, continuing to serve grits, eggs and country-fried steak, and it is rare to drive in the South without seeing the glowing yellow Scrabble board sign lit up at all hours of the night, welcoming the weary driver. In 2004, 3.2 million pounds of grits were consumed each year at Waffle Houses, and 2 percent of all eggs produced in the United States were consumed at one of Waffle House's 1,500 restaurants. Atlanta still has the single largest number of Waffle Houses in the country, and the original Avondale Estates location is opened once a month as a museum.

The co-founders both passed away in 2017, within a few weeks of each other.

TRUETT CATHY GREW UP in the outskirts of the city, the son of a boardinghouse owner who learned how to cook by helping his mother as she served the family guests. He went to Atlanta's Boys High School (now Grady High School), and like any other teenage boy at the time, he used to take his girlfriend to the Varsity in his Ford Model T. "I always admired Mr. Gordy for the way he treated his customers and made sure everything was all right. Watching that place may very well be what inspired me to get into the restaurant business."[188]

At age twenty-five, Cathy opened up a restaurant with his brother called the Dwarf Grill in Hapeville, Georgia, but was frustrated because his chicken sandwiches were expensive to produce and took longer to prepare than cheaper offerings like hamburgers and fries. After negotiating with new suppliers, Cathy began selling a sandwich with a boneless chicken breast, fried quickly in pure peanut oil and seasoned with over twenty spices, slapped on a bun with a pickle, so that customers from the nearby Ford assembly plant and Delta Air Lines headquarters could buy one, eat it quickly and go back to work. He called his sandwich the Chick-fil-A and licensed the sandwich to over fifty restaurants, including Waffle House, but later decided to open individual Chick-fil-A restaurants, the first at Greenbriar Mall in Atlanta. Cathy's sandwich soon became Atlanta's favorite sandwich.

Cathy was unique in his operation of Chick-fil-A, guiding the company using Christian principles, which occasionally resulted in significant controversy. In 2014, Truett Cathy passed away at age ninety-three, with his son Dan Cathy taking on the role of president. Chick-fil-A has continued to

grow, becoming one of the country's most influential fast-food companies, and, in 2018, had approximately two thousand locations and was worth an estimated $8 billion, though still entirely owned by the Cathy family.

WHILE MEN CREATED EVERY type of eating establishment in Atlanta from high-end restaurants to cheap hot dog shops in the 1930s to 1950s, female entrepreneurs were more restricted. Banks would not lend women money, and an unmarried woman could not get a credit card or credit account until the late 1970s—plus, female entrepreneurs in male-dominated spheres were generally shunned and criticized. Selling meals or taking in boarders was the only respectable means of making a living for widows, so tearooms sprang up across the country. Contrary to their name, tearooms did not necessary revolve around the beverage or the repast of afternoon tea. Tearooms were often small restaurants, serving mainly lunch, owned by women with generally female employees and serving a largely, though not exclusively, female clientele.

In 1951, Mary McKinsey, a redheaded war widow with lots of personality, purchased a tearoom on Ponce de Leon Avenue from a Mrs. Fuller, renaming it "Mary Mac's Tea Room," a name that has stayed through the ages. When McKinsey got married and decided to leave Atlanta, she sold her business to her friend Margaret Lupo, who relied on loans from female family members to pay the purchase price since no bank would give an unmarried woman a loan. Though Lupo was not the original founder, she was the one who turned Mary Mac's into an Atlanta institution. Lupo expanded Mary Mac's from one room and 75 seats to five rooms and 375 seats. Lupo was always at the front counter, a "gentle, sweet lady who tasted everything before it went out of the kitchen."[189]

Eating at Mary Mac's was an experience: guests sat at white-clothed tables with tiny yellow pencils and filled out the printed order form, choosing options such as fried chicken, vegetables and squash soufflé. Everyone wanted Mary Mac's bottomless pitcher of sweet tea, described on the menu as "the table wine of the South," and while waiting for food, guests looked at pictures of the many VIPs who visited the restaurant, from Jessica Tandy to Bill Clinton. Known by her employees as "Mother," Lupo addressed every guest by the universal name "Darlin'" and used many old recipes from her mother and grandmother at the restaurant. The signature dish at

Mary Mac's was and continues to be its pot likker, the southern soup made from boiled greens, a dish that Lupo explained "is very hard to get seasoned right."[190] The restaurant focused on fresh food, not canned, and, in 1979, one employee did nothing but wash, tear and cook turnip greens.

Margaret Lupo passed away in 1998, and Mary Mac's Tea Room endures under the direction of John Ferrell, hand-picked by Lupo to continue Mary Mac's traditions.

BESIDES BEING OPENED AT the rise of the restaurant age, Mary Mac's, Waffle House, Chick-fil-A and the Varsity all had one other thing in common: in the next twenty years, they were among the city's first restaurants to serve both black and white patrons, a response to a movement headquartered in Atlanta that changed the nation.

COLLARD GREENS AND OTHER BITTER GREENS

Margaret Lupo of Mary Mac's has been hailed as Georgia's "Queen of Greens," a true honor in a state that cherishes its collards. For 150 years, Georgia and Atlanta have owned collard greens like no other vegetable. They are an easy vegetable to plant and grow like weeds in the Georgia climate. The statistics are astounding: in 1924, Georgia produced 90 percent of the collard seed shipped across the world; when the Centennial Olympics came to the city, Atlanta was one of the top three markets for greens in the country; and in 2012, Georgia was the second-largest producer of collard greens, with thirteen thousand acres of greens spread across the state.

Yet if you ask any Atlanta kid, they'll tell you that collards are a love 'em or hate 'em vegetable, the Georgia equivalent of brussels sprouts and broccoli—and it appears that this has been the fight for almost 150 years. In 1883, an Atlanta journalist praised the collard as a "delicacy that is no rarity, a luxury that is likewise a substantial."[191] A year later, the same newspaper flipped its opinion on the green, publishing sarcastically that it was a shame the frost hit the collard crop because "[h]ow can we entertain our city cousins and keep up their dyspepia and visits long apart without

this succulent shrubbery?"[192] Forty years later, the same newspaper called the collard a "degenerate cabbage," while a 1926 article disputed this claim, stating that the "south's great green vegetable is the collard."[193] It's an argument for the ages.

Interestingly, many of Atlanta's cookbooks don't specifically mention collard greens, even though they are Georgia's most popular greens. Most of the early cookbooks generally referred to "greens," and it is not clear if this is because it was assumed that the greens would be collards, if the author expected all greens to be cooked in the same way or if greens were considered too simple of a dish to be put in a cookbook. There was also certainly a class and race element involved; collards were the greens associated with slaves and poor whites, while spinach was preferred by the wealthy, and even as late as the 1970s, spinach was difficult to find in Atlanta.

Mrs. A.P. Hill (1886) assumed that cooks would pick greens from their own gardens and referred to collards using the old fashioned term "cole." Cooking them with ham hock was not necessary, either, though she believed a poached egg was:

> **Greens.**—Kale, or cole, mustard, cabbage sprouts, turnip tops, to any of which may be added a few beet tops, the youth shoots of the poke plant, all make good spring greens. Pick and wash them; let them lie in cold water at least an hour before they are used. Put them on in plenty of boiling water salted; boil briskly twenty minutes; they will sink to the bottom when done. Take them up in a colander; press the water from them; put upon a hot dish; cut across the leaves in several places with a sharp knife; pour over melted butter; dress with poached eggs, either placed upon the dish of greens or served in a separate dish. They are not good unless served hot. Some persons prefer greens boiled with a piece of bacon or hock bone of ham. No matter in what way they are cooked, poached eggs should accompany them.[194]

The *Dixie Cook-Book* (1883) devotes numerous pages to beet greens and cabbages but does not mention collard greens even once, and neither do any of the other cookbooks in that era. The *Atlanta Woman's Club Cook Book* (1921) does not specifically mention collard greens but generally suggests cooking greens with salt pork.

Mrs. S.R. Dull's *Southern Cooking* (1928) compendium, which became the mainstay for generations of Atlanta cooks, was the first Atlanta cookbook

to include three recipes for all of the parts of the collards. Unlike Mrs. Hill, who thought that ham hock was only a potential accompaniment, Mrs. Dull necessitated the use of ham hock:

> **Collards.** The blue and white stem collards are strictly a southern vegetable, and not good until the frost and cold have made them brittle and tender. The leaf is dark green with a large, thick stem running through the center about half the length of leaf. Collards are boiled with seasoning meat or ham hock about 2 hours. They must be boiled slowly, and kept well under water.
>
> **Collard Sprouts.** After the collard has been cut and used the stalk if left standing will in the spring send out very tender sprouts. These sprouts are cooked the same as collards, not requiring as long cooking or as much water.
>
> **Collard Stalks.** Strip off the leafy part and cut stalks in 1 inch pieces. Boil until tender in salt water. Drain and serve with melted butter or white sauce.[195]

In addition to the vegetable, pot likker, the seasoned broth remaining after the greens are cooked, is usually set aside and brought to the table in a bowl, to be served as a nutritious and flavorful soup with cornbread or hoecake. Mary Mac's Tea Room continues that long-held tradition, and guests can go there and purchase a bowl of pot likker and cornbread for a few dollars even today.

FOOD FOR THE SOUL

Civil Rights Movement: 1950s to 1970s

n 1935, a six-year-old boy walking through the streets of Downtown Atlanta saw masses of people standing in breadlines, humiliated and defeated as they waited to be served soup and nickel bread during the Great Depression. He later said that this early childhood experience spurred his "anticapitalistic feelings." That little boy was named Martin Luther King Jr.

King grew up in a large yellow-paneled house in the Sweet Auburn neighborhood, a few blocks away from the Municipal Market on Edgewood Avenue and near Ebenezer Baptist Church, where his father was the pastor. In the 1940s, Atlanta was strictly segregated; King remembered that he could not go to the lunch counter downtown to buy a hamburger or a cup of coffee. But, oh, he could eat on Auburn Avenue. Black-owned businesses boomed in Atlanta in the 1930s, and restaurants were the most common business type, with 222 black-owned restaurants across the city because they could be started up with limited capital. People came from all over the world to eat at Ma Sutton's, where they would have her decadent fried chicken, barbecue, ribs, light rolls, cornbread, coffee and homemade preserves. At night, the Yeah Man and the Top Hat entertained with jazz music and dancing, while Big Smittie's Grill, the Economy Delicatessen and Chop Suey served up delicious meals.

King ran around with his siblings and friends on Auburn Avenue and headed back home for his mother's delicious tea cakes baked fresh on Saturday morning or to grab the soft, fluffy biscuits prepared by his

grandmother Jennie. His mother's peach cobbler was unrivaled, and King said he searched his whole life to find anyone who could make cobbler like her. Soul food—the term coined in the mid-1900s by jazz musicians, black magazines and African American ministers to describe home cooking— was an important part of the King family life. Sunday dinners, in which the "gospel bird," fried chicken, was often served, was a way for the family to reconnect, communicate and discuss thoughts after Daddy King's sermons at Ebenezer.

After graduating from Morehouse College in 1948, King went to Crozer Seminary in Pennsylvania and then Boston University. There, he met a rising young singer at the New England Conservatory named Coretta Scott, who grew up in rural Alabama, the daughter of a middle-class farmer. Like King, her earliest memories of segregation were associated with food; she remembered how unfair it was that she had to get her ice cream cone out of the side door rather than walking inside the white-owned drugstore, how the drugstore owner would make her wait until he served all the white children and that no matter what flavor she requested, the man would give her whatever he had extra in stock at the same price the white children paid.

At King's and Coretta's first cafeteria lunch at Sharaf's Restaurant on Massachusetts Avenue, they talked about everything from music to literature and discussed the soul food they both loved and missed from back home in the South. A few months later, the pair had become serious, and one night, Coretta cooked King her banana pudding and King's favorite cabbage smothered in bacon, while Coretta's sister made Creole pork chops. King and his friend appreciatively ate all the food the ladies cooked, and he teased that Coretta met his requirements for a wife since she had passed his cooking "test."[196]

Soon, King asked Coretta to marry him, and after their wedding in Alabama, they returned to Boston to finish their final years at university. On Thursday nights, King did the cooking because Coretta had a late evening class. He was quite proud of his cooking ability and would make "highly seasoned, overcooked, and delicious" soul food—smothered cabbage, pork chops, fried chicken, pigs' feet, pigs' snout, pigs' ears, turnip greens with ham hock and cornbread from a mix.[197]

In 1954, the two returned to the South, basing themselves in Montgomery, Alabama, where King accepted his first job as pastor of Dexter Avenue Baptist Church at age twenty-five. While Coretta took care of their newborn girl, King assumed the leadership of the Montgomery Bus Boycott, begun

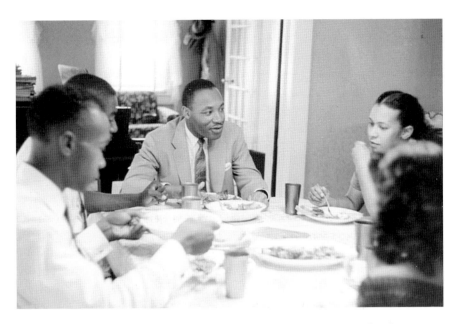

Martin Luther King Jr. having dinner in Montgomery. *Michael Ochs Archive/Getty Images.*

when Rosa Parks refused to sit at the back of a bus. It was over a "prophet's dinner" of steak and onions, turnip greens and cornbread that King made an important friend. Ralph David Abernathy was the pastor at the rival church to Dexter Avenue, and when King dropped a friend off at the Abernathys' house, Juanita Abernathy invited him to stay to eat. King said that though he had dinner waiting for him, "Lord, that food is smelling so good. Well, I believe I will join you, if you don't mind."[198]

Mrs. Abernathy was a first-rate cook, and King loved his meals and the conversation with the Abernathys as they planned how to continue the boycott and stave off the Ku Klux Klan (KKK) and the segregationist policies of the city. Ralph David Abernathy recalled:

> *I remember one night in Montgomery when she had served home-made ice cream and [King] was about to start on his second bowl. Suddenly he stopped with his spoon in midair. "Juanita," he said, "I believe we can solve this whole boycott problem if we carry a bowl of this ice cream over to [Governor] George Wallace. I think I'll take it over right now." He started to rise, then sank back in his chair. "No," he said. "He doesn't deserve it. I'm just going to sit here and eat it myself."[199]*

King's efforts paid off. When the City of Montgomery finally succumbed to the bus boycott, ordered by the Supreme Court to integrate the buses, Martin Luther King Jr. was a national hero and *Time* magazine published a full-page cover of him.

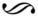

In 1958, while King was signing his first book, *Stride Toward Freedom*, in Harlem, a deranged woman stabbed King, nearly hitting his aorta. The doctor who operated on King famously stated that if King had sneezed, King would have died. King, convalescing in the hospital, received a phone call from his sister-in-law Naomi Ruth King in Atlanta, and she asked him, "What can I do for you?" And he said, half-jokingly, "Make me a sweet potato pie." Naomi took him at his word and quickly made one and gave it to Coretta as she left for the airport to be with King. Naomi recalled, "The pie was smoking hot, all packed up in a box." Later that afternoon, King called Naomi back, and she "heard him smack his lips. 'Girl,' he said, 'this pie is still hot. What am I going to do with you?'"[200] Naomi said she knew, then, that he was "stronger than any of us realized."

In February 1960, the King family moved back to Atlanta to work full-time on the civil rights movement, with Dr. King taking on the assistant pastor role at Ebenezer Baptist Church. Coretta wrote,

> *Sometimes you might drop into the pastor's study at Ebenezer, and there would be my husband gnawing at a pig's foot while the delighted parishioner who had brought him a jar of her specialty sat proudly watching his enjoyment. Dear Martin! He always complained that our cooking was too fattening, yet it was exactly what he loved, and with a plate of greens before him, he never could remember his diet.*[201]

Despite King being the most famous African American in the country, many of Atlanta's restaurants remained closed to him. Once, he struck up a conversation with a white passenger on an airplane and the passenger invited King to have lunch at the Atlanta airport. The two went into the restaurant, where the hostess looked at King and said, "I'll have to seat you at a separate table." She directed him to an area behind a curtain and said, "Everything is the same: the food, the table, and the chairs are the same." King responded, "Oh, no. It is not the same. When you segregate me, you

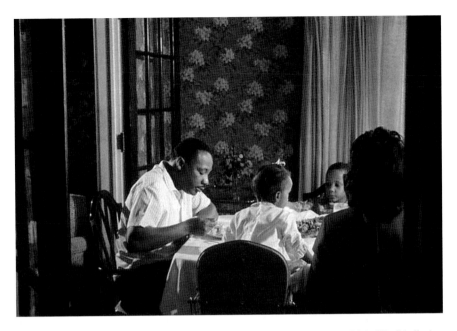

Dr. King having dinner with his family after church on November 8, 1964. *Flip Schulke/ Getty Images.*

deprive me of fellowship with my brother here, when I want to continue to talk to him....It is not at all the same."[202]

Fed up with Atlanta's segregated dining rooms and inspired by the student lunch counter sit-ins in Greensboro, three students at the Atlanta University Center met at Yates and Milton Drug Store in October 1960. Over milkshakes and sandwiches, the students drafted "An Appeal for Human Rights." It was published in all of the city's major newspapers, denouncing segregation and insisting that the students intended to use every legal and nonviolent means to obtain full citizenship rights. King explained that the lunch counters were the right place for the students to start protesting because, as Coretta had once been denied an ice cream at the drugstore, almost every African American had experienced the "tragic inconveniences" of the lunch counter that denied him service. "In a real sense the 'sit in' represented more than a demand for service; it represented a demand for respect."[203]

A few months after moving to Atlanta, King sat at his mother's house, dipping some cornbread into Mother King's slow-cooked turnip greens, when Lonnie King of the Atlanta Student Movement stopped by to ask King to join them at a sit-in at Rich's Department Store. King and the students sat down at Rich's popular lunch counter the next day, and the City of Atlanta

police came and arrested the protesters, belying the city's slogan that it was the "City Too Busy to Hate." But Mayor William Hartsfield, remembering the after-effects of the 1906 race riot, treated the prisoners well, providing African American guards, games, books and phone messages. The first prison meal—steak smothered in onions—made it clear that these prisoners would receive favorable treatment.

Hartsfield, meanwhile, began intensive negotiations toward the desegregation of all downtown stores. While King and the students sat in jail, thousands of black student protesters marched in front of Rich's Department Store, well coordinated using two-way radios and military-style formations. Shortly thereafter, the KKK in full regalia arrived to protest outside Rich's famous restaurant. Hartsfield announced in typical Atlanta booster fashion to the press, "Well, at least in the field of lunch counter demonstrations, Atlanta can claim two firsts. With the help of the Ku Klux Klan, it can be the first to claim integrated picketing. And now we have radio-directed picketing. At least we are handling our problems in a progressive way."[204]

A week later, news spread through Atlanta that Hartsfield ordered the unconditional release of students held in city jail and pledged to have King and the others out of the county jail by Monday morning; desegregation talks would begin on Monday. Coretta met with many others at Paschal's Restaurant to wait for the students and King to arrive.

But King was not released. Instead, the Dekalb County Sheriff's Office arrested King for violating probation due to not converting his Alabama driver's license to a Georgia driver's license. Unlike the City of Atlanta, neighboring Dekalb County was notoriously white supremacist: the Ku Klux Klan had established its headquarters at Dekalb County's Stone Mountain after the 1906 race riots and the infamous Leo Frank trial. The

Dr. King and Lonnie King being arrested at Rich's Department Store lunch counter sit-in. *AP photo.*

Dekalb judge found King guilty, sentencing him to four months' hard labor in Reidsville maximum security prison, where he was placed in handcuffs and chains with hardened criminals.

Democrat John F. Kennedy, awaiting the upcoming presidential election, intervened on King's behalf, a surprise since, at the time, most African Americans voted Republican because Abraham Lincoln had been a Republican. Kennedy's efforts resulted in King's release, and African American pastors like Daddy King stood on their pulpits that Sunday and announced their support for Kennedy. Most political scientists believe it was the black vote that decided that election. Kennedy becoming president was a turning point in the civil rights movement, and his presidency would not have happened without those lunch counters in Downtown Atlanta.

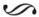

Atlanta's African American–owned restaurants played a critical role in the civil rights movement. The Southern Christian Leadership Conference (SCLC), Student Nonviolent Coordinating Committee (SNCC) and the civil rights movement, in general, were plagued with financial worries, and the movement relied on many wealthy donors. Atlanta's restaurant owners stepped up, recognizing that the movement needed meeting space and food for the countless workers and volunteers.

Benjamin Burdell Beamon's restaurant on Auburn Avenue served as the headquarters for SNCC as members wrote their bylaws and planned the lunch counter demonstrations. Beamon worked as a dishwasher in the Henry Grady Hotel during the Great Depression, eventually saving enough money to invest in the hotel and restaurant in the Herndon Building on Auburn Avenue and then became a promoter for some of the top African American entertainers in the city. Beamon allowed the students to camp out in the private dining room at B.B. Beamon's Café to organize their efforts, leading to the Rich's Department Store sit-in.

Across town, near the Atlanta University Center, SNCC leaders also frequently met at the elegant Frazier's Café Society—founded by Evelyn Jones Frazier and her husband, Luther, in 1946—with white tablecloths, glittering chandeliers and crystal goblets. Reverend Regina Fletcher remarked, "Once I was finally able to go into a white establishment, I really was not that moved or impressed…because by going to Frazier's, I had experienced the same level of service, the same level of presentation."[205] Congressman John Lewis,

then president of SNCC, said that Frazier's had "some of the best vegetable dishes you'd find any place in the South: early peas, green beans, fresh corn, turnips, collard greens…and yams that were out of this world. We'd often go there to eat, then move down to the basement for a meeting."[206]

For breakfast, there was a fair chance that the civil rights leaders would be eating at Busy Bee Cafe on West Hunter Street, a short walk from the Atlanta University Center and Dr. King's home in Hunter Hills. Opened by self-taught cook Lucy Jackson in 1947, Busy Bee was a tiny place where strangers literally brushed shoulders while eating Mama Jackson's famed ham hocks and chitlins. "During the civil rights movement, we'd start our day at Busy Bee or Paschal's," said Ambassador Andrew Young, "But you didn't go to those places so much to eat as you did to meet. That's where you found out what was going on."[207]

Next door to Busy Bee, Paschal's Restaurant served as the "unofficial headquarters of the civil rights movement." James and Robert Paschal were brothers from rural McDuffie County, Georgia. Their mother was noted for her cooking talents, and her tea cakes were a "much-loved, prized childhood favorite." In addition to working with her husband picking cotton to live on a meager sharecropper's salary, Lizzie Paschal cooked the best pound cakes in McDuffie County and became one of the premier bakers for white women, selling cakes, cobblers and pies. Robert became a talented cook, too, often using Lizzie's recipes, while James was a born businessman, starting his business empire in grade school. When Robert and James moved to Atlanta, they decided to open a small sandwich shop, selling fried chicken sandwiches, based on Lizzie's light golden recipe. The first restaurant was miniscule, and it did not even have a kitchen: Robert fried up chicken at his home and sent the fried chicken in a taxi to James, who placed it between slices of bread and sold it to the clamoring fans. Within months, the business, situated at the edge of the Atlanta University Center, had lines out the door.

A decade later, the Paschal brothers opened up a gorgeous new brick restaurant across the street, with white tablecloths, professionally trained waitresses and Robert's famous fried chicken, collards, cornbread and sweet potato pie. Though the restaurant had "colored only" business signs, it was the first in the city that seated people together at the same tables regardless of race, and James once said that the only law they ever violated was the segregation law.

In the early 1960s, King came to the Paschal brothers and asked them for a place to bring fellow activists to "eat, meet, rest, plan, and strategize." "How could we refuse?" wrote James. "We had the resources and the place. We believed we had been called to be part of the Movement."[208] Paschal's

became King's headquarters, with room 101 in the hotel attached to Paschal's restaurant reserved specifically for the civil rights workers. Paschal's was the main planning headquarters for the March on Washington, the Selma March for Voting Rights and the Poor People's Campaign. Coretta once said that Paschal's "is as important a historical site for the American Civil Rights Movement as Boston's Faneuil Hall is to the American Revolution."[209]

KING AND THE CIVIL rights leaders were optimistic about desegregation in Atlanta; after the Rich's lunch counter sit-in, King went on television explaining that the "reasonable climate" in Atlanta meant that desegregation would be "very smooth."[210] Nationally, Congress passed the Civil Rights Act of 1964, desegregating all public accommodations, including restaurants, and Mayor Ivan Allen of Atlanta was the first southern mayor to publicly support the legislation. Soon, longtime white institutions like Chick-fil-A, the Varsity and Mary Mac's began serving guests of both races with relatively minimal fuss. For example, when black protesters asked to be seated at the Waffle House in Midtown, Joe Rogers defused the protest by "inviting everyone inside who wished to eat."[211]

But there were a few notorious holdouts, and of these, no segregationist restaurant impacted Atlanta's history more than Lester Maddox's Pickrick Restaurant. Maddox was an unapologetic white supremacist, believing that blacks were intellectually inferior to whites and segregation was justified in Scripture. Maddox was a brilliant marketer, too, developing his restaurant's popularity with his full-page advertisements titled, "Pickrick Says," in which he included incendiary political commentary alongside his restaurant's weekly specials. One such 1960 advertisement asked, "Was Hitler really killed or is he in disguise and operating from City Hall or the Atlanta Police Station?" and then went on to describe his skillet-fried chicken for sale at fifty cents.

As Maddox began pursuing a political career, his attacks on politicians increased in furor, resulting in Pickrick's ads becoming the most widely read item in the Saturday *Atlanta Journal*. Blue-collar whites and segregationists felt that Maddox spoke for them, especially as the civil rights movement grew, while the city's elites and integrationists criticized Maddox as an ignorant racist. Ivan Allen Jr., when he was campaigning in 1957, said, "I was quite aware that my most serious opposition would come from Lester Maddox,

a 10th grade drop-out who ran a blue-collar fried-chicken restaurant.... As polarization set in, his star rose higher."[212] By 1962, the Pickrick served more than half a million people each year, largely based on the success of Maddox's "Pickrick Says" ads.[213]

Most famously, in 1964, when three black men came into his store to buy some of his fried chicken, he brandished a pistol and yelled at them, and some customers took pickaxe handles that Maddox had put by the door and sold for two dollars each, calling them "Pickrick Drumsticks," to make it clear that blacks would not be served. The incident was captured on the nightly news and then became national news when Maddox sued to challenge the constitutionality of Section II of the Civil Rights Act of 1964, which banned segregation in all public accommodations. The Eleventh Circuit Court of Appeals upheld the law and ordered Maddox to admit black patrons within twenty days. Rather than complying, Maddox shut down the Pickrick, stating that he would never submit to integration, which paved the way to his appointment as the state of Georgia's 1966 governor and later election to lieutenant governor.

MARTIN LUTHER KING JR. said that he had "never been more embarrassed of Georgia" than the day Maddox became governor. But King had little time to contemplate the effects. He was working in Chicago to end housing discrimination and remove African Americans from the ghetto.

Meanwhile, in Atlanta, Operation Breadbasket was making significant strides with Atlanta corporations. Described by King as "one of the most inspiring movements that Atlanta has ever had," Operation Breadbasket systematically used the power of the pulpit to impact Atlanta businesses. Daddy King and the other pastors at the African American churches chose a single company to target, telling their congregations to boycott the stores and companies until the stores and companies began hiring African Americans. While the boycotts continued, the pastors met with the companies to force integration and diversity hiring practices, creating remarkable results.

Their first target was Colonial Bakery, one of Atlanta's largest bakeries, where the group found that there were only 55 black employees in a work force of 275, and all of those black workers were in the sanitation and dishwashing departments. The group asked for 18 additional black hires, and Colonial Bakery agreed, marking Operation Breadbasket's first success.

Coca-Cola Bottling Company was the first "selective buying victim" and began hiring numerous African Americans after the black boycotts. Gordon Foods Corporation agreed to employ and double the salary of more than fifty ex-cooks and maids. The group negotiated with the Marriott Motor Hotel, resulting in the hiring of waitresses, cashiers and a black banquet manager. Operation Breadbasket resulted in diversity hiring at most of the city's grocery stores, including A&P, Borden's, Food Giant, Munford Inc. and Winn-Dixie Stores.

By 1967, Operation Breadbasket had won five thousand jobs, equal to $22 million a year in new income for the black community, mostly in the Atlanta area. Once outsourced to Chicago and helmed by Reverend Jesse Jackson, Operation Breadbasket achieved national recognition, though eventually created a schism within King's organization when Operation Breadbasket separated from the SCLC.

But while African Americans were making strides toward economic equality and dismantling segregation laws, wealthy white families began self-segregating by moving to the suburbs of Atlanta, populating cities like Marietta, Chamblee and Tucker, while in-town neighborhoods like Grant Park and Decatur became predominantly black and lower income. Grocery stores predictably followed customers with money and began shuttering their in-town stores, resulting in food deserts where residents did not have consistent access to fresh vegetables and fruits. By 1971, the city seriously considered shutting down the Municipal Market, located in the mostly middle-class black Sweet Auburn neighborhood, arguing that the market was in poor condition, infested with rats and flies, overflowing with raw sewage and needed at least $200,000 in renovations the city could not afford. Mayor Maynard Jackson—Atlanta's first African American mayor—personally stepped in and took interest in the million-dollar renovation of the Municipal Market, which reopened in 1975, making it one of the few produce merchants that remained in the predominantly black Downtown Atlanta.

ON FEBRUARY 4, 1968, Martin Luther King Jr. stood at a pulpit at Ebenezer Baptist Church in Atlanta and described the eulogy he wanted to be made at his death, in one of his most moving and prescient speeches,

If any of you are around when I have to meet my day, I don't want a long funeral. And if you get somebody to deliver the eulogy, tell them not to talk too long....Tell them not to mention that I have a Nobel Peace Prize— that isn't important....I'd like somebody to mention that day that Martin Luther King Jr. tried to give his life serving others. I'd like for somebody to say that day that Martin Luther King Jr. tried to love somebody....I want you to be able to say that day that I did try to feed the hungry....I want you to say that I tried to love and serve humanity.

Exactly two months later, as he was relaxing at a Memphis hotel waiting to go to a church banquet at the home of Reverend Samuel "Billy" Kyles, King asked Kyles what they were going to have for dinner. King, ever worried about the meal to be served, wanted to make sure they would get real soul food and not some "dainty starvation of asparagus and greens." After King's persistent prodding, Ralph David Abernathy called Kyles's wife, who said they would be having "roast beef, sweetbreads, chitterlings, pork chops, neck bones, fried chicken, and ham in the meat line, plus six kinds of salad, featured turnip greens and candied sweet potatoes, a bread table of hot rolls, corn bread, corn muffins, biscuits, and corn pones, and pretty much the works for dessert."[214] King, more than satisfied, got ready.

Dr. King never ate that meal. A few minutes later, he walked onto the balcony of the Lorraine Motel and the shot rang out that ended his life. Atlantans mourned and continue to mourn their lost son—an icon, a foodie and a national hero—dead at just thirty-nine years old.

FRIED CHICKEN

Fried chicken was one of Martin Luther King Jr.'s favorite meals. At Paschal's, Marshall Slack, the waiter assigned to serving the civil rights leaders, said King often ordered fried chicken, candied yams and collard greens. Bernard Lee, a student who worked with King, said he was once shocked by the quantity of fried chicken consumed by King and Abernathy. In Montgomery, King helped a woman named Georgia Gilmore start her own home-based restaurant, serving fried chicken and pies, after she was fired as a cook due to her civil rights activism.

Fried chicken was not just King's favorite food—it may be Atlanta's favorite food. Georgia is the number-one producer of poultry in the country. Many

of Atlanta's most famous twentieth-century restaurants have focused on fried chicken: Chick-fil-A, Paschal's, Busy Bee, the Pickrick and Mary Mac's. Lemon Pepper Wet, the Atlanta-invented wings from American Deli, made by slathering dry-rubbed wings with lemon sauce, have been immortalized by Atlanta's hip-hop musicians and rappers and on the FX television show *Atlanta*. If you Google "Atlanta fried chicken," you'll be staggered by the number of options. There are three social media accounts documenting the ubiquitous chicken bones strewn across Atlanta's parking lots. It's not like Atlanta has a thing for garbage; it's just that Atlanta has a thing for chicken.

In Atlanta, fried chicken has played a role in almost every aspect of daily life since the city's founding. Chickens were an easy animal for urban dwellers to raise since they take minimal space, and by 1911, there were so many people raising chickens that the *Atlanta Georgian* magazine hired a "Poultry Doctor" to provide a column on how to properly raise them.

In the antebellum period, frying chickens took a long time, with choosing the chicken, catching it, killing it, plucking it, then butchering and cooking it, so it was a dish best served on Sunday when cooks had the most leisure time, resulting in the chicken often being referred to as the "gospel bird." Frying chicken in fat was a simple and easy use of the food, one that has been used across the world over centuries. The southern invention associated with frying chicken was dredging the chicken in cornmeal, an obvious choice since cornmeal was so prevalent in the South.

By 1883, the *Atlanta Constitution* encouraged laborers to become chicken farmers because the demand was always far in excess of supply, and such demand would "continue as long as people eat, and fried chicken is as popular as it is in Georgia."[215] Fried chicken was invariably brought along to picnics, camp meetings and religious gatherings and became the common food served at "company" dinners.

Okay, so King loved fried chicken, fried chicken is indisputably an important part of both soul food and southern food and King's hometown is well known as a fried chicken haven. So then why have so many restaurants come under fire for serving fried chicken on Martin Luther King Day? What is racist about fried chicken?

Like hoecakes, fried chicken became a tool to stereotype black people as lazy and ignorant. Prior to 1915, fried chicken wasn't necessarily associated with African Americans, nor was it considered a lower-class meal. An 1882 *Atlanta Constitution* article stated in relatively mild language, "Especially when there is to be a general meeting at their churches, the pious good negroes feel it due the brethren to furnish them fried chicken and luscious chicken

pie."[216] And in 1910, a fried chicken and corn dinner was described as an "elegant supper" at twenty-five cents per meal.[217]

It was the 1915 film *Birth of a Nation* that changed the way southerners viewed fried chicken. The most famous scene in the movie is a group of actors portraying shiftless elected black legislators drinking alcohol, boisterously laughing, with bare feet kicked up on a desk, and one brazenly eating fried chicken in the legislative hall. A year later, drawing upon the imagery of fried chicken equaling ignorance, the *Atlanta Constitution* published a "Southern Character Sketch" featuring "Old-Time Plantation Negroes," focused specifically on "ketchin' a chicken," using ridiculing vernacular. Likewise, Snowdrift, a type of vegetable shortening, advertised its product by showcasing an antebellum mammy frying chicken, explaining that the cook's "repitashun" for fried chicken was due to her use of Snowdrift.

Meanwhile, though African Americans were being mocked and stereotyped for eating fried chicken, the truth was that everyone in Atlanta, white and black alike, was eating a whole lot of it, as the dish became one of the most popular in the city at restaurants, cafés and picnic suppers. A 1921 *Atlanta Constitution* article explained that one of the best parts of traveling in Georgia is consuming the "incomparable Georgia resources of fried chicken, hot biscuit, real hen eggs and watermelon."[218] And that is true today; there are fried chicken spots on nearly every street.

Just as there are a seemingly endless number of places to eat fried chicken in Atlanta, there are numerous ways to cook fried chicken. Mrs. A.P. Hill spent almost two pages describing how to make it, first detailing how to clean, butcher and prepare the chicken. Then to fry them, she recommended rolling each piece in flour or cornmeal, frying in plenty of boiling lard and serving with a salt and pepper gravy.

Mrs. S.R. Dull's recipe for fried chicken also provided instructions on how to clean, butcher and prepare the chicken for frying, and she recommended rolling each piece in flour, frying in hot grease and serving with cream gravy. She cautioned, "Never pour gravy over chicken if you wish Georgia fried chicken."

By the time Nathalie Dupree and Cynthia Graubart wrote *Mastering the Art of Southern Cooking*, prepackaged, pre-butchered chicken was common, so their descriptions of fried chicken skip over the butchering and cleaning. Their fried chicken recipe is nearly two pages long, they explain, because "frying chicken is a challenge to fledgling cooks." Unlike their predecessors, they brine their chicken in buttermilk, dredge with flour (but not cornmeal) and then fry in shortening and butter and serve without any gravy.

NEW EATS, NEW ATLANTA

New Southern Cooking and International Atlanta: 1970s to the Present

Jimmy Carter had a specific morning ritual. He woke in the Governor's Mansion in Atlanta, hopped out of bed, made breakfast—warm, creamy grits with a puddle of soft-boiled eggs and cheese—poured a cup of coffee, ate and put the dishes in the dishwasher. When Carter stayed at the Americana Hotel in New York, knowing the governor's predilection for the South's favorite meal, the chef added grits to the menu. And after Carter chose Walter Frederick Mondale as his running mate, the press christened the duo "Grits and Fritz!," with caricatures showing Carter standing in a box of grits.

After Carter became president, his love of southern food became well known, and he even named his private plane "Peanut One." He drank sweet milk by day and buttermilk at night and ate cheese sandwiches, butter with his crackers and icy cold tomatoes, turnips, black-eyed peas and corn fresh from the garden. Having made his fortune as a peanut farmer, he enjoyed peanut brittle, peanut butter and jelly sandwiches and peanut butter chiffon pie, but he liked salted deep-fried fresh peanuts best of all. His favorite food was steak and potatoes, and like any Georgia boy, he had a "weakness for Brunswick stew or barbecue."[219] Suddenly, Atlanta's homegrown cuisine took the national stage due to Carter's term in office.

WHILE PRESIDENT CARTER BROUGHT traditional southern food to a national audience, an Atlanta chef was transforming southern cooking into gourmet cuisine. Nathalie Dupree grew up in Virginia in the 1940s, reared on her mother's cooking, who "bless her heart, didn't fry chickens."[220] Realizing that cooking was "the only thing I had ever been good at," she told her mother after college that she wanted to be a cook. But her mother dissuaded her, telling her that "ladies don't cook." A decade later, Dupree attended the famed London Cordon Bleu, and one afternoon, when she ran into Julia Child on the street, Child advised Dupree to teach people how to cook because we "need cooking schools in America."

After a stint as a chef in Majorca, Dupree returned to her then husband's home in Social Circle, Georgia, where she opened a little restaurant named Nathalie's, whose opening dishes were iced cucumber soup with shrimp, pork tenderloin with mustard sauce and sweetbreads with brown butter. Prominent Atlantans trekked down to Social Circle to try Dupree's French dishes made from local southern ingredients. One of Dupree's frequent customers was the vice president at Rich's Department Store, and he hit on the idea of opening a cooking school at Rich's helmed by Dupree. When Dupree called Julia Child for her advice about the type of cooking school she should run, Child said, "a full participation one, of course."[221]

Rich's Cooking School was like nothing else in the country at the time. Most cooking schools were instructional, as in the days of Mrs. Dull's demonstration classes, where students watched the teacher prepare meals.

Rich's Cooking School was participatory, and each student stood in front of one of twenty stoves and learned how to cook by physically preparing the dishes Dupree taught them. Dupree tested whether egg whites were properly whipped by holding a bowl full of them upside down above her head, and on one odiferous day, the entire Rich's department store smelled "like baby's diapers" as she taught her students how to pan-sauté kidneys. The cooking school was a sensation, buoyed by the charming and sassy yet self-deprecating Dupree.

At first, she taught entirely French recipes like trout meunière and cold lemon soufflé but, over time, substituted southern

Nathalie Dupree. *Nathalie Dupree.*

ingredients, insisting, like Alice Waters had in California, that fresh and seasonal were best. Instead of spinach roulades, the students cooked turnip green roulades, and Dupree picked herbs from her back garden to use in the cooking school. Legions of cooks learned under Dupree's careful watch, marking her love of mentoring, "I choose to operate on the pork chop theory. If there's only one pork chop in the pan, it goes dry. But if there are two pork chops in the pan, the fat from one feeds the other."[222] As her students left her school, they began cooking at some of the South's best restaurants, spreading Dupree's European and seasonal approach to southern cooking.

The ever-busy Dupree began writing cookbooks, and her first hardback cookbook, *New Southern Cooking*, was written as a "desperation method" to bridge the gap in income after the Rich's Cooking School closed due to Downtown Atlanta's declining sales. *New Southern Cooking* was a hit, and White Lily Flour approached Dupree to run a PBS show named after her bestselling cookbook to showcase southern cooking to a curious national audience. A generation after southern women had left the kitchen to begin careers, Dupree offered them a fun way to return by making southern cooking simple, using local fresh produce and ingredients and never expecting perfection.

Dupree's work and accolades could fill a chapter on their own, with fifteen cookbooks, numerous newspaper columns, three hundred television episodes and the receipt of dozens of culinary awards, including four James Beard Awards. Like Annabella Hill's and Henrietta Dull's, Dupree's cooking methods transformed the way Atlanta's housewives cooked and ate. But she refuses to take credit for the shift, instead explaining that at the core, she was just taking people back to southern cooking's roots, forcing them to utilize what was already in their gardens. New southern cooking is about "using old traditional ingredients in new ways, as well as using new ingredients in old ways."[223] In the preface to her James Beard Award–winning cookbook, she wrote, "The fun of new Southern cooking is to take the old and the new and put them together with creative zest."[224]

WHEN NATHALIE DUPREE BEGAN cooking in Social Circle, she couldn't find fresh herbs or mushrooms. Though these ingredients grew easily and well in Georgia, restaurants only used dried herbs and maybe a bit of parsley

in their cooking. The grocery stores sold soggy, canned mushrooms, and if she found fresh mushrooms, they were the white button variety. The rise of convenience foods from the 1930s to the 1970s had resulted in the loss of home garden plots, and many farmers did not grow or sell a huge variety of produce in the city. The Municipal Market in Downtown Atlanta was struggling due to the deterioration of the inner-city neighborhoods. Although the Atlanta State Farmer's Market sold traditional southern favorites like collards, squash and tomatoes in bulk, it rarely sold "esoteric produce" like "clementines, romaine, [and] shallots," since such foods did "not comprise a typical Atlanta menu."[225]

Robert Blazer intended to change that. Blazer grew up in Rhode Island, watching the daily work of his father's variety store in Pawtucket, and moved to Atlanta in 1977 because "I wanted to get to a warmer climate and I think the economics are better here."[226] He opened Your Dekalb Farmer's Market (YDFM) in June 1977, first as a 7,500-square-foot produce stand, selling fresh fruit and vegetables brought in daily from Georgia and surrounding states.

By 1979, newspapers proclaimed that "the time is ripe for the proliferation of neighborhood farmers' markets." Your Dekalb Farmers Market was the largest of these, with 22,500 square feet on Medlock Road and a wide variety of produce, much of it hauled by Blazer's contracted rigs from across the country, with a complete seafood market and a large assortment of cheeses, preserves, honeys, eggs and breads. Blazer began internationalizing and expanding his selection of foods, offering the "widest, cross-cultural array" of food "ever assembled in Atlanta."[227] Ten years after Nathalie Dupree complained that she couldn't find mushrooms or rosemary in Atlanta, YDFM offered 350 kinds of cheeses and 30 types of Asian herbs, including cilantro, daikon and gai lan, as well as California delicacies like spinach, avocados and romaine.

Though YDFM's prices were cheaper than the supermarket's and the quality and variety were greater, customers had to work for their produce due to the market's overwhelming popularity. The *Constitution*'s food editor quipped, "If the three words 'Dekalb Farmers Market' leave a bad taste in your mouth, it's probably because three shopping carts pinned you in between the peppers and cucumbers one Saturday morning or a noisy, honking forklift chased you from the seafood to the cheese department."[228]

To combat the space limitations, Blazer purchased 100 acres on the outskirts of Decatur and built a 100,000-square-foot boxy warehouse, creating one of the largest seafood and meat markets in the country, a

massive produce section and an on-site commercial bakery. In the 1980s and 1990s, YDFM became a meeting place, a gathering spot, an employment opportunity and a haven for Atlanta's international community. Blazer hired new immigrants arriving in Dekalb County, and soon, over 90 percent of the Market's employees were immigrants, mostly Ethiopian. Those immigrants influenced the food produced, purchased and sold, resulting in samosas and rice candy replacing grits and peach cobbler at the Market's cafeteria.

Today, though ethnic and international markets proliferate in Atlanta, YDFM continues to be one of the city's favorites, bringing in over 100,000 eager customers per week, and construction is underway for an enlarged market to serve retail and wholesale customers. The company operates efficiently and economically, in part because of its supply chains, including YDFM-owned cargo ships that import produce grown in Mexico specifically for the market and its many in-state and out-of-state wholesale customers.

And longtime Atlantans are guaranteed to run into a friend at YDFM because *everyone* shops there, regardless of race, ethnicity, religion or socioeconomic status. That makes Robert Blazer proud. Blazer says that, over the last thirty years, YDFM has become a "community service" because his goal has always been to ensure that guests are "given a consistent supply of high quality produce and food at a reasonable price." Blazer explained, "It's more than a food place. It's a place where the world has learned to get along with each other."[229]

THE SUCCESSES OF DUPREE'S *New Southern Cooking* and Blazer's YDFM were part of a larger shift happening in Atlanta, that of immigration and the internationalization of the city. Unlike most other cities in the country, immigrants had never chosen Atlanta. In the 1870s, eastern Europeans came in waves to the Northeast due to relaxed immigration laws, but they did not choose Atlanta because they did not want to compete with inexpensive African American labor. In the 1960s, Hispanic and Asian immigrants flowed into the Northeast and West Coast due to relaxed immigration quotas, but they did not choose still-segregated Atlanta because they did not want to be treated as second-class citizens.

In 1977, only 2 percent of Atlanta's population were immigrants or descendants of immigrants, and only 92 of the approximately 1,500 restaurants in the Yellow Pages could be classified as immigrant cuisine.

Frank Ma was one of these early immigrant restaurant owners. After learning about the city from the movie *Gone with the Wind*, Ma decided to move from Taiwan to Atlanta in 1970, saying he fell in love with all of the trees when he came on a business trip. When he moved to Atlanta, he got a job at Peking Chinese Restaurant on Buford Highway, near Druid Hills, working for a Chinese man from Korea who did not know much about cooking Chinese food.

There were five Chinese restaurants at the time, and they all served chop suey, a Chinese American mixture of leftover foods such as beef, vegetables and rice mixed with soy sauce. Ma had never heard of the American chop suey and instead begin serving real Peking fare, such as mushu pork, potstickers, Mongolian beef and garlic chicken.[230] His cuisine focused largely on home cooking, inspired by his mother's excellent cooking, but he adapted those Chinese dishes to southern tastes because, "Americans love sweet. Well you taste the sweet nothing will go wrong. Too salty, they can't handle. Too sour they can't handle. But sweet they can handle."[231]

Ma began opening and closing restaurants like most people open and close their front door: he opened Tienjing Chinese Restaurant, then Frank Ma's Hunan Chinese Restaurant in Sandy Springs, China Royal Restaurant in Roswell and China Express in the Midtown Promenade and then began doing Asian restaurant consulting work, helping with the creation of Frank Ma's Gourmet, Dah San Yuan and Frank Ma South. An enthusiastic promoter and mentor, he became the founder and president of the Atlanta Chinese Restaurant Association. By the 1990s, there were probably six hundred Chinese restaurants in the city.

Around the same time Frank Ma started teaching Atlantans about potstickers, a Korean immigrant named Young Shinn began selling rice crackers and Asian sweets in a 1,400-square-foot shop in the Lindbergh area. By the early 1980s, Shinn had expanded into wholesale and was manufacturing eggroll wrappers and noodles to provide to the growing Chinese and Korean restaurant businesses. In 1995, Shinn partnered with his son Harold Shinn to open a large 20,000-square-foot facility on Buford Highway, which they called the Buford Highway Farmer's Market. At first, they struggled as they tried to appeal to the black and white residents of Atlanta but realized that they were much better off marketing to Hispanic workers and shoppers. Harold Shinn explained, "[I]n the last twenty years hands-down the largest growth, and in my opinion the biggest impact would be the Hispanic shopper, absolutely hands-down."[232]

The Hispanic surge described by Shinn occurred almost overnight. In 1990, as Shinn began building out the plans for the Buford Highway Farmer's Market, only 3 percent of Atlanta's population was of immigrant descent; in New York, by comparison, 25 percent was foreign-born or of immigrant descent. Then, in 1990, everything changed when Atlanta was chosen to be the location of the 1996 Centennial Olympics. The city promised $1.2 billion in funds to hold the games, creating a huge demand for construction labor, resulting in a flood of Hispanic immigrant labor, to the extent that one major construction company said that "we would be out of business if it wasn't for the Hispanic work force."[233] At the same time, Asian immigrants, lured by their predecessors' success and seeing opportunities in the Olympics, began arriving in the city and opening businesses.

Those immigrants needed a place to live, and Buford Highway at the edge of Chamblee and Doraville was the obvious choice. Doraville and Chamblee were traditional blue-collar working-class southern neighborhoods, about fifteen miles from Downtown Atlanta, with most families working at the Kodak and GM plants in the early twentieth century. When these manufacturing facilities shut down in the 1970s, the towns struggled, leaving most businesses and retail stores empty and housing prices at an all-time low. In the 1980s and 1990s, immigrant families realized that Buford Highway was a space they could carve out for their own with inexpensive housing, convenient access to the metro system and plenty of vacant retail space.

Because immigrants of all nationalities—from Hispanics, Asians to eastern Europeans—all arrived in Buford Highway at the same time in the early 1990s, they did not have the time or space to spread out and create their own neighborhoods, as seen in New York's Chinatown and Japantown. Instead, Buford Highway became the first international corridor in the Southeast and one of the few international corridors in the country where people of every country, community, race and religion existed, commingling, eating and working together. The *Atlanta Constitution* described Buford Highway as "ethnic Atlanta's economic lifeblood and cultural showcase" with Vietnamese accountants, Russian newspapermen, Hispanic grocers and Korean restaurateurs creating thriving enterprises by the early 1990s.

But not everyone was happy about the change. In 1992, residents complained in a petition that day laborers were turning the neighborhood into "the worst part of the inner-city area of New York," while the police chief said the residents' problems would not be resolved "until these people go back to where they came from."[234] Months later, Doraville's vice mayor blasted plans to build an International Village in its borders, stating, "Why

would we want to attract more immigrants when we got all we want? We got plenty. We got enough to go around. If you want any in your neighborhood, we'll send you some." Facing intense backlash from the press and public, plus the obvious fact that the immigrants were bringing in much-needed revenue and growth, the politicians backed down and apologized. But echoing the 1970s white flight from in-town neighborhoods, more than a third of Chamblee's white residents fled even deeper into the suburbs to areas like Duluth, Alpharetta and Marietta.

Anyway, there was no holding back the immigrant rush into Atlanta. Buford Highway would have boomed regardless of the city council's support because Buford Highway had become the backbone of the immigrant community, and Atlantans quickly began to accept and encourage the internationalization of its food. When Guido Benedit founded Havana Sandwich Shop at the extreme southern end of Buford Highway in 1974, he served up traditional Cuban sandwiches, arroz con pollo, flan and platanos. There was much common ground between Cuban and southern food, such as putting collard greens and smoked ham hocks in caldo gallego or using okra in a bowl with smoked ham and rice, reflecting the African influence on both cuisines. By 1991, Atlanta's palates had become more adventurous, and 75 percent of Havana Sandwich Shop's clientele was non-Hispanic, with other restaurants on Buford Highway serving even more traditional fare like bacalao a la Vizcayna (dried cod with potatoes, olives and onions) and masitas de puerco (fried hunks of pork tenderloin with onions).

Driving down Buford Highway in 2019, the neighborhood is a medley of food, food and more food and immigrant entrepreneurial spirit. The almost overwhelming shopping centers are crowded with Hispanic bodegas, Korean barbecue spots, authentic dumpling shops, Japanese sushi bars and Chinese bubble tea houses. Buford Highway has become a byword in the South for its expansive and creative immigrant cuisine.

It took 150 years, but Atlanta finally has become the international food city it always claimed to be.

SWEET AS A PEACH

Frank Ma was right in saying that Atlantans like their sweets. They do. Atlanta has always had sweet shops, bakeries, confectioneries and candy places, starting with Toney Maquino's confectionery in the 1850s. When it

comes to fruit, Atlantans prize nothing more than peaches, which is ironic because peaches do not grow all that well in the hilly climate, as seen in the uniqueness of the peach tree for which Standing Peachtree was named. Nonetheless, Atlanta's cookbook authors have provided a bevy of peach recipes over the centuries.

Peach pies have always been a popular way to showcase the fruit. In the Reconstruction period, peach pie was usually the dessert of choice at high-end restaurants, including the 1882 bounteous Thanksgiving feast at the Markham House. By the 1920s, peach pies were an accepted part of barbecues and picnics, though hand pies were usually preferred at those occasions. Those peach hand pies were the perfect Georgia treat to be served at the Varsity, and Meredith Ford, longtime Atlanta food critic, once wrote, "If I ever get to heaven, the fried peach pies from the Varsity will surely be there to greet me—only there, they'll come sans fat and calories."[235]

Peach pie recipes have changed over time, too. While Mrs. A.P. Hill (1867) explained that peach pie could be made in the same way as apple pie, she recommended the "Cut and Come Again" pie for common everyday use. In an open hearth oven, she lined the interior with pastry, then added sliced juicy peaches and laid on a top crust. After the top crust was cooked, it was removed and the fruit was then sweetened and spiced and the crusts replaced. She recommended serving the peach pie cold with cream sauce.

Mrs. Dull (1928) recommended making a sugar syrup, boiling the peaches in the syrup until they were tender and then baking the syrup and peaches in a crust, but she also provided a few variations, including a recipe for peach hand pies. By the mid-1950s, canned cling peaches were almost as popular as fresh peaches, leading the 1976 Atlanta food editor to gripe that it was impossible to get fresh peach pies in Georgia restaurants even at the peak of peach season.

Today, in the summertime, fresh peach pies and peach cobblers adorn half the menus in the city. But there are also a profusion of new twists on the classic recipes: Revolution Doughnuts offers peach sliders, Bellina Alimentari makes a basil peach panna cotta and Watershed serves peach churros with cotton candy and blood orange peach consommé. Peaches are no longer relegated exclusively to the dessert table, either: Chef Eddie Hernandez at Taqueria del Sol serves a green peach salad with lime dressing, and Chef Nick Leahy at Saltyard pairs creamy homemade burrata with pickled peaches. These chefs are at the frontier of southern cooking, utilizing conventional southern ingredients with unconventional or international cooking methodologies, a tribute to the modern food city that Atlanta has become.

EPILOGUE

I n 2015, when I began thinking about sharing Atlanta's food history, a book didn't come to my mind. I launched a walking tour company, Unexpected Atlanta Tours & Stories, that offers Atlanta Food Walks and Atlanta History Tours. I thought there were plenty of organizations, articles and books out there focused on the historians. I wanted to be on the ground, introducing locals and visitors to my favorite restaurants and showing them why the barbecue we eat today is not all that different than the barbecue the Native Americans ate ten thousand years ago.

Unexpected Atlanta and Atlanta Food Walks took off, largely because people connected with those stories of food entrepreneurs. Visitors repeatedly asked me for more stories about the city's food and its history, which had me thinking about new ways to tell Atlanta's food story. A book was the obvious answer. But I was not asking the right question.

The right question was, why does Atlanta's food history matter?

It matters because, in Atlanta, many marginalized people—the Native Americans, the slaves, the poor, the African American men and women, the immigrants—have done much of our food innovation, production, preparation and cooking, and their stories are often ignored. By telling this story of the city's food, I have had the opportunity to share with you remarkable people like Myra Miller and James Tate, former slaves who made their fortunes on food, and Annabella Hill and Henrietta Dull, who both came from poverty to become the most noted food authorities in the city.

It matters because what we eat is very much tied up in who we are as a city. Food has been pivotal in key incidents, from the founding of Standing Peachtree to the first mayoral race to the race riot of 1906 to the internationalization of Buford Highway. That's no coincidence: the South has always been a largely agricultural economy, and the capital of the South has necessarily become a bastion for food. Until the early 1900s, food was the single largest business in Atlanta, and in the twenty-first century, Atlanta-founded companies like Coca-Cola and Waffle House continue paving the path of food innovation across the country. Today, gentrification, internationalization and domestic migration are also changing the city, resulting in a rapidly evolving food scene.

And it matters because if we want to continue succeeding as a city, food justice needs to be at the core of what we accomplish. The people of this city have faced famine and starvation during the Civil War; pellagra, which wiped out scores of people due to nutritional deficiencies; and the creation of food deserts due to Jim Crow policies, segregation and poverty. In 2018, Atlanta has one of the highest rates of food insecurity in the country at 18.5 percent compared to the national average of 12.7 percent, meaning that almost one in five Atlantans lack "consistent access to enough food for an active, healthy life." Food has always been a large part of Atlanta's struggle to be better, to achieve more, to represent equality and to live up to the moniker of "the city too busy to hate."

Simply put, Atlanta's food history matters because it is, and always has been, the city built on food.

ACKNOWLEDGEMENTS

Much of this book was developed through exhaustive research into daily newspapers in Atlanta, including the *Southern Confederacy*, the *Atlanta Constitution*, the *Atlanta Journal*, the *Sunny South* and many others. Other important primary sources utilized throughout this book are diary entries from people who lived in the relevant periods and oral interviews remembering the past. Wherever possible, I tried to use contemporaneous diary entries rather than later oral interviews.

Atlanta authors have produced an incredible assortment of cookbooks. It is a true privilege to live in a city where so many accomplished women and cooks have catalogued the cuisine of the time.

I am deeply indebted to the many Atlanta historians who have come before me and whose books have a permanent place on my desk. Though this city has a relatively short history, it is an action-packed one in which every year brings significant change and the works of all of these historians helped guide my research.

Longtime Atlantans will quarrel with me over my choices in restaurants and food entrepreneurs, and I sympathize, because I would have loved more space to write about the Colonnade, Atkins Park, Little's, The Majestic, Horseradish Grill, Moe's and Joe's, Manuel's Tavern, Nikolai's Roof, Bones, the Peasant Restaurants, Pittypat's Porch and many more. Suffice it to say that I agonized over these choices and have enough material for another few books on Atlanta's historic restaurants.

The gracious and delightful Nathalie Dupree provided me with most of the material on her life and her passion for New Southern cooking. Robert Blazer, too, gave me a wonderful interview about the growth of Your Dekalb Farmer's Market and its importance in the city. Marshall Slack at Paschal's was kind enough to provide me with the inside details of Dr. Martin Luther King Jr.'s passion for food.

The staff at Emory's Archival Department helped me find Henry Grady's Delmonico's menu. (I danced around the kitchen when I learned that they had it!) Thank you to the Decatur Library librarians, who have pulled loads of books for me on a regular basis. Thank you to the Auburn Avenue Research Library and Atlanta History Center's Kenan Research Center. The lovely folks at Historic Oakland Cemetery helped me dig up facts and details on numerous food entrepreneurs, including Myra Miller and Henry Durand, and I am proud to work closely with them throughout the year. Any and all errors are mine alone.

A huge thank-you to readers Victoria Lemos, Margaret Spencer, Chetan Sankar, Lakshmi Sankar and Patrick McConnell, who waded through the book in early stages and gave me indispensable feedback.

Laurie Krill and Amanda Irle at The History Press shepherded this book from an idea to a reality, and this book would not have been possible without their constant assistance.

I am deeply grateful to my entire team at Unexpected Atlanta, particularly our operations guru Sarah McConnell and all of our food vendors who have kept our tours succeeding while my head has been in the past.

My parents always have been my biggest cheerleaders. Thank you for the thousands of dinner table conversations in which you inspired in me a great passion for the written word, for teaching, and for kindness and justice for all.

My daughters, Amara and Kareena, are my two favorite foodies, and it is no lie that they both will choose locally smoked North Georgia trout over fish sticks. I have had the best times exploring this city's food with both of you, and I love you both immensely. My sweet doggie Abby lay next to my feet for much of the writing of this book, my muse and my comfort as I agonized over what to keep and what to cut.

And, last but never least, Patrick, this book is yours as much as it is mine. With you, all things are possible.

NOTES

Chapter 1

1. The Creek Nation is a confederacy of many tribes throughout the Southeast, including the Muskogee, Hitchiti, Cowetas, Abihkas and Alabama. The Muskogee lived in Northern Georgia, where present-day Atlanta is located, but the British interchangeably referred to the Muskogee as the Creek tribe, leading to some historical confusion.
2. Garrett, *Atlanta and Environs*, 1:9. There is some debate on whether the name Standing Peachtree derived from an actual peach tree or a "pitch tree"—in other words, a pine tree. However, numerous firsthand reports show that as far back as 1812, there was an immense peach tree that stood next to the village. Atlanta's earliest lawyer, Leonard C. Simpson, stated that his father told him that the name came from a "large seedling peach tree of the red Indian variety which stood near the bank of the creek and whose immense size made it an object of mark." Wash Collier, too, reported that Standing Peachtree led to the naming of Peachtree Creek because there was a beautiful peach tree that stood on a knoll where it emptied into the Chattahoochee River. Garrett, *Atlanta and Environs*, 2:451; Mitchell, "Story of the 'Standing Peachtree,'" 20–22. More conclusively, the word *pakana* literally means "peach" or "may apple" in Muskogean. Swanton, *Early History*, 273–74. Therefore, this author continues to believe that the Muskogee village was named Standing Peachtree, after a peach tree, marking the city's association with food right from the start.

3. Hawkins, *Letters*, 22.
4. Garrett, *Atlanta and Environs*, 1:9.
5. Ibid., 12.
6. Hill, *Mrs. Hill's New Cook-Book*, 240.
7. Butler and Porter, *Cabbagetown Families*, 71.

Chapter 2

8. Martin, *Atlanta and Its Builders*, 1:16.
9. Garrett, *Atlanta and Its Environs*, 2:450.
10. Ibid., 1:137.
11. Ibid., 1:168.
12. Martin, *Atlanta and Its Builders*, 1:56.
13. Newman, *Southern Hospitality*, 12.
14. Garrett, *Atlanta and Its Environs*, 1:59.
15. Martin, *Atlanta and Its Builders*, 1:80.
16. "State Agricultural Convention," *Atlanta Constitution* [hereafter *AC*], August 13, 1874.
17. "Sweet Potatoes," *Carroll Free Press*, March 2, 1888.
18. Wing and Carlisle, *Atlanta Woman's Club Cook Book*, 21.

Chapter 3

19. Garrett, *Atlanta and Its Environs*, 1:47.
20. Martin, *Atlanta and Its Builders*, 1:85.
21. Russell, *Atlanta, 1847–1890*, 72.
22. "Historic Meetings of the Past," *AC*, March 16, 1896.
23. Martin, *Atlanta and Its Builders*, 1:399.
24. "New Candy Manufactory and Bakery," *Atlanta Weekly Intelligencer and Cherokee Advocate*, June 22, 1855.
25. Russell, *Atlanta, 1847–1890*, 42.
26. Shenton, *Slavery in the Cities*, 4.
27. Russell, *Atlanta, 1847–1890*, 72.
28. Garrett, *Atlanta and Its Environs*, 486.
29. Hunter, *To 'Joy My Freedom*, 56.
30. Wortman, "Why Was Robert Webster."
31. Pioneer Citizens' Society of Atlanta, *Pioneer Citizens'*, 48–49

32. Wortman, *Bonfire*, 70–84.
33. "Story of Atlanta's Very Latest and Most Unique Enterprise," *AC*, November 13, 1898.
34. "Atlanta's Most Unique Industry," *AC*, October 17, 1899.
35. "Harry Stockdell Dies in Athens," *AC*, September 12, 1912.
36. Hill, *Mrs. Hill's New Cook-Book*, 65.
37. Moss, *Barbecue*, 112.
38. Fleetwood, "Master Barbecue Artist."

Chapter 4

39. Garrett, *Atlanta and Its Environs*, 497.
40. "Capital City," *Southern Confederacy*, March 5, 1861.
41. "Commercial," *Southern Confederacy*, March 4, 1861, 3.
42. Range, *Century of Georgia Agriculture*, 28.
43. "Give Us Bread," *Southern Confederacy*, March 5, 1861.
44. "Crops, &tc., in Carrol," *Southern Confederacy*, June 1, 1861
45. Smith, *Starving the South*, 12.
46. Betts, "How to Get Coffee."
47. Betts, "Peach Leaf Yeast."
48. "Query?," *Southern Confederacy*, March 6, 1862.
49. "Salt Wars," *New York Times*, December 26, 2013.
50. Betts, "Editorial Correspondence."
51. Russell, *Atlanta, 1847–90*, 97–98.
52. Wortman, *Bonfire*, 139 (italics in original).
53. Hunter, *To 'Joy My Freedom*, 10; "Markets and Other Matters," *Southern Confederacy*, January 27, 1863, 3.
54. "Markets and Other Matters," *Southern Confederacy*, January 27, 1863, 3.
55. *Americus Sumter Republican*, March 27, 1863.
56. Smith, *Starving the South*, 27; Moore, *Confederate Commissary General*, 166.
57. Wortman, *Bonfire*, 190.
58. Stone Diary, March 22, 1864.
59. Miller, *Soul Food*, 197.
60. Stanton, "Hoecake Jingle," 4.
61. Stone, *Diary*, March 20, 1864.
62. "Our Rome Correspondent Abroad," *Southern Confederacy*, July 5, 1862, 2 (emphasis in original).
63. Sherman, "Recollections of a Half Century and More," 217.

64. Arp, "Arp on Patriotism," 2.

65. "Cornbread for Europe," *AC*, December 27, 1888, 4.

66. Fisher, *What Mrs. Fisher Knows*, 11.

67. "The Johnny Cake," *AC*, August 26, 1901, 4.

68. Wilcox, *New Dixie Cook-Book*, 42.

Chapter 5

69. Moore, *Confederate Commissary General*, 220.

70. Ibid., 230.

71. Stone, *Diary*, March 12, 1864.

72. Hoehling, *Last Train*, 83.

73. Garrett, *Atlanta and Its Environs*, 1:570.

74. Stone, *Diary*, June 7, 1864.

75. Mohr, *On the Threshold*, 177.

76. Stone, *Diary*, July 4, 1864.

77. Hinman, *Story of the Sherman Brigade*, 568.

78. Wortman, *Bonfire*, 257.

79. Ibid.

80. Hinman, *Sherman Brigade*, 533.

81. Huff, *My 80 Years in Atlanta*, chapter 3.

82. Wortman, *Bonfire*, 281.

83. "Gen. Sherman's Division," *New York Times*, September 1, 1864, 1.

84. Stone, *Diary*, July 21, 1864.

85. Hoehling, *Last Train*, 143.

86. Ibid., 212.

87. Berry, *Diary*, August 3, 1864.

88. Hoehling, *Last Train*, 225.

89. Ibid., 406.

90. Ibid., 445.

91. Wortman, *The Bonfire*, 333.

92. Garrett, *Atlanta and Its Environs*, 1:658.

93. Hoehling, *Last Train*, 488, 492.

94. Sherman, *Memoirs of General William T. Sherman*.

95. Hilliard, *Hog Meat and Hoecake*, 41.

96. Ibid., 42.

97. Wing and Carlisle, *Atlanta Woman's Club Cook Book*, 79.

Chapter 6

98. Taylor, "From the Ashes," 43.
99. Garrett, *Atlanta and Its Environs*, 1:670.
100. Russell, *Atlanta, 1847–90*, 118, quoting Effie McNaught to Mother, July 14, 1867, in William McNaught-James Ormond Papers, Atlanta History Center.
101. Link, *Atlanta*, 71.
102. Taylor, *From the Ashes*, 118–19.
103. Andrews, *South Since the War*, 340.
104. "Atlanta," *Natchez Daily Courier*, October 27, 1866.
105. *Atlanta Daily Herald*, January 21, 1873.
106. Garrett, *Atlanta and Its Environs*, 1:766.
107. "G.W. Jack," *AC*, September 14, 1873.
108. "Silver Wedding," *AC*, November 5, 1875.
109. "Funeral of Myra Miller," *AC*, May 6, 1891, 3.
110. "The Place to Go To," *AC*, November 8, 1874.
111. "Thompson's Restaurant," *AC*, January 25, 1874.
112. Cooley, *To Live and Dine in Dixie*, 46.
113. Hunter, *To Joy My Freedom*, 30.
114. "Studies of the Race Problem," *Sunny South*, September 26, 1885.
115. Hunter, *To Joy My Freedom*, 59.
116. Taylor, *From the Ashes*, 331.
117. "Work for Women," *AC*, June 2, 1869.
118. "Voice from the Kitchen," *Sunny South*, November 6, 1875.
119. "Table Talk," *AC*, December 3, 1882.
120. "Man About Town," *AC*, July 2, 1882.
121. "South's Need of Good Cooks," *AC*, January 14, 1883.
122. Hill, *Mrs. Hill's New Cook-Book*, 10–11.
123. "Industrial School," *AC*, December 16, 1875.
124. "Practical Education of Women," *AC*, November 21 1875.
125. "Cooking Club," *AC*, September 23, 1880.
126. Ibid.; "School for Cooking," *AC*, July 15, 1883.
127. "South's Need of Good Cooks," *AC*, January 14, 1883.
128. Dupree, *Nathalie Dupree's Southern Memories*, 60.

Chapter 7

129. Harris, *Life of Henry W. Grady*, 147.
130. Henry Woodfin Grady papers, MSS 28, Box 3, Nixon, 383.
131. Link, *Atlanta*, 154–55.
132. Henry Grady Papers, MSS 28, BV 7.
133. Garrett, *Atlanta and Its Environs*, 2:49.
134. Sullivan, *Georgia*, 125.
135. Link, *Atlanta*, 143.
136. Garrett, *Atlanta and Its Environs*, 2:24.
137. "Passing of Durand's Depot," *AC*, January 20, 1913.
138. "Durand's New Coffee Device," *AC*, October 13, 1893.
139. "Dudley Glass," *AC*, February 23, 1943.
140. "Passing of Durand's Depot"; "Henry Durand Opens Palatial New Café," *AC*, June 23, 1903.
141. "Pulse of Trade," *AC*, March 13, 1892, 21.
142. Newman, *Southern Hospitality*, 50.
143. "The Exposition," *AC*, November 3, 1881.
144. "Jones's Restaurant," *AC*, December 9, 1881.
145. "Dorsett's Clipper Saloon," January 27, 1869, 3.
146. Hill, *Mrs. Hill's New Cook Book*, 47.

Chapter 8

147. Grady, *Race Problem*.
148. Link, *Atlanta*, 155.
149. Burns, *Rage in the Gate City*, 17.
150. "From Bondage to Fortune," *AC*, February 2, 1896.
151. Link, *Atlanta*, 129.
152. "Atlanta University," *AC*, June 27, 1874.
153. Burns, *Rage in the Gate City*, 102.
154. "Novel Tour of City Officials," *AC*, July 4, 1897.
155. "Decatur Street," *AC*, July 2, 1893.
156. "Hail Society Avenue," *AC*, January 21, 1905.
157. "Soda Water Drinkers," *AC*, August 18, 1889.
158. Washington, *Up from Slavery*, 10.
159. Hill, *Mrs. Hill's New Cook Book*, 338.
160. Dull, *Mrs. Dull's Southern Cooking*, 219–22.

Chapter 9

161. Hickey, *Hope and Danger*, 57.
162. "No Cause for Alarm," *Jackson Daily News*, September 26, 1906.
163. Bauerlein, *Negrophobia*, 217.
164. Kuhn, Joye and West, *Living Atlanta*, 10.
165. Martin, *Atlanta and Its Builders*, 2:433.
166. Berry, "Black Memorial Institute," 562–64.
167. "'Possum Letters," *AC*, January 6, 1909.
168. "Notable Assemblage Gathered," *AC*, January 16, 1909.
169. "How New York Papers View 'Possum," *AC*, January 18, 1909.
170. "Price of Flour Soars," *AC*, May 27, 1909.
171. Sharpless, *Cooking in Other Women's Kitchens*, 19.
172. "Georgia Collards," *AC*, December 6, 1883.
173. "Opossum," *AC*, December 3, 1874; "Atlanta Wholesale Price Current," *AC*, December 24, 1875.
174. G.A. Scofield, "Possum: The Latest Craze."
175. LaFrance, "President Taft Ate a Lot of Possums."

Chapter 10

176. Kuhn, Joye and West, *Living Atlanta*, 113.
177. Ibid., 119–20.
178. Baker, *Following the Color Line*, 63.
179. Kuhn, Joye and West, *Living Atlanta*, 200.
180. Carey, "Herman Lay."
181. Dull, *Southern Cooking*, xii.
182 Byrn, "Godmother of Southern Cooking."
183. Dull, *Southern Cooking*, 3.
184. "Prominent Part in Business," *AC*, October 23, 1912.
185. Osinski, "Cornerstone of Waffle House."
186. Auchmutey, "Waffle House."
187. Ibid.
188. Auchmutey, "Varsity at 75."
189. Auchmutey, "Lupo Kept a Tradition Alive."
190. Auchmutey, "Mother's Back at Mary Mac's."
191. "Georgia Collards," *AC*, December 6, 1883.
192. "Collard Crop," *AC*, January 26, 1884.

193. Hastings, "Useful Home Garden"; "Supplies the World," *AC*, June 7, 1926.
194. Hill, *Mrs. Hill's New Cook-Book*, 188–89.
195. Dull, *Southern Cooking*, 92.

Chapter 11

196. King, *My Life*, 68.
197. Ibid., 90.
198. Branch, *Parting the Waters*, 106.
199. Abernathy, "My Old Friend Martin." 6.
200. King, *AD and ML King*, 40–41.
201. King, *My Life*, 90–91.
202. Ibid., 190.
203. King and Carson ed., *Autobiography*, 139.
204. Newman, *Southern Hospitality*, 164.
205. Crenshaw, "Evelyn Jones Frazier, 95."
206. Lewis, *Walking with the Wind*, 319.
207. "Eat Lunch," *Atlanta Magazine*, October 28, 2017.
208. Paschal, *Paschal's*, 127.
209. Henry, "Atlanta's Forgotten Black History."
210. WSB-TV newsfilm clip, October 19, 1960.
211. Osinski, "Cornerstone of Waffle House."
212. Short, *Everything Is Pickrick*, 46.
213. Ibid., 44.
214. Branch, *At Canaan's Edge*, 762.
215. "Chickens and Eggs," *AC*, January 17, 1883.
216. "In the Henroost," *AC*, August 18, 1882.
217. "'Candidates' Supper' Will Be Given Tonight," *AC*, August 11, 1910.
218. "Climax of Georgia's Resources," *AC*, June 26, 1921.

Chapter 12

219. Stroud, "Say Cheese."
220. Dupree, interview with the author, July 27, 2018.
221. Dupree and Graubart, *Mastering the Art*, 13.
222. Cress, "Sweet Taste of Success."

223. Dupree, interview.

224. Dupree, *New Southern Cooking*, xix.

225. Olsson, "Making The 'International City,'" 72–73.

226. Thwaite, "Take Your Pick of Markets."

227. Byrn, "Merry Marketplace."

228. Ibid.

229. Robert Blazer, interview with the author, August 1, 2018.

230. Medley, Ma interview, 25.

231. Ibid., 55–56.

232. Medley, Shinn interview, 25.

233. Olsson, "Making the 'International City,'" 37.

234. Guthey, "Hispanic Leaders Furious."

235. Goldman, "'Bucket List' for Food-Centric Folks."

BIBLIOGRAPHY

Books

Allen, Frederick. *Atlanta Rising: The Invention of an International City, 1946–1996.* Marietta, GA: Longstreet Press, 1996.

———. *Secret Formula: The Inside Story of How Coca-Cola Became the Best-Known Brand in the World.* New York: Open Road Integrated Media, 1994.

Andrews, Sidney. *The South Since the War: As Shown by Fourteen Weeks of Travel and Observation in Georgia and the Carolinas.* Boston: Ticknor and Fields, 1866.

Baker, Ray Stannard. *Following the Color Line: An Account of Negro Citizenship in the American Democracy.* New York: Doubleday, Page & Company, 1908.

Baldwin, Lewis V. *Behind the Public Veil: The Humanness of Martin Luther King Jr.* Minneapolis, MN: Fortress Press, 2016.

Bauerlein, Mark. *Negrophobia: A Race Riot in Atlanta, 1906.* San Francisco: Encounter Books, 2001.

Berry, Carrie. *Diary of Carrie Berry: A Confederate Girl.* http://dlg.galileo.usg.edu/cgi/turningpoint?repo=ahc;item=ahc0029f-001;format=pdf.

Branch, Taylor. *At Canaan's Edge: America in the King Years, 1965–68.* New York: Simon & Schuster, 2006.

———. *Parting the Waters: America in the King Years, 1954–63.* New York: Simon & Schuster, 1988.

———. *Pillar of Fire: America in the King Years, 1963–65.* New York: Simon & Schuster, 1998.

Braund, Kathryn E. Holland. *Deerskins and Duffels: Creek Indian Trade eith Anglo-America, 1685–1815*. Lincoln: University of Nebraska Press, 1993.

Burns, Rebecca. *Rage in the Gate City: The Story of the 1906 Atlanta Race Riot*. Athens: University of Georgia Press, 2009.

Butler, Rhonda, and Pam Durban Porter. *Cabbagetown Families, Cabbagetown Food*. Atlanta: Patch Publications, 1976.

Carter, E.R. *The Black Side: A Partial History of the Business, Religious, and Educational Side of the Negro in Atlanta, Ga*. Berkeley: University of California Berkeley, 1894.

Cathy, S. Truett. *How Did You Do It, Truett?: A Recipe for Success*. Decatur, GA: Looking Glass Books, 2007.

Chirhart, Ann Short, and Betty Wood. *Georgia Women: Their Lives and Times*. Athens: University of Georgia Press, 2009.

Clarke, E.Y. *Illustrated History of Atlanta*. Atlanta: Cherokee Publishing, 1879.

Cooley, Angela. *To Live and Dine in Dixie: The Evolution of Urban Food Culture in the Jim Crow South*. Athens: University of Georgia Press, 2015.

Davis, Ren, and Helen Davis. *Atlanta's Oakland Cemetery: An Illustrated History and Guide*. Athens: University of Georgia Press, 2012.

Davis, Robert Scott. *Civil War Atlanta*. Charleston, SC: The History Press, 2011.

Davis, Stephen. *Atlanta Will Fall: Sherman, Joe Johnston, and the Yankee Heavy Battalions*. Wilmington, DE: Scholarly Resources, 2001.

DuBois, W.E.B. "The Talented Tenth." In *The Negro Problem: A Series of Articles by Representative Negroes of Today*, edited by Booker T. Washington. New York: J. Pott & Company, 1903.

Dull, Mrs. S.R. [Henrietta]. *Mrs. Dull's Southern Cooking*. Athens: University of Georgia, 1928.

Dupree, Nathalie. *Nathalie Dupree's Southern Memories: Recipes and Reminisces*. Athens: University of Georgia Press, 2004.

———. *New Southern Cooking*. Athens: University of Georgia Press, 1986.

Dupree, Nathalie, and Cynthia Graubart. *Mastering the Art of Southern Cooking*. Layton, UT: Gibbs Smith, 2012.

Edge, John T. *The Potlikker Papers: A Food History of the Modern South*. New York: Penguin Press, 2017.

Ellis, Franklin. *History of Cattaraugus County, New York*. Philadelphia: J.S. Lippincott, 1879.

Ferrell, John. *Mary Mac's Tea Room: 70 Years of Recipes from Atlanta's Favorite Dining Room*. Kansas City, MO: Andrews McMeel Publishing, 2010.

Fisher, Abby. *What Mrs. Fisher Knows About Old Southern Cooking.* San Francisco: Women's Co-Op Printing Office, 1879.

Garrett, Franklin M. *Atlanta and Environs: A Chronicle of Its People and Events.* Vol. 1. Athens: University of Georgia Press, 1969.

———. *Atlanta and Environs, A Chronicle of Its People and Events.* Vol. 2. *1880s–1930s.* Athens: University of Georgia Press, 1969.

Georgeson, Stephen P. *Atlanta Greeks: An Early History.* Charleston, SC: The History Press, 2015.

Grady, Henry. *The Race Problem, An After Dinner Speech.* Philadelphia: J.D. Morris & Company, 1900.

Hahn, Steven C. *The Invention of the Creek Nation, 1670 to 1763.* Lincoln: University of Nebraska Press, 2004.

Hardeman, Nicholas P. *Shucks, Shocks, and Hominy Blocks: Corn as a Way of Life in Pioneer America.* Baton Rouge: Louisiana State University Press, 1999.

Hawkins, Benjamin. *Letters of Benjamin Hawkins, 1796–1806.* Savannah: Georgia Historical Society, 1916.

Hertzberg, Steven, *Strangers within the Gate City: The Jews of Atlanta, 1845–1915.* Philadelphia: Jewish Publication Society, 1978.

Hickey, Georgina. *Hope and Danger in the New South City: Working-Class Women and Urban Development in Atlanta, 1890–1940.* Athens: University of Georgia, 2003.

Hill, Annabella P. *Mrs. Hill's New Cook-Book.* New York: G.W. Dillingham Company, 1876.

Hilliard, Sam Bowers. *Hog Meat and Hoecake: Food Supply in the Old South, 1840–1860.* Carbondale: Southern Illinois University Press, 1972.

Hinman, Wilbur F. *Story of the Sherman Brigade.* Alliance: Ohio State University, 1897.

Hoehling, A.A. *Last Train from Atlanta: The Heroic Story of an American City Under Siege.* Atlanta: Thomas Yoseloff, 1958.

Huff, Sarah. *My 80 Years in Atlanta.* http://www.artery.org/08_history/UpperArtery/CivilWar/SaraHuff.html.

Hunter, Tera W. *To 'Joy My Freedom: Southern Black Women's Lives and Labors after the Civil War.* Cambridge, MA: Harvard University Press, 1998.

King, Coretta Scott. *My Life with Martin Luther King Jr.* London: Puffin Books, 1994.

King, Martin Luther, Jr., ed. Claybourne Carson. *The Autobiography of Martin Luther King Jr.* New York: Warner Books, 1998.

King, Naomi Ruth Barber. *AD and ML King: Two Brothers Who Dared to Dream.* Bloomington, IN: AuthorHouse, 2014.

Kuhn, Clifford, Harlon Joye and E. Bernard West. *Living Atlanta: An Oral History of the City, 1914–1948*. Athens: University of Georgia Press, 1990.

Lane, Barbara. *Echoes from the Battlefield: First-Person Accounts of Civil War Past Lives*. CreateSpace Independent Publishing Platform, 2012.

Lewis, John. *Walking with the Wind: A Memoir of the Movement*. New York: Simon & Schuster Paperbacks, 2015.

Lewis, Lloyd. *Sherman: Fighting Prophet*. Lincoln: University of Nebraska, 1993.

Link, William. *Atlanta, Cradle of the New South: Race and Remembering in the Civil War's Aftermath*. Chapel Hill: University of North Carolina Press, 2015.

Martin, Joel W. *Sacred Revolt: The Muskogees' Struggle for a New World*. Boston: Beacon Press, 1991.

Martin, Thomas H. *Atlanta and Its Builders: A Comprehensive History of the Gate City of the South*. Atlanta: Century Memorial Publishing Company, 1902.

———. *Atlanta and Its Builders: A Comprehensive History of the Gate City of the South*. Vol. 2 Atlanta: Century Memorial Publishing Company, 1902.

McDonald, Janice. *The Varsity*. Charleston, SC: Arcadia Publishing 2011.

Miller, Adrian. *Soul Food: The Surprising Story of an American Cuisine, One Plate at a Time*. Chapel Hill: University of North Carolina Press, 2013.

Mohr, Clarence L. *On the Threshold of Freedom: Masters and Slaves in Civil War Georgia*. Baton Rouge: Louisiana State University Press, 2001.

Moore, Jerrold Northrop. *Confederate Commissary General: Lucius Bellinger Northrop and the Subsistence Bureau of the Southern Army*. Shippensburg, PA: White Mane Publishers, 1996.

Moss, Robert. *Barbecue: The History of an American Institution*. Tuscaloosa: University of Alabama Press, 2010.

Newman, Harvey K. *Southern Hospitality: Tourism and the Growth of Atlanta*. Tuscaloosa: University of Alabama Press, 1999.

Paschal, James Vaughn, as told to Mae Armster Kendall. *Paschal's: Living the Dream*. Lincoln, NE: iUniverse, 2006.

Pendergrast, Mark. *For God, Country, and Coca-Cola*. New York: Basic Books, 2000.

The Pioneer Citizens' Society of Atlanta. *Pioneer Citizens' History of Atlanta, 1833–1902*. Atlanta: Byrd Printing Company, 1902.

Range, Willard A. *A Century of Georgia Agriculture, 1850–1950*. Athens: University of Georgia Press, 1954.

Raymond, Ida. *Southland Writers*. Philadelphia: Claxton, Remsen & Haffelfinger, 1870.

Reed, Wallace Putnam. *History of Atlanta, Georgia: With Illustrations and Biographical Sketches of Some of Its Prominent Men and Pioneers*. Atlanta: D. Mason & Company, 1889.

Ruffin, Edward. *Farmers' Register*. Petersburg, VA: Edmund and Julian C. Ruffin, 1840.

Russell, James Michael. *Atlanta, 1847–1890: City Building in the Old South and the New*. Baton Rouge: Louisiana State University Press, 1988.

Sharpless, Rebecca. *Cooking in Other Women's Kitchens: Domestic Workers in the South, 1865–1960*. Chapel Hill: University of North Carolina Press, 2010.

Shenton, James P. *Slavery in the Cities: The South, 1820 to 1860*. Kent, OH: Kent State University Press, 1965.

Sherman, William T. *Memoirs of General William T. Sherman*. New York: D. Appleton and Company, 1875. https://www.loc.gov/collections/william-t-sherman-papers/about-this-collection.

Short, Bob. *Everything Is Pickrick: The Life of Lester Maddox*. Macon, GA: Mercer University Press, 1999.

Smith, Andrew F. *Starving the South: How the North Won the Civil War*. New York: St. Martin's Press, 2011.

Smith, Ron, and Mary O. Boyle. *Prohibition in Atlanta: Temperance, Tiger Kings, & White Lightning*. Charleston, SC: The History Press, 2015.

Stone, Cyrena Bailey. *Cyrena Bailey Stone Diary*. Ms 1000, Hargrett Rare Book and Manuscript Library, the University of Georgia Libraries, 1864.

Sullivan, Buddy. *Georgia: A State History*. Charleston, SC: Arcadia Publishing, 2010.

Swanton, John R. *Early History of the Creek Indians and Their Neighbors*. Washington, D.C.: Smithsonian Institution Bureau of American Ethnology Bulletin 73, 1922.

Wade, Richard C. *Slavery in the Cities: The South 1820–1860*. Oxford, UK: Oxford University Press, 1967.

Washington, Booker T. *Up from Slavery: An Autobiography*. Garden City, NJ: Doubleday & Company, 1901.

Weld, Theodore Dwight, and C. Stephen Badgley. *American Slavery as It Is: Testimony of a Thousand Witnesses*. Chapel Hill: University of North Carolina at Chapel Hill, 2000.

Wilcox, Estelle Woods. *The New Dixie Cook-Book and Practical Housekeeper*. Atlanta: Clarkson & Company, 1889.

Wing, Mrs. Newton C., and Mrs. J.A. Carlisle. *Atlanta Woman's Club Cook Book*. Atlanta: Atlanta Woman's Club, 1921.

Wortman, Marc. *The Bonfire: The Siege and Burning of Atlanta*. Philadelphia: Perseus Books Group, 2009.

Articles

Abernathy, Ralph David. "My Old Friend Martin." *Tennessean: USA Weekend*, January 12–14, 1990, 6.

Alexander, Robert G., "Negro Business in Atlanta." *Southern Economic Journal* 17, no. 4 (April 1951): 451–64.

Americus Sumter Republican. March 27, 1863.

Andrews, Maud. "Trials of Housekeeping: Why Our Hotels and Boarding Houses Are Filled." *Atlanta Constitution*, December 16, 1888, 4.

Arp, Bill. "Arp on Patriotism: Truths Plainly and Tersely Told—He Treats of Patriotism." *Atlanta Constitution*, September 26, 1884, 2.

Atlanta Constitution. "Alas and Alack Free Lunches Going." April 17, 1897, 8.

———. "Ate Corn Bread; Death Resulted." November 28, 1908, 1.

———. "Atlanta's Most Unique Industry." October 17, 1899, 11.

———. "The Atlanta University." June 27, 1874, 3.

———. "Atlanta Wholesale Price Current." December 24, 1875, 4.

———. "Barrooms Bums." August 11, 1889, 5.

———. "The Belmont!" April 28, 1889, 1.

———. "Broad Street's Importance." September 22, 1895, 17.

———. "Bruff's Column." April 9, 1906, 6.

———. "Business Chances." December 8, 1888, 3.

———. "'A Candidates' Supper' Will Be Given Tonight." August 11, 1910, 8.

———. "Chicken Brunswick Stew." August 13, 1922, 18.

———. "Chickens and Eggs." January 17, 1883, 4.

———. "Chiefs of the Rail." November 6, 1875, 3.

———. "Climax of Georgia's Resources in Marble and Fried Chicken." June 26, 1921, 2K.

———. "The Collard Crop." January 26, 1884, 2.

———. "The Cooking Club." September 23, 1880, 1.

———. "Cornbread Aids Southern Teeth." August 20, 1912, 8.

———. "Cornbread for Europe." December 27, 1888, 4.

———. "Col. Thos. W. Webb Dies at Jefferson." September 7, 1909, 9.

———. "Decatur Street." July 2, 1893, 10.

———. "Dorsett's Clipper Saloon." January 27, 1869, 3.

———. "Dudley Glass." February 23, 1943, 7.

———. "Durand's New Coffee Device." October 13, 1893, 8.

———. "Durand's Restaurant No More." October 22, 1914, 7.

———. "Dying of Pellagra, Woman Takes Life." October 7, 1910, 4.

———. "An Elegant Dinner." December 1, 1882, 7.

———. "The Exposition." November 3, 1881, 2.

———. "From Bondage to Fortune." February 2, 1896, 12.

———. "Funeral of Myra Miller." May 6, 1891, 3.

———. "Georgia Collards." December 6, 1883, 4.

———. "G.W. Jack." September 14, 1873, 4.

———. "Hail Society Avenue, Exit Decatur Street." January 21, 1905, 7.

———. "Harry Stockdell Dies in Athens." September 12, 1912, 1.

———. "The Haunts of the Lowly and the Vicious." July 20, 1881, 4.

———. "Henry Durand Opens Palatial New Café." June 23, 1903, 5.

———. "Historic Meetings of the Past." March 16, 1896, 4.

———. "How New York Papers View 'Possum Banquet." January 18, 1909, 2.

———. "How Women Servants Are Paid." October 19, 1878, 1.

———. "Industrial School." December 16, 1875, 3.

———. "In Presence of Outraged Girl Black Field Is Shot to Death by Enraged Atlanta Citizens." August 1, 1906, 1.

———. "In the Henroost." August 18, 1882, 2.

———. "The Johnny Cake." August 26, 1901, 4.

———. "Jones's Restaurant." December 9, 1881, 8.

———. "Little Switzerland." August 6, 1887, 8.

———. "Little Switzerland Reopened." April 20, 1888, 7.

———. "Lively Scenes in the Police Court." July 18, 1899, 9.

———. "The Man About Town." July 2, 1882, 1.

———. "Municipal Market Marks Triumph for Atlanta Woman's Club." January 27, 1924, 44.

———. "The New City Prison." May 6, 1891, 7.

———. "North Carolina." January 9, 1874, 2.

———. "Notable Assemblage Gathered to Do Honor to President-Elect." January 16, 1909, 3.

———. "Novel Tour of City Officials." July 4, 1897, 17.

———. "On Saturday Night." October 15, 1893, 7.

———. "The Opossum: Atlanta as an Opossum Market—A New but Thriving Industry." December 3, 1874.

———. "Our Confectioners." July 31, 1875, 1.

———. "Passing of Durand's Depot." January 20, 1913, 5.

———. "Pellagra Cause of His Suicide." August 28, 1912, 7.

———. "Pellagra Cured by Correct Diet." October 22, 1915, 1.

———. "Piedmont House Menu." November 19, 1905, 24.

———. "The Place to Go To." November 8, 1874, 3.

———. "'Possum Letters Are Still Pouring in from Six States." January 6, 1909, 5.

———. "The Practical Education of Women." November 21, 1875, 2.

———. "Price of Flour Soars Upward." May 27, 1909, 1–2.

———. "Prominent Part in Business Life Taken by Greeks." October 23, 1912, A11.

———. "The Pulse of Trade: Leading Business Men on the Situation." March 13, 1892, 21.

———. "The Queer Case." June 14, 1879, 1.

———. "Rare Festivities Down in 'Dive.'" September 18, 1898, 6.

———. "A Royal Punch." December 28, 1888, 5.

———. "School for Cookin.," July 15, 1883, 11.

———. "Silver Wedding of Mr. and Mrs. Perino Brown: The Social Event of the Season." November 5, 1875, 3.

———. "Sitting on an Atlanta Water Plug He Recounts His Life." October 11, 1887, 8.

———. "Snowdrift Ad." September 11, 1924, 16.

———. "The South's Need of Good Cooks." January 14, 1883, 11.

———. "State Agricultural Convention: Startling Figures in Favor of Small Farms." August 13, 1874, 3.

———. "Story of Atlanta's Very Latest and Most Unique Enterprise." November 13, 1898, 5.

———. "Supplies the World." June 7, 1926, 4.

———. "Table Talk: What Is Going On in the Local Market for Table Supplies, Etc." December 3, 1882, 9.

———. "Tech Students Give Banquet." January 20, 1907, 33.

———. "The Thompson House." May 9, 1875.

———. "Thompson's." October 23, 1873, 3.

———. "Thompson's Restaurant." April 15, 1869, 3.

———. "Thompson's Restaurant." January 25, 1874, 8.

———. "Thompson's Restaurant." February 2, 1876.

———. "Thompson's Restaurant! Complete Renovation for the Fall Season." October 18, 1874, 4.

———. "Thompson's Restaurant: Important to the Public." May 30, 1876, 1.

———. "Wet or Dry?" November 25, 1885, 1.

———. "Work for Women." June 2, 1869, 2.

———. "A World in Walls!" January 26, 1879, 3.

Atlanta Daily Herald. January 21, 1873.

Atlanta Journal-Constitution. "Mother's Back at Mary Mac's." March 9, 1994, H1.

Atlanta Magazine. "Eat Lunch where Civil Rights Movement Leaders Once Held Meetings." October 28, 2017, http://www.atlantamagazine. com/50bestthingstodo/eat-lunch-where-civil-rights-movement-leaders-once-held-meetings.

Atlanta Weekly Intelligencer and Cherokee Advocate. "Commercial." June 14, 1855, 3.

————. "For Sale, at the Georgia Drug Store." June 14, 1855, 3.

————. "New Candy Manufactory and Bakery." June 22, 1855, 4.

Auchmutey, Jim, "Lupo Kept a Tradition Alive." *Atlanta Journal-Constitution*, July 1, 1998, D3.

————. "The Varsity at 75." *Atlanta Journal-Constitution*, October 5, 2003.

————. "Waffle House: Recipe for Southern Success Is History." *Atlanta Journal-Constitution*, September 2, 2008.

Bainbridge, Julia. *Atlanta Magazine*. "What's Up with the Chicken Bones in Atlanta?" March 30, 2017, http://www.atlantamagazine.com/dining-news/whats-chicken-bones-atlanta.

Bennette, Fred C., Jr. "The Atlanta Chapter of Operation Breadbasket Bi-Annual Report." February 6, 1968, http://www.thekingcenter.org/archive/document/atlanta-operation-breadbasket-bi-annual-report.

Bent, Silas, "Let's Grab a Bite." *Atlanta Constitution*, April 13, 1941, 6.

Berry, Riley M. Fletcher. "The Black Memorial Institute." *Good Housekeeping Magazine* 53 (July 1911): 562–64.

Betts, Vicki. "Atlanta Southern Confederacy, March 1861–May 1863." (2016). "Editorial Correspondence." *Southern Confederacy*, June 8, 1862, 2. https://scholarworks.uttyler.edu/cw_newstitles/11.

————. "Atlanta Southern Confederacy, March 1861–May 1863" (2016). "How to Get Coffee." *Southern Confederacy*, August 27, 1861, 1. https://scholarworks.uttyler.edu/cw_newstitles/11.

————. "Atlanta Southern Confederacy, March 1861–May 1863" (2016). "Peach Leaf Yeast." *Southern Confederacy*, November 1, 1861, 2. https://scholarworks.uttyler.edu/cw_newstitles/11.

Bradwell, I.G., "Last Days of the Confederacy." *Confederate Veteran* 29 (1921): 58.

Brigham, A.A., "Advice from the Poultry Doctor." *Atlanta Georgian and News*, May 27, 1911, 33.

Byrn, Anne. "The Godmother of Southern Cooking (with Gas)." *Bitter Southerner.* https://bittersoutherner.com/henrietta-dull-southern-cooking#. XJGMdxNKiL8.

————. "Merry Marketplace: New DeKalb Farmers Market Will Make Shopping a Pleasure." *Atlanta Constitution*, September 25, 1986, 18F.

Carey, Bill. "Herman Lay and America's Appetite for Junk Food." *Nashville Post*, September 11, 2000. https://www.nashvillepost.com/home/article/20446310/herman-lay-and-americas-appetite-for-junk-food.

Carroll Free Press. "Sweet Potatoes." March 2, 1888, 4.

Clay, Karen, Ethan Schmick and Werner Troesken, "The Rise and Fall of Pellagra in the American South." Draft article, 2016, http://eh.net/eha/wp-content/uploads/2016/08/ClayTroesken.pdf.

Coolong, Timothy. "Commercial Production and Management of Cabbage and Leafy Greens." UGA Extension Bulletin 1181 (Reviewed January 2017), http://extension.uga.edu/publications/detail.html?number=B1181&title=Commercial%20Production%20and%20Management%20of%20Cabbage%20and%20Leafy%20Greens.

Crenshaw, Holly. "Evelyn Jones Frazier, 95, Restaurateur, Brought Style, Class to Segregated South." *Atlanta Journal-Constitution*, September 6, 2007, B5.

Cress, Doug. "The Sweet Taste of Success." *Atlanta Constitution*, May 25, 1994, C1.

Fleetwood, M.L. "Master Barbecue Artist Gives Famous Brunswick Stew Receipt." *Atlanta Constitution*, August 23, 1931, 17.

Goldman, Meredith Ford. "A 'Bucket List' for Food-Centric Folks." *Atlanta Constitution*, July 3, 2009, D4.

Guthey, Greig. "Hispanic Leaders Furious at Chamblee Officials' Remarks." *Atlanta Journal/Atlanta Constitution*, August 21, 1992, D3.

Harper's Weekly. "'Possum and 'Taters." June 26, 1909, 29–30.

Harris, Joel Chandler. "Nights with Uncle Remus." *Atlanta Constitution*, March 9, 1884, 2.

Hartley, Grace, "Simple Food—Hearty Flavor." *Atlanta Constitution*, December 30, 1973.

Hastings, H.G. "The Useful Home Garden." *Atlanta Constitution*, February 25, 1917, 7.

Henry, Scott, "Atlanta's Forgotten Black History." *Creative Loafing*, February 16, 2010, https://creativeloafing.com/content-185557-Cover-Story:-Atlanta's-forgotten-black-history.

Jackson Daily News. "No Cause for Alarm." September 26, 1906, 6.

Krogh, Josie. "Collard Greens: Not Just a Southern Thing Anymore." UGA Cooperative Extension, April 10, 2015, http://www.caes.uga.edu/newswire/story.html?storyid=5428&story=Collard-Boom.

LaFrance, Adrienne. "President Taft Ate a Lot of Possums." *The Atlantic*, November 26, 2015, https://www.theatlantic.com/notes/2015/11/president-taft-ate-a-lot-of-possums/417873.

Mackle, Elliott. "Havana Good Time Eating Out in Atlanta's Cuban Restaurants." *Atlanta Constitution*, September 12, 1991, W10.

McConnell, Akila. "Grits: An American Story." *Cultures & Cuisines*, October 2015.

Miller, Adrian. "That Time Jimmy Carter Made America Obsessed with Grits." *Extra Crispy*, September 2, 2016, http://www.myrecipes.com/extracrispy/that-time-jimmy-carter-made-america-obsessed-with-grits.

Miner, Michael. "A Guide to Grits." *Atlanta Constitution*, July 28, 1976, 17.

Mitchell, Eugene M. "The Story of the 'Standing Peachtree.'" *Atlanta Historical Bulletin* 1, no. 2 (January 1928): 10.

Moore, Idera McClellan. "The Old-Time Atlanta Constitution Plantation Negroes." *Atlanta Constitution*, March 26, 1916, 6.

Natchez Daily Courier. "Atlanta." October 27, 1866, 2.

New York Times. "Gen. Sherman's Division." September 1, 1864, 1.

———. "The Salt Wars." December 26, 2013.

Osinski, Bill. "The Cornerstone of Waffle House." *Atlanta Journal-Constitution*, December 24, 2004.

Platte, Mark. "The New Wave from the East." *Atlanta Constitution*, February 25, 1983, C7.

Ruggles, W.B. "Turtle Soup." *Atlanta Weekly Intelligencer*, November 4, 1854, 1.

Schumm, Laura. "America's Patriotic Victory Gardens." History.com, accessed May 29, 2014, https://www.history.com/news/americas-patriotic-victory-gardens.

Scroggins, Deborah. "DeKalb's Melting Pot Is Bubbling." *Atlanta Constitution*, January 12, 1992, 8.

Severson, Kim. "Green Peach Salad with Simple Lime Dressing." *New York Times*, accessed August 15, 2018, https://cooking.nytimes.com/recipes/1019255-green-peach-salad-with-simple-lime-dressing.

Sherman, Andrew. "Recollections of a Half Century and More." *Americana (American Historical Magazine)* 11 (1916).

Sibley, Celestine. "Food for Thought." *Atlanta Constitution*, August 13, 1976, 4H.

Southern Confederacy. "Beach & Root Advertisement." March 4, 1861, 2.

———. "The Capital City." March 5, 1861, 3.

———. "Commercial." June 26, 1861, 3.

———. "Commercial." March 4, 1861, 3.

———. "Crops, &tc., in Carrol." June 1, 1861, 2.

———. "Exemptions." March 17, 1863, 3.

———. "Give Us Bread." March 5, 1861, 2.

————. "Markets and Other Matters." January 27, 1863, 3.

————. "The Monopoly and Extortion Bill." March 7, 1862, 3.

————. "Our Rome Correspondent Abroad." July 5, 1862, 2.

————. "Query?" March 6, 1862, 4.

————. "Salt Again." January 12, 1862, 2.

————. "The Women's Seizures." March 20, 1863, 3.

Stanton, Frank L. "The Hoecake Jingle." *Atlanta Constitution*, March 14, 1922, 4.

Stevenson, Paul. "Bathing Beauties and Burnt Fingers; All in a Fourth." *Atlanta Constitution*, July 5, 1921, 3.

Stroud, Kandy. "Say Cheese." *Atlanta Constitution*, January 3, 1977, 18.

Sunny South. "Studies of the Race Problem. The Character the Negro Has Developed as a Law-Abiding Citizen." September 26, 1885, 4.

————. "A Voice from the Kitchen." November 6, 1875, 5

Thwaite, Jean. "Take Your Pick of Markets." *Atlanta Constitution*, August 2, 1979, F1.

White, Gayle, "Ponce's Jumping as Suburbs Sleep." *Atlanta Constitution*, June 14, 1979, B-1.

Williams, Teresa Crisp, and David Williams. "The Women Rising: Cotton, Class, and Confederate Georgia's Rioting Women." *Georgia Historical Quarterly* 86, no. 1 (Spring 2002): 59.

Wilson, M.A. "Home Cooking." *Atlanta Constitution*, July 17, 1919, 11.

Wortman, Marc. "Why Was Robert Webster, a Slave, Wearing What Looks Like a Confederate Uniform?" *Smithsonian Magazine*, October 2014. https://www.smithsonianmag.com/history/why-was-robert-webster-slave-wearing-what-looks-confederate-uniform-180952781.

Young, Patrick, "Immigrant America on the Eve of the Civil War." *Long Island Wins*, March 2, 2011. https://longislandwins.com/news/national/immigrant-america-on-the-eve-of-the-civil-war.

Personal Papers and Other Materials

Blazer, Robert. Interview with the author. August 1, 2018.

Dupree, Nathalie. Interview with the author. July 27, 2018.

Henry Woodfin Grady papers, MSS 28, available at Emory University Rare Materials Collection.

————. Harold Shinn Interview, Southern Foodways Alliance, April 3, 2010, https://www.southernfoodways.org/app/uploads/shinn-harold_sfa-medley_03april10.pdf.

Olsson, Tore C. "Making The 'International City': Work, Law, and Culture in Immigrant Atlanta, 1970–2006." Master's thesis, University of Georgia, 2007, https://getd.libs.uga.edu/pdfs/olsson_tore_c_200708_ma.pdf.

"Possum: The Latest Craze." Words by G.A. Scofield. Music by J.B. Cohen. New York: Pease Piano Company, 1909.

Slack, Marshall. Interview with the author. April 14, 2015.

Tate, Lakeisha, "Navigating Food Deserts: A Geo-Ethnography of Atlanta Residents' Experiences, Routines, and Perceptions." PhD diss., Georgia State University, 2018, https://scholarworks.gsu.edu/sociology_diss/103.

Taylor, Arthur Reed. "From the Ashes: Atlanta During Reconstruction, 1865–1876." PhD diss., Emory University, 1973.

WSB-TV newsfilm clip of Dr. Martin Luther King Jr. speaking about Rich's Department Store, October 19, 1960, http://crdl.usg.edu/cgi/crdl?format=_video&query=id%3Augabma_wsbn_37496&_cc=1

INDEX

Recipes

ABOUT THE AUTHOR

Akila Sankar McConnell has been sharing stories of Atlanta's food and history for over a decade, writing for numerous publications, including *Condé Nast Traveler* and About.com. In 2015, she launched Unexpected Atlanta Walking Tours, which offers Atlanta Food Walks and Atlanta History Tours, and was named by *National Geographic* as the top tour to experience the city. She frequently speaks at conferences, both locally and nationally, about the intersection of food and storytelling. Akila lives in Decatur, and in the summer, you'll find her hunting for sweet corn and peaches at farmers' markets with her husband and two micro-foodies.